THE BEST OF
THE BEST OF
BUSINESS
CARD
DESIGN

ROCKPORT

£27-50

THE BEST OF
THE BEST OF
BUSINESS
CARD
DESIGN

ROCKPORT PUBLISHERS

GLOUCESTER, MASSACHUSETTS

First published in the United States of America by
Rockport Publishers, Inc.
33 Commercial Street
Gloucester, Massachusetts 01930-5089
Telephone: (978) 282-9590
Fax: (978) 283-2742
www.rockpub.com

ISBN 1-59253-004-4
Cover and Layout design: *tabula rasa*
Cover image and page 5: T.DeBrocke/Retrofile.com

Grateful acknowledgment is given to Jeannet Leendertse for her
work from *The Best of Business Card Design 4* on pages 6-189.

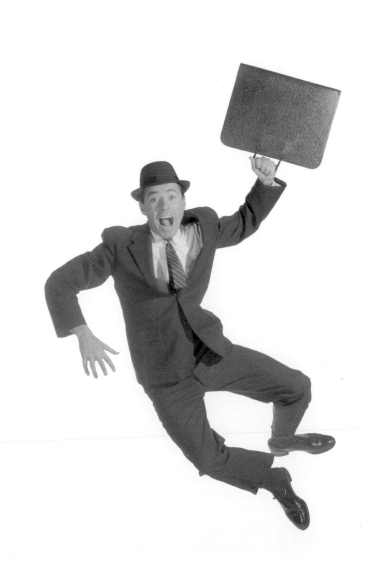

2

Design Firm
 The Riordon Design Group
Art Director
 Ric Riordon
Designer
 Dan Wheaton
Client
 Self-promotion
Software/Hardware
 Adobe Illustrator, Adobe
 Photoshop, QuarkXpress
Paper/Materials
 Beckett Expression
Printing
 Somerset Graphics

3

Design Firm
 Matite Giovanotte
Art Director
 Stefania Adani
Designer
 Stefania Adani
Client
 XT Societá Di Consulenza
Software/Hardware
 Freehand, Macintosh
Paper/Materials
 Fedrigoni Nettuno Bianco Artico
Printing
 2 Colors

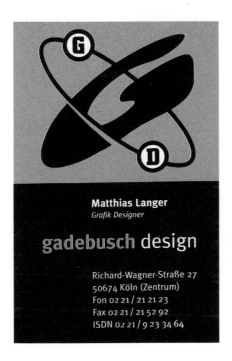

2

3

1

Design Firm
 Langer Design
Designer
 Matthias Langer
Client
 Gadebusch Design
Software/Hardware
 QuarkXpress, Freehand,
 Macintosh
Printing
 2 Colors

Design Firm
The Riordon Design Group
Art Director
Ric Riordon
Designer
Dan Wheaton
Client
Chuck Gammage Animation
Software/Hardware
Adobe Photoshop, QuarkXpress
Paper/Materials
Classic Crest
Printing
Somerset Graphics

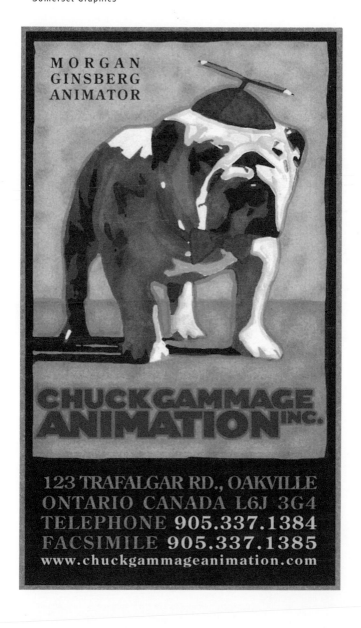

Design Firm
Sibley Peteet Design
Art Director
Donna Aldridge
Designer
Donna Aldridge
Illustrator
Donna Aldridge
Client
Ray Laskowitz
Software/Hardware
Adobe Illustrator, Macintosh
Paper/Materials
Cougar Opaque Cream
Printing
Millet The Printer

PIECEWORK
PRODUCTIONS

RAY LASKOWITZ
PHOTOGRAPHER
DALLAS, TEXAS
75214-0734

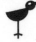

214-941-3678
PWork1121@AOL.com

1
Design Firm
Creative Company
Art Director
Chris Novd
Designer
Chris Novd
Client
Roth Heating & Cooling
Software/Hardware
Macintosh
Paper/Materials
Lustro Dull
Printing
Panther Print

2
Design Firm
Niehinger & Rohsiepe
Art Directors
C. Niehinger, H. Rohsiepe
Designers
C. Niehinger, H. Rohsiepe
Client
Eckart Schuster, Consultant
Software/Hardware
Freehand 8.o, Macintosh
Paper/ Materials
Gmund Die Natuerlichen
Printing
Black, Red, and Silver

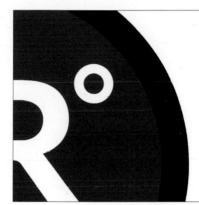

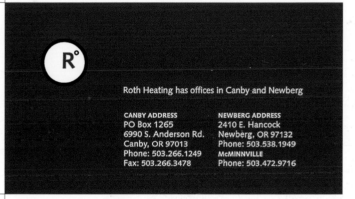

1

2

Design Firm
R & M Associati Grafici
Art Directors
Di Somma/Fontanella
Client
Self-promotion
Software/Hardware
Adobe Illustrator, Macintosh
Printing
Offset

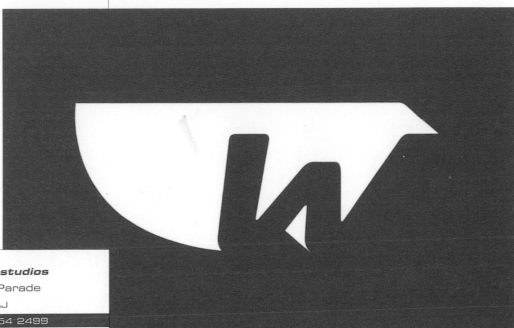

wasps artists' studios
256 Alexandra Parade
Glasgow G31 3AJ
tel +44 141 554 2499
fax +44 141 556 5340
email gillianblack@waspsstudios.org.uk
web www.waspsstudios.org.uk

Gillian Black
General Manager

Design Firm
 Graven Images Ltd.
Art Director
 Janice Kirkpatrick
Designer
 Colin Raeburn
Client
 Wasps Artists' Studios
Software/Hardware
 Adobe Illustrator, QuarkXpress
Paper/Materials
 Conqueror, Oyster Wove, 300 gsm
Printing
 2 Color Litho

1

Design Firm
J. Gail Bean, Graphic Design
Art Director
J. Gail Bean
Designer
J. Gail Bean
Illustrator
J. Gail Bean
Client
Self-promotion
Software/Hardware
Adobe Illustrator 7.0, Macintosh
Paper/Materials
Cougar 80 lb. Natural Smooth
Printing
Rainbow Printing, Marietta GA;
2 Color

2

Design Firm
Dean Johnson Design
Art Director
Bruce Dean
Designer
Bruce Dean
Illustrator
Bruce Dean
Client
Tod Martens Photography

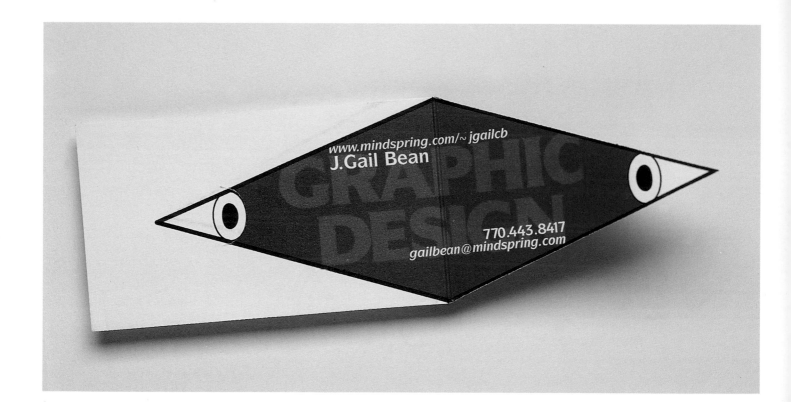

1

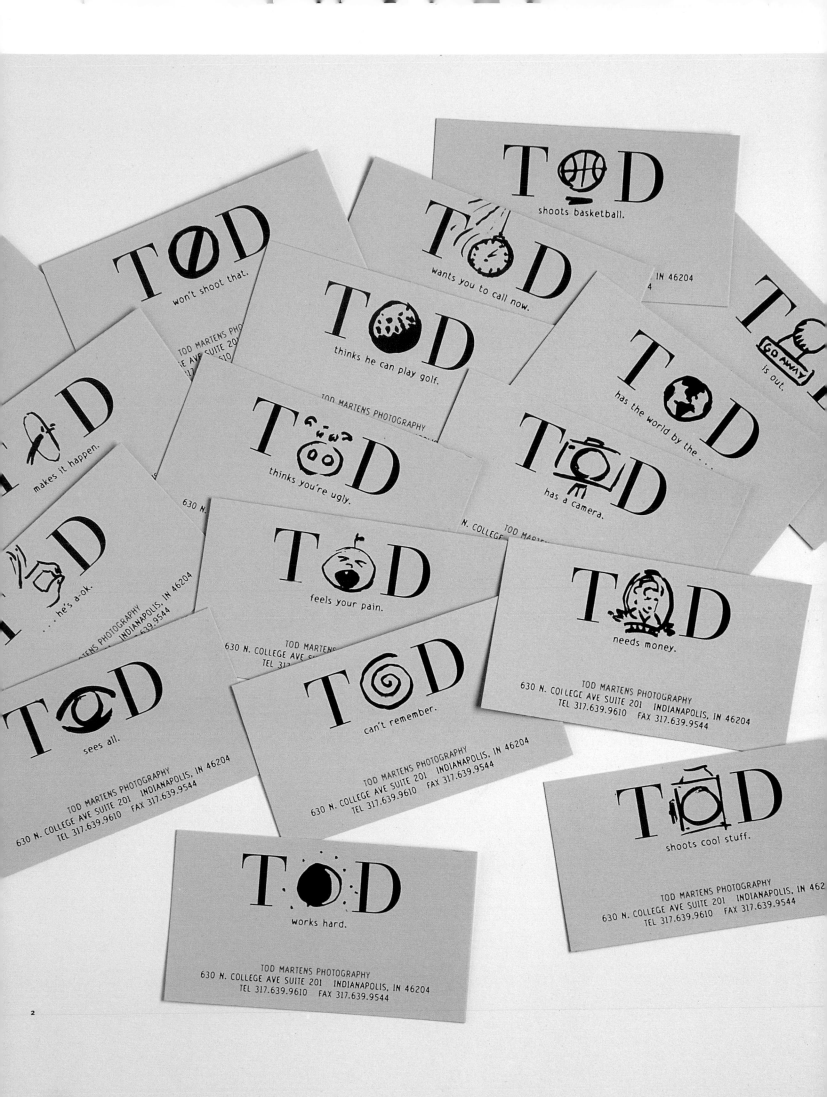

Design Firm
 Treehouse Design
Art Director
 Tricia Rauen
Designer
 Tricia Rauen
Client
 Salon Blu
Software/Hardware
 Adobe Illustrator
Paper/Materials
 Strathmore Elements
Printing
 Blair Graphics

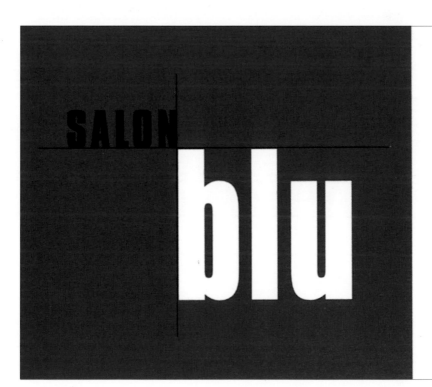

SALON blu

Dino Gugliuzza

2510 Main Street
Suite D
Santa Monica
California 90405

310.392.3331 *tel*
310.392.4811 *fax*

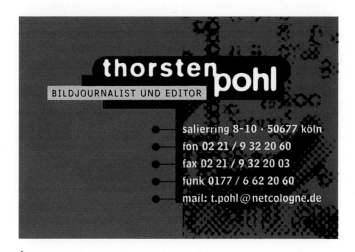

1

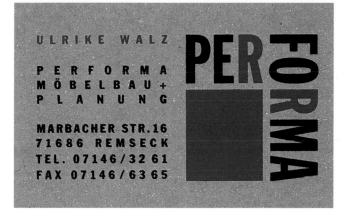

2

1

Design Firm
Langer Design
Designer
Matthias Langer
Client
Thorsten Pohl, Cutter & Editor
Software/Hardware
QuarkXpress, Adobe Photoshop,
Macintosh
Printing
2 Colors

2

Design Firm
Michael Kimmerle·Art
Direction + Design
Art Director
Michael Kimmerle
Designer
Michael Kimmerle
Illustrator
Michael Kimmerle
Client
Performa
Software/Hardware
QuarkXpress, Macintosh
Paper/Materials
Naturals, König 650 glm2
Printing
Siebdruck, Screen Printing

3

Design Firm
Castenfors & Co.
Art Director
Jonas Castenfors
Designer
Jonas Castenfors
Client
Inredningsbyrån Inte & Co.
Software/Hardware
QuarkXpress
Paper/Materials
Skandia
Printing
Elfströms Tryckeri

ROBERT ÖHMAN

kommendörsgatan 12
114 48 stockholm
telefon 08-407 06 01
telefax 08-678 33 44
mobil 070-715 70 82
robert@inte-co.com
www.inte-co.com

inredningsbyrån INTE & CO

3

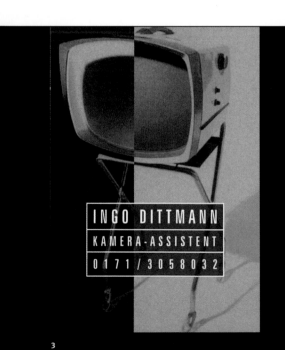

PAOLA OCONE

VIA VARANO 72

80054 GRAGNANO (NA)

TELEFONO 081. 8712322

1

1
Design Firm
 R & M Associati Grafici
Art Directors
 Di Somma/Fontanella
Client
 Paola Ocone
Software/Hardware
 Adobe Illustrator, Macintosh
Printing
 Offset

2
Design Firm
 Design Center
Art Director
 John Reger
Designer
 Sherwin Schwartzrock
Client
 Self-promotion
Software/Hardware
 Freehand, Macintosh
Paper/Materials
 Lustro Gloss
Printing
 Pro-Craft Printing

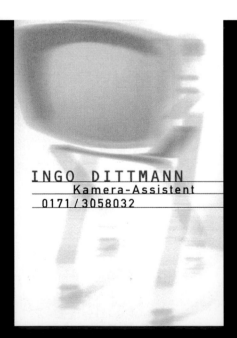

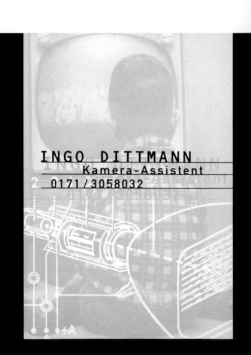

3

2

Vanessa J. Mathwig
Marketing Manager

Design Center, Inc.
15119 Minnetonka Boulevard
Minnetonka, MN 55345 USA
Tel: (612) 933 9766
Fax: (612) 933 1562

Email: dc@design-center.com
Web: design-center.com

INGO DITTMANN • KAMERA-ASSISTENT • 0171/3058032

3
Design Firm
 Langer Design
Designer
 Matthias Langer
Client
 Ingo Dittmann,
 Camera Assistant
Software/Hardware
 QuarkXpress, Adobe Photoshop,
 Macintosh
Printing
 2 Colors

1

Design Firm
 Opera Grafisch Ontwerpers
Art Directors
 Ton Homburg, Marty Schoutsen
Designers
 Sappho Panhuysen,
 Ton Homburg
Client
 Rijksmuseum Voor Volkenkunde
Software/Hardware
 QuarkXpress, Macintosh
Paper/Materials
 Chambord
Printing
 Drukkerij Oomen Breda

2

Design Firm
 Case
Designer
 Kees Wagenaars
Client
 Self-promotion
Software/Hardware
 QuarkXpress
Paper/Materials
 Pecunia
Printing
 PMS 392

RIJKSMUSEUM voor
VOLKENKUNDE
LEIDEN National Museum
of Ethnology

Steenstraat 1
Postbus 212
2300 AE Leiden
The Netherlands

drs. Herman de Boer
head of exhibitions

T +31 (0)71 5168 800
F +31 (0)71 5128 437
herman@rmv.nl

1

case

Kees Wagenaars

Baronielaan 78 4818 RC Breda
t 076 5215187 f 076 5217457
e kwcase@knoware.nl

2

Design Firm
 Design Center
Art Director
 John Reger
Designer
 Cory Docken
Client
 Ncell Systems
Software/Hardware
 Freehand, Macintosh
Paper/Materials
 Strathmore Writing
Printing
 Pro-Craft

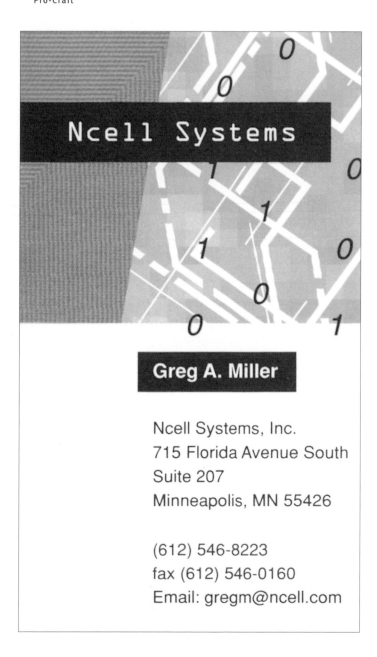

Ncell Systems

Greg A. Miller

Ncell Systems, Inc.
715 Florida Avenue South
Suite 207
Minneapolis, MN 55426

(612) 546-8223
fax (612) 546-0160
Email: gregm@ncell.com

BileniaTech

Noah Prywes
CEO. CCCC - General Partner

BileniaTech, LP
2400 Chestnut Street
Philadelphia. PA
19103-4316

Voice 215.854.0555
ext. 211
Fax 215.854.0665
Prywes@BileniaTech.com
www.BileniaTech.com

1

billennium
Year 2000 | COBOL Software Factory

billennium.lp
tony newshel
general manager

2300 chestnut street
philadelphia pa
19103

voice 215.854.0555
fax 215.854.0665
newshel@billenn.com
http://www.billenn.com

2

1
Design Firm
LF Banks + Associates
Art Director
Lori F. Banks
Designer
John German
Client
BileniaTech, LP
Software/Hardware
Freehand
Paper/Materials
Neenah Classic Columns
Printing
RoyerComm Corporation

2
Design Firm
LF Banks + Associates
Art Director
Lori F. Banks
Designer
John German
Client
Billennium, LP
Software/Hardware
Freehand
Paper/Materials
Neenah Classic Columns
Printing
Fern Hill Printing Co.

3
Design Firm
LF Banks + Associates
Art Director
Lori F. Banks
Designer
John German
Client
@Risk, Inc.
Software/Hardware
Freehand, Adobe Photoshop
Paper/Materials
Neenah Classic Columns
Printing
Quality Lithographing Co.

@RISK
SolutionsThroughDataMining

Patrick M. Baldasare
President & CEO

SolutionsThroughDataMining

web www.atRiskInc.com e-mail PBaldasare@atRiskInc.com
Tel 610.296.0800 x701 Fax 610.296.8181
1205 Westlakes Drive Suite 180 • Berwyn • PA • 19312

3

Design Firm
 LF Banks + Associates
Art Director
 Lori F. Banks
Designer
 Lori F. Banks
Client
 Self-promotion
Software/Hardware
 Freehand
Paper/Materials
 Grafika Lineal
Printing
 Quality Lithographing Co.

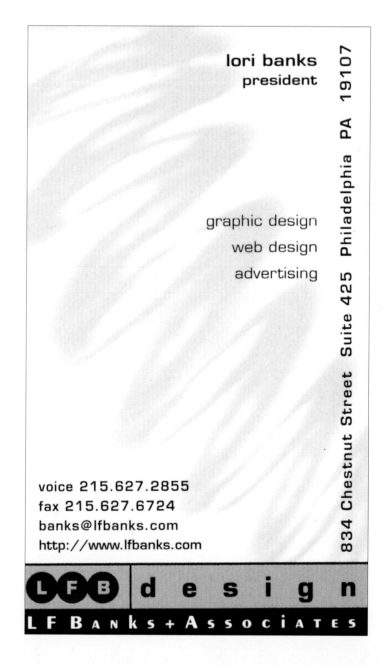

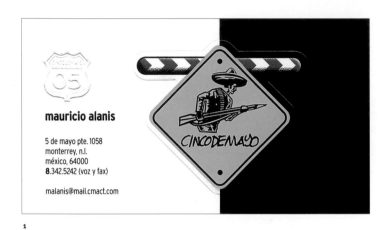

1
Design Firm
Cincodemayo Design
Art Director
Mauricio H. Alanis
Designer
Mauricio H. Alanis
Client
Self-promotion
Software/Hardware
Freehand 7.0, Macintosh
Paper/Materials
Magnomatt
Printing
5DM Offset Printing

1

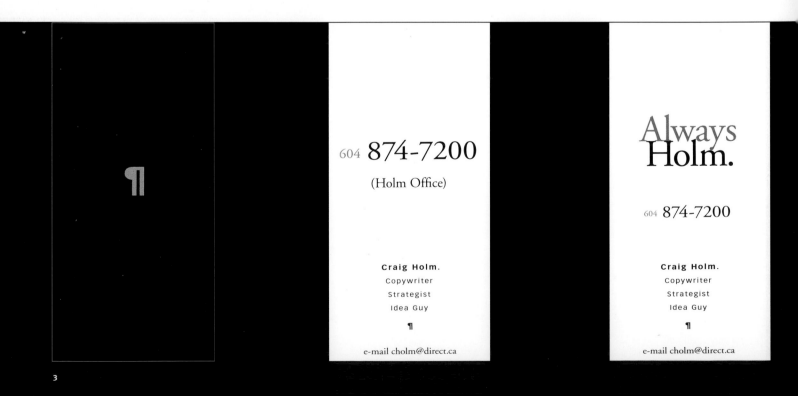

3

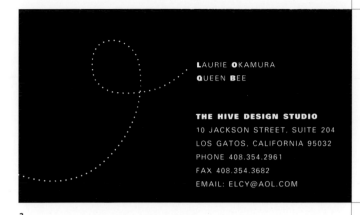

LAURIE OKAMURA
QUEEN BEE

THE HIVE DESIGN STUDIO
10 JACKSON STREET, SUITE 204
LOS GATOS, CALIFORNIA 95032
PHONE 408.354.2961
FAX 408.354.3682
EMAIL: ELCY@AOL.COM

2

2
Design Firm
The Hive Design Studio
Art Directors
Laurie Okamura, Amy Stocklein
Designers
Laurie Okamura, Amy Stocklein
Client
Self-promotion
Software/Hardware
Adobe Illustrator, Macintosh
Paper/Materials
Cranes Crest
Printing
Mission Printers

Call Holm
More Often.

604 874-7200

Craig Holm.
Copywriter
Strategist
Idea Guy

¶

e-mail cholm@direct.ca

Call Me.
I'm Holm.

604 874-7200

Craig Holm.
Copywriter
Strategist
Idea Guy

¶

e-mail cholm@direct.ca

3
Design Firm
Big Eye Creative
Art Directors
Perry Chua, Dann Ilicic
Designer
Perry Chua
Copy writer
Craig Holm
Client
Craig Holm
Software/Hardware
Adobe Illustrator
Paper/Materials
Potlatch McCoy
Printing
Clarke Printing

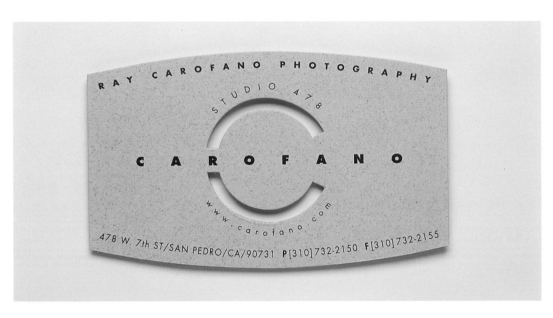

Design Firm
D Zone Studio, Inc.
Designer
Joe L. Yule
Client
Ray Carofano Photography
Software/Hardware
Adobe Illustrator, QuarkXPress
Paper/Materials
Fraser Passport Cover
Printing
1/o Black

Design Firm
 Elizabeth Resnick Design
Art Director
 Elizabeth Resnick
Designer
 Elizabeth Resnick
Client
 Design Times Magazine
Software/Hardware
 QuarkXpress 3.32, Macintosh
Paper/Materials
 Mohawk Superfine Natural
Printing
 Alpha Press, Waltham, MA

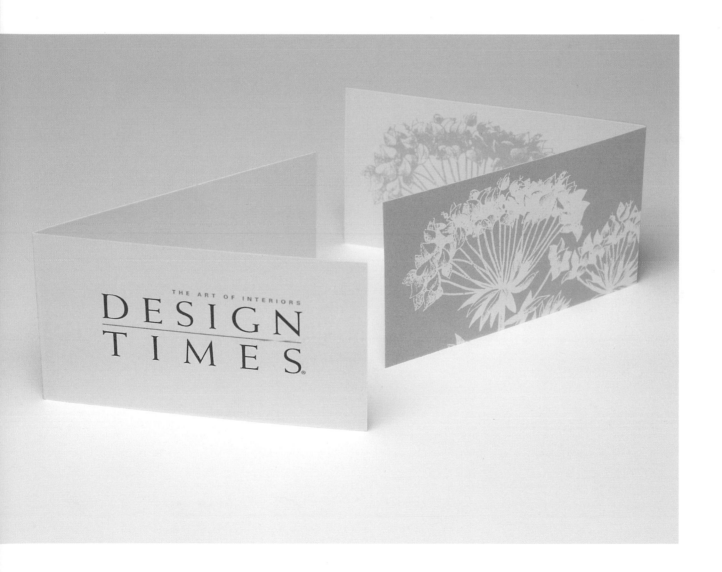

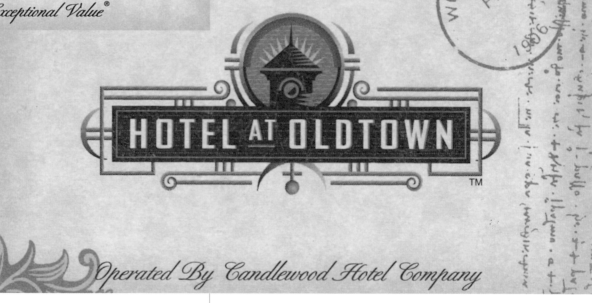

830 EAST FIRST · WICHITA, KS 67202

Tel 316-267-4800 · *Fax* 316-267-4840

RESERVATIONS 888-CANDLEWOOD EXT. 521222

WWW.HOTELATOLDTOWN.COM

Barbara Waitt **DIRECTOR OF SALES**

Delivering Exceptional Value®

Operated By Candlewood Hotel Company

Design Firm
 Greteman Group
Art Director
 Sonia Greteman
Designers
 James Strange, Garrett Fresh
Client
 Hotel at Oldtown
Software/Hardware
 Freehand
Paper/Materials
 Astroparche Cream
Printing
 Offset

804.329.0661

C. BENJAMIN DACUS

bendacus@richmond.infi.net

1

DAVID RICCARDI

The CONTINENTAL

8400 WILSHIRE BLVD.

BEVERLY HILLS, CA 90211

323.782.9717

2

The Cigar Place
SÃO PAULO

AL. SANTOS, 1787
SÃO PAULO, SP
CEP 01419-002
TEL: (11) 251-1131

BRASIL

3

1
Design Firm
 Zeigler Associates
Art Director
 C. Benjamin Dacus
Designer
 C. Benjamin Dacus
Client
 C. Benjamin Dacus
Software/Hardware
 QuarkXpress
Paper/Materials
 French Construction
Printing
 Offset, Pine Tree Press,
 Richmond, VA

2
Design Firm
 [i]e design
Art Director
 Marcie Carson
Designers
 Cya Nelson, David Gilmour
Client
 The Continental
Software/Hardware
 Adobe Illustrator, Macintosh
Paper/Materials
 French Construction
Printing
 3 Metallic PMS

3
Design Firm
 José J. Dias da S. Junior
Art Director
 José J. Dias da S. Junior
Designer
 José J. Dias da S. Junior
Client
 The Cigar Place
Software/Hardware
 Corel Draw, PC
Paper/Materials
 Unpolished Couche 180 g
Printing
 2 Color (Black & Pantone 1385)

DE ZONNEHOF
centrum voor moderne kunst

Zonnehof 4a • Postbus 699 • 3800 AR Amersfoort
T 033 4633034 **F** 033 4652691
E zonnehof@worldonline.nl

DE ZONNEHOF
centrum voor moderne kunst

TINNEKE SCHOLTEN
medewerker artotheek

Zonnehof 4a • Postbus 699 • 3800 AR Amersfoort
T 033 4633034 **F** 033 4652691
E zonnehof@worldonline.nl

Design Firm
 Opera Grafisch Ontwerpers
Art Directors
 Ton Homburg, Marty Schoutsen
Designer
 Marty Schoutsen
Client
 De Zonnehof
Software/Hardware
 QuarkXpress,Macintosh
Paper/Materials
 Oxford 250 gr.
Printing
 Drukkerý Printing

1

Design Firm
 Vestígio
Art Director
 Emanuel Barbosa
Designer
 Emanuel Barbosa
Client
 Emanuel Barbosa Design
Software/Hardware
 Freehand, Macintosh
Paper/Materials
 Torras Paper

2

Design Firm
 The Weller Institute for the
 Cure of Design, Inc.
Art Director
 Don Weller
Designer
 Don Weller
Illustrator
 Don Weller
Client
 Park City Museum
Software/Hardware
 Photoshop, QuarkXpress

**Emanuel
Barbosa
Design**

Rua da Vassada, 1682
Milheirós
4470 Maia
Tel. 02 - 9011868
Portugal

1

PARK CITY MUSEUM

Marianne Cone
Director

528 Main St.
P.O. Box 555
Park City, UT 84060
(801)649-0375

2

Alexander Stone & Co.
solicitors

Anita K Salwan

4 west regent street, glasgow G2 1AW
tel: +44 (0) 141 332 8611
fax: +44 (0) 141 332 5482
e-mail: mailbox@alexanderstone.co.uk

1

1
Design Firm
Graven Images Ltd.
Art Director
Mandy Nolan
Designer
Colin Raeburn
Client
Alexander Stone & Co. Solicitors
Software/Hardware
QuarkXpress. Macintosh
Paper/Materials
Conqueror, Brilliant White, 300 gsm
Printing
3 Color Litho

Heads Inc.
176 Thompson Street #2D New York, NY 10012
T+F 212 533 8693

So Takahashi

PMS 5743

2

2
Design Firm
Heads Inc.
Art Director
So Takahashi
Designer
So Takahashi
Client
Self-promotion
Software/Hardware
QuarkXpress
Printing
GM Imaging

Design Firm
 400 Communications Ltd.
Art Director
 Peter Dawson
Designer
 Peter Dawson
Client
 Print & Design Limited
Software/Hardware
 QuarkXpress, Macintosh
Printing
 2 Color Litho

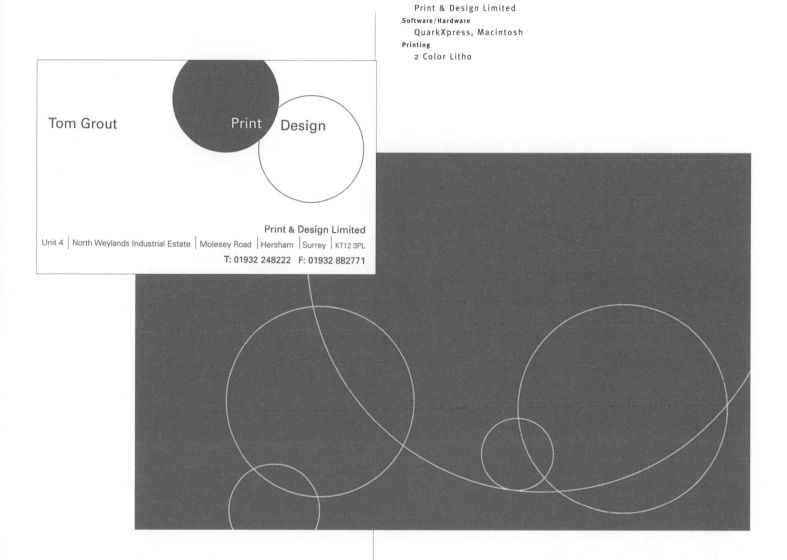

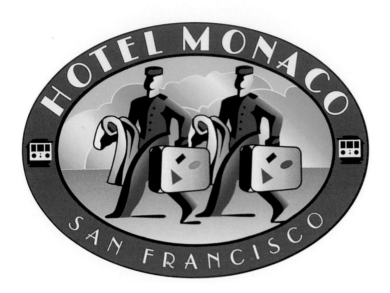

MATTHEW JENSEN
DIRECTOR OF SALES

501 GEARY STREET
SAN FRANCISCO, CALIFORNIA 94102
DIRECT 415-292-8131 / 800-214-4220
FAX: 415-292-0149
AIRLINE ACCESS CODE: KC

OTHER KIMPTON GROUP
HOTELS:

SAN FRANCISCO • THE PRESCOTT HOTEL 800.283.7322 • SEATTLE • HOTEL VINTAGE PARK 800.624.4433 • HOTEL VINTAGE PLAZA 800.243.0555 • BEVERLY HILLS • BEVERLY PRESCOTT HOTEL 800.421-3212 • SEATTLE • ALEXIS HOTEL 800.426-7033

1

1
Design Firm
 Second Floor
Art Director
 Warren Welter
Designer
 Lori Powell
Illustrator
 Lori Powell
Client
 Hotel Monaco/Kimpton Group
Software/Hardware
 QuarkXpress, Adobe
 Illustrator, iMac
Printing
 Hatcher Press

2
Design Firm
 Wallace/Church
Art Director
 Stan Church
Designer
 Wendy Church
Illustrator
 Lucian Toma
Client
 The Axis Group, Llc.
Software/Hardware
 Adobe Photoshop,
 Adobe Illustrator

3
Design Firm
 Bruce Yelaska Design
Art Director
 Bruce Yelaska
Designer
 Bruce Yelaska
Client
 Self-promotion
Software/Hardware
 Adobe Illustrator
Paper/Materials
 Strathmore Writing Wove
Printing
 Offset - Vision Printing

4
Design Firm
 Inox Design
Art Director
 Mauro Pastore
Designer
 Mauro Pastore
Client
 Free Pass
Software/Hardware
 Adobe Photoshop,
 QuarkXpress,
 Adobe Illustrator
Printing
 Offset, 2 Colors

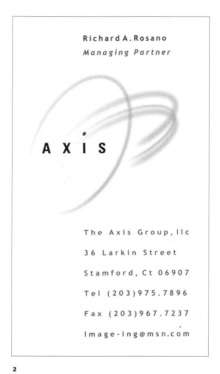

Richard A. Rosano
Managing Partner

A X I S

The Axis Group, llc

36 Larkin Street

Stamford, Ct 06907

Tel (203)975.7896

Fax (203)967.7237

Image-ing@msn.com

2

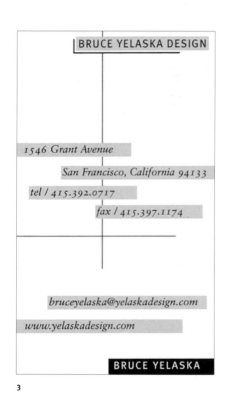

BRUCE YELASKA DESIGN

1546 Grant Avenue

San Francisco, California 94133

tel / 415.392.0717

fax / 415.397.1174

bruceyelaska@yelaskadesign.com

www.yelaskadesign.com

BRUCE YELASKA

3

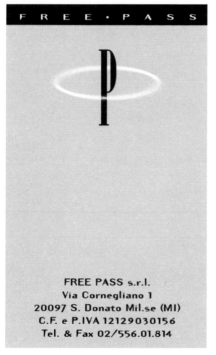

F R E E • P A S S

FREE PASS s.r.l.
Via Cornegliano 1
20097 S. Donato Mil.se (MI)
C.F. e P.IVA 12129030156
Tel. & Fax 02/556.01.814

4

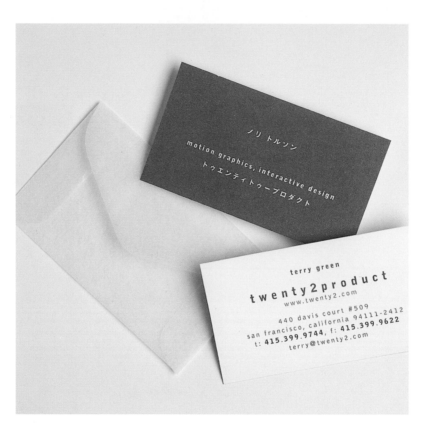

Design Firm
 twenty2product
Art Director
 Terry Green
Designer
 Terry Green
Client
 Self-promotion
Software/Hardware
 Freehand
Paper/Materials
 Simpson Protocol,
 Westvaco Glassine
Printing
 Valencia Printing

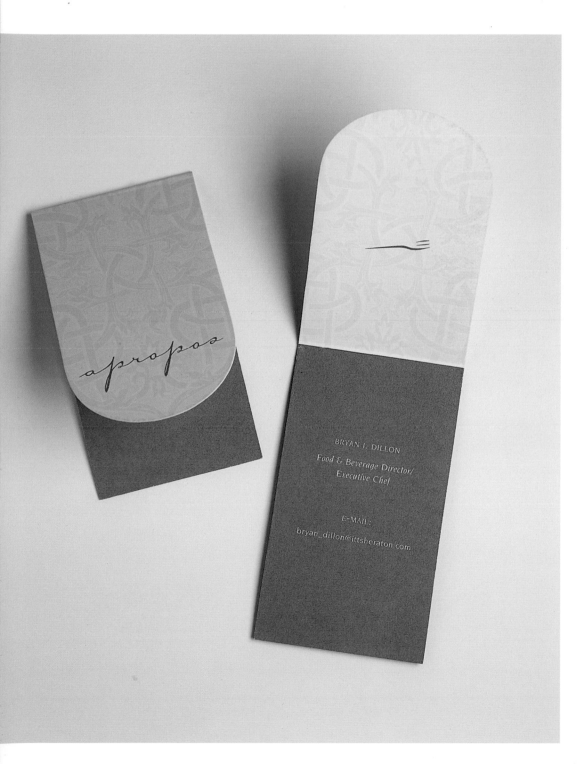

Design Firm
 Harris Design
Art Director
 Toni Harris-Hadad
Designer
 Toni Hadad
Client
 Apropos
Software/Hardware
 QuarkXpress, Adobe Photoshop,
 Adobe Illustrator 8
Printing
 Offset, 2 PMS, die cut

BRYAN I. DILLON

Food & Beverage Director/
Executive Chef

E-MAIL:
bryan_dillon@ittsheraton.com

Rick Vermeulen

Via Vermeulen
William Boothlaan 4
3012 VJ Rotterdam
The Netherlands
Tel: + 31 (0)10 - 213.27.80
Fax: + 31 (0)10 - 213.47.22
e-mail: viarick@ipr.nl

1

perdura
Stahl- und Anlagentechnik Michael Rammelmann

Dipl.-Ing. Michael Rammelmann
Geschäftsführer

Industriestraße 7
D-59457 Werl
Tel. 0 29 22 · 86 51 86
Fax 0 29 22 · 86 51 88
mobil 01 73 · 2 72 89 32
e-mail perdura-werl@t-online.de

2

1
Design Firm
Via Vermeulen
Art Director
Rick Vermeulen
Designer
Rick Vermeulen
Photographer
Monica Nouwens
Client
Self-promotion

2
Design Firm
graphische formgebung
Art Director
Herbert Rohsiepe
Designer
Herbert Rohsiepe
Client
Perdura
Software/Hardware
Freehand 8.o, Macintosh
Printing
Blue, Black, & Silver

83 COLUMBIA ST. SUITE 400, SEATTLE, WA 98104

TEL 206·682·3685 FAX 206·682·3867

HAMMERQUIST & HALVERSON

CAROL DAVIDSON

E-MAIL carol@hammerquist.net

Design Firm
 Hornall Anderson Design Works
Art Director
 Jack Anderson
Designers
 Jack Anderson, Mike Calkins
Illustrator
 Mike Calkins
Client
 Hammerquist & Halverson
Software/Hardware
 Freehand, Macintosh
Paper/Materials
 Mohawk Navaho

en digitized written spoken

tized spoken digitized writt

en digitized ritte spoken

tized written spoken digitiz

ten spoken digiti

en digitized writt

ROBIN SHEPHERD
creative communications

18576 TWIN CREEKS ROAD

MONTE SERENO, CA 95030

PHONE: 408.354.2441

FAX: 408.354.3181

EMAIL: rswriter@flash.net

WEB: www.greatwords.com

WORDS WITH IMPACT

Design Firm
 The Hive Design Studio
Art Directors
 Laurie Okamura, Amy Stocklein
Designers
 Laurie Okamura, Amy Stocklein
Illustrator
 Pete Caravalho
Client
 Robin Shepherd
Software/Hardware
 Adobe Illustrator, Macintosh
Paper/Materials
 Strathmore
Printing
 Mission Printers

Design Firm
Big Eye Creative
Art Director
Perry Chua
Designers
Perry Chua, Nancy Yeasting
Client
Clarke Printing
Software/Hardware
Adobe Illustrator
Paper/Materials
Starwhite Vicksburg
Printing
Clarke Printing

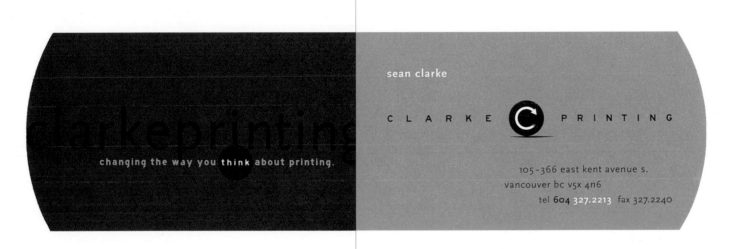

1

Design Firm
H3/Muse
Designer
Harry M. Forehand III
Client
Jeff Forehand
Software/Hardware
Macintosh
Printing
Local Color, Santa Fe

2

Design Firm
H3/Muse
Designer
Harry M. Forehand III
Client
Orotund Turmoil
Software/Hardware
Macintosh
Printing
Local Color, Santa Fe

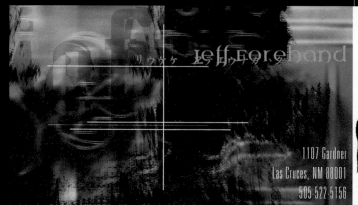

1

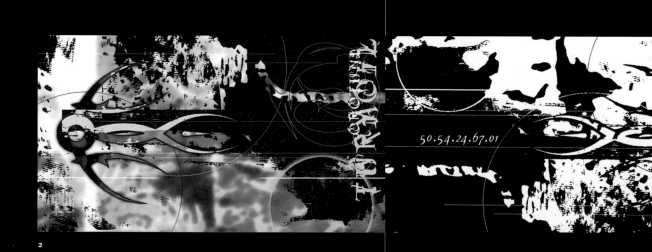

2

Design Firm
 H3/Muse
Designer
 Harry M. Forehand III
Client
 Tim Forehand
Software/Hardware
 Macintosh
Printing
 Local Color, Santa Fe

Design Firm
 Atelier Tadeusz Piechura
Art Director
 Tadeusz Piechura
Designer
 Tadeusz Piechura
Client
 TVP - LODZ
Software/Hardware
 Corel 7, Pentium 200
Printing
 Offset

Design Firm
 Atelier Tadeusz Piechura
Art Director
 Tadeusz Piechura
Designer
 Tadeusz Piechura
Client
 Photo Studio,
 Jacek Jakub Marczewski
Software/Hardware
 Corel 7, Pentium
Printing
 Laser Printer, 2nd Edition,
 New Version

De Elleboogkerk Postbus 699 / NL - 3800 AR Amersfoort
Langegracht 36 / T 033 461 40 88 / F 033 464 05 50
armando.museum@worldonline.nl

ARMANDOMUSEUM

Paul Coumans / Directeur

Design Firm
 Opera Grafisch Ontwerpers
Art Directors
 Ton Homburg, Marty Schoutsen
Designers
 Sappho Panhuysen,
 Marty Schoutsen
Client
 Armando Museum
Software/Hardware
 QuarkXpress, Macintosh
Paper/Materials
 Distinction Prestige
Printing
 Drukkerij Printing Amersfoort

De Elleboogkerk Postbus 699 / NL - 3800 AR Amersfoort
Langegracht 36 / T 033 461 40 88 / F 033 464 05 50
armando.museum@worldonline.nl

ARMANDOMUSEUM

Henk Panjer / Beheerder

De Elleboogkerk Postbus 699 / NL - 3800 AR Amersfoort
Langegracht 36 / T 033 461 40 88 / F 033 464 05 50
armando.museum@worldonline.nl

ARMANDOMUSEUM

Miriam Windhausen / Conservator

1

Design Firm
 S & S Design
Art Director
 Mónica Sánchez Farfán
Designer
 Mónica Sánchez Farfán
Photographer
 Giancarlo Yuli
Client
 Giancarlo Yuli, Photographer
Software/Hardware
 Adobe Photoshop 5.0,
 QuarkXpress 4.0, Zbmaptiva
Paper/Materials
 White Fine Cardboard
Printing
 Valdez Printers

2

Design Firm
 400 Communications Ltd.
Art Director
 Peter Dawson
Designer
 Peter Dawson
Client
 Opus Furniture Limited
Software/Hardware
 QuarkXpress, Macintosh
Printing
 2 Special Colors

Jonathan Crabtree

Opus Furniture Limited

5 Sandy's Row London E1 7HW
Telephone: +44 (0)171 247 2224 Fax: +44 (0)171 247 1168

2

ifa

Institut für Auslands-
beziehungen e. V.

Postfach 10 24 63
70020 Stuttgart

Charlottenplatz 17
70173 Stuttgart

Tel. 0711 / 22 25-0
Fax 0711 / 2 26 43 46

e-mail: info@ifa.de
http://www.ifa.de

ifa

Institute for Foreign
Cultural Relations

P. O. Box 10 24 63
D-70020 Stuttgart

Charlottenplatz 17
D-70173 Stuttgart

Tel. 0049-711 / 22 25-0
Fax 0049-711 / 2 26 43 46

e-mail: info@ifa.de
http://www.ifa.de

1

1

Design Firm
Michael Kimmerle·Art
Direction + Design
Art Director
Michael Kimmerle
Designer
Michael Kimmerle
Client
Institut für
Auslandsbeziehungen e.V.
Software/Hardware
QuarkXpress, Macintosh
Paper/Materials
Diplomat
Printing
Offset

2

Design Firm
R & M Associati Grafici
Art Director
Di Somma/Fontanella
Client
Self-promotion
Software/Hardware
Adobe Illustrator, Macintosh
Printing
Offset

MAURIZIO DI SOMMA

80053 CASTELLAMMARE DI STABIA_ITALIA
TRAVERSA DEL PESCATORE 3

RAFFAELE FONTANELLA

R&MASSOCIATIGRAFICI

COMUNICAZIONE VISIVA

TELEFONO +39 081 870 50 53_FAX 0818702195

2

Design
　Firm Stang
Designer
　Stang Gubbels
Client
　Self-promotion
Software/Hardware
　QuarkXpress, Macintosh
Paper/Materials
　Graniet
Printing
　Offset

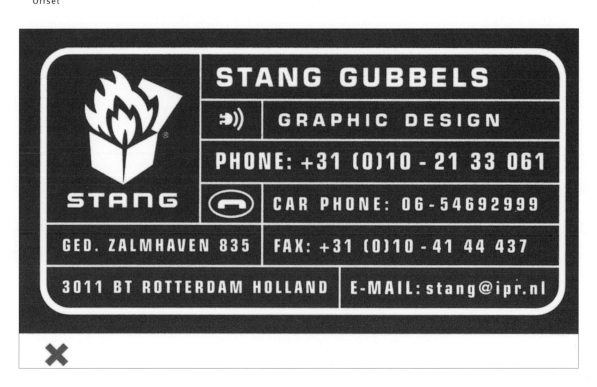

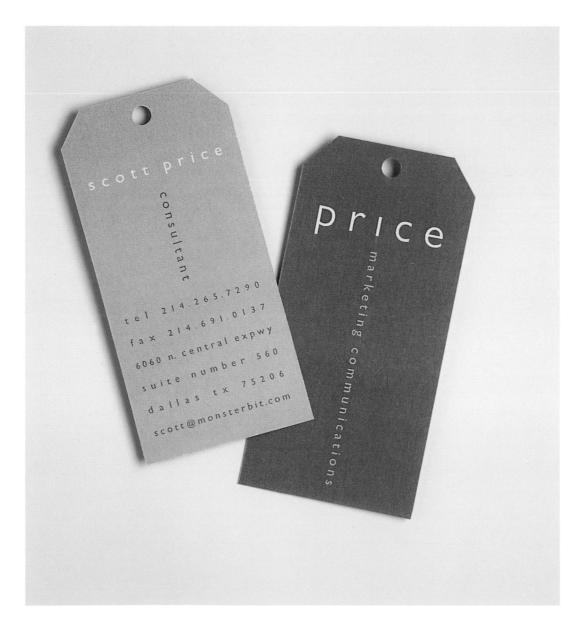

scott price

consultant

tel 214.265.7290
fax 214.691.0137
6060 n. central expwy
suite number 560
dallas tx 75206
scott@monsterbit.com

price

marketing communications

Design Firm
 Joy Price
Designer
 Joy Price
Client
 Scott Price, Price Marketing
 Communications
Software/Hardware
 Adobe Illustrator, Macintosh
Printing
 Digitally Printed on
 Chromapress System;
 Corners Trimmed by Hand;
 Punched by Hand

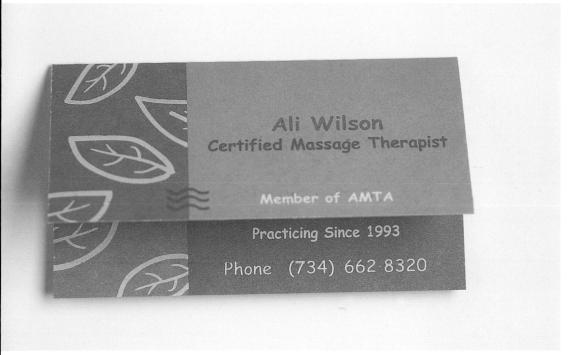

Design Firm
Spectrum Graphics Studio
Designer
Joanne Spangler
Illustrator
Joanne Spangler
Client
Ali Wilson, Ali Wilson Massage
Software/Hardware
Adobe Illustrator 8.0
Paper/Materials
Wausau Royal Fiber, Balsa 80 lb. Cover
Printing
Spectrum Printers; 3 PMS: Bronze 876, Yellow 124, Orange 718

MARKETING BRAINS
creative soul

creative CULMINATOR

MIKE PEMBERTON
mikeyp@creativeco.com

CREATIVE COMPANY

3276 Commercial St SE Suite 2
Salem Oregon 97302
l 503.363.4433 Fax 503.363.6817
www.creativeco.com

Design Firm
 Creative Company
Art Director
 Matt Davis
Designer
 Matt Davis
Client
 Self-promotion
Software/Hardware
 Macintosh
Paper/Materials
 Strobe Dull Cover
Printing
 K.P. Corporation

1
Design Firm
 Bruce Yelaska Design
Art Director
 Bruce Yelaska
Designer
 Bruce Yelaska
Client
 Bikram's Yoga College of India
Software/Hardware
 Adobe Illustrator
Paper/Materials
 Strathmore Writing Wove
Printing
 Offset, Vision Printing

2
Design Firm
 Kan & Lau Design Consultants
Art Director
 Kan Tai-Keung
Designers
 Kan Tai-Keung, Lam Wai Hung
Client
 Friends of Mine Group Limited
Software/Hardware
 Freehand 8.0
Paper/Materials
 300 gsm High White Wove
 (Conqueror)
Printing
 Offset

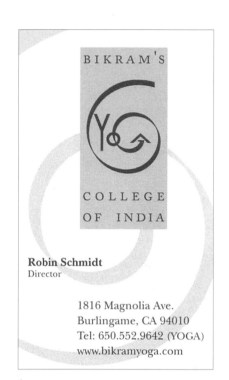

BIKRAM'S

COLLEGE
OF INDIA

Robin Schmidt
Director

1816 Magnolia Ave.
Burlingame, CA 94010
Tel: 650.552.9642 (YOGA)
www.bikramyoga.com

1

友 福 集 團 有 限 公 司
FRIENDS *of* MINE GROUP LIMITED

Unit 302, 3/F
38 Russell Street
Causeway Bay, Hong Kong
Tel (852) 2545 3635
Fax (852) 2970 2226

Eva S. W. Fung
Assistant to Managing Director

Mobile Phone 9473 2350

友 福 集 團 有 限 公 司
FRIENDS *of* MINE GROUP LIMITED

香 港 銅 鑼 灣
羅 素 街 38 號 3 樓 302 室
電話 (852) 2545 3635
傳真 (852) 2970 2226

馮 瑞 華
董事總經理助理

手 提 電 話 9473 2350

2

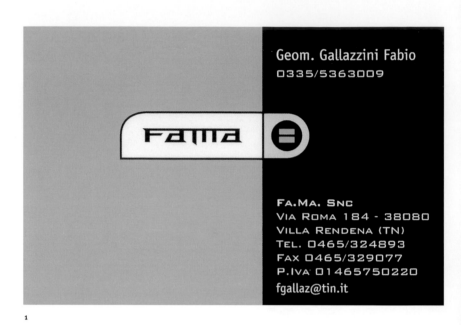

1

Design Firm
Inox Design
Art Director
Mauro Pastore
Designer
Mauro Pastore
Client
FA.MA.
Software/Hardware
Adobe Illustrator, QuarkXpress
Printing
Offset, 3 & 1 Color

afterhours

pt Grafika Estetika Atria
Jalan Merpati Raya 45, Jakarta 12870, Indonesia
tel +62 21 8306819 fax +62 21 8290612
e.mail info@afterhours.co.id

afterhours

2

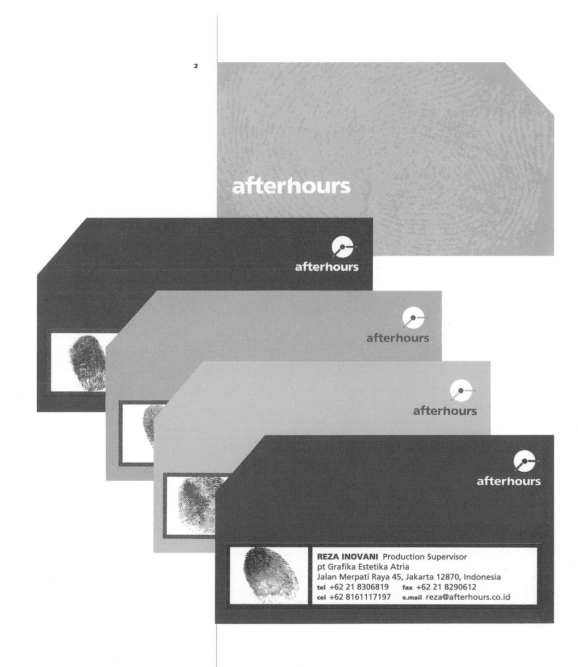

2
Design Firm
 Afterhours: pt Grafika
 Estetika Atria
Art Director
 Lans Brahmantyo
Designer
 Lans Brahmantyo
Client
 Self-promotion
Software/Hardware
 Freehand 8
Paper/Materials
 Fox River Superfine Eggshell
Printing
 Harapan Prima

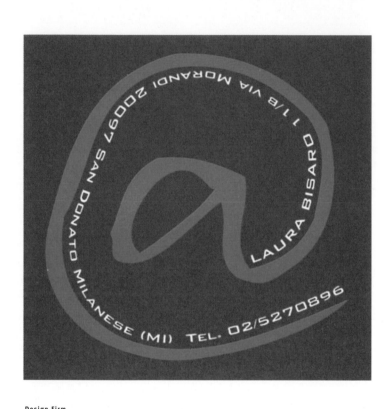

Design Firm
 Inox Design
Art Director
 Masa Magnoni
Designer
 Mauro Pastore
Illustrator
 Masa Magnoni
Client
 Laura Bisaro
Software/Hardware
 Adobe Illustrator
Printing
 Offset, 1 Color

1
Design Firm
400 Communications Ltd.
Art Director
David Coates
Designer
David Coates
Illustrator
David Coates
Client
Self-promotion
Software/Hardware
QuarkXpress, Adobe Photoshop,
Macintosh
Paper/Materials
300 gsm
Printing
1 Special, Process Blue

2
Design Firm
Troller Associates
Art Director
Fred Troller
Designer
Fred Troller
Client
Primo
Paper/Materials
Strathmore, Bristol
Printing
Offset

David Coates
graphic designer

m 0958 503348 t 0181 547 2356
34a Southsea Road Kingston upon Thames Surrey KT1 2EH

1

John M. Tremaine
President

114 Washington Street
South Norwalk CT 06854
203.866.4321

2

Finance Manager
Bomie S.Y. Chan

 FRUITO RICCI

[Office]
Unit 302, 3/F., 38 Russell Street, Causeway Bay, Hong Kong
Tel 2545 3635 Fax 2970 2226

[Shop]
Shop 7C, G/F., Site 1, Whampoa Garden, Hunghom, Kowloon
Tel 2363 8618, 2363 8622 Fax 2363 8210

[寫字樓]
香港銅鑼灣羅素街38號3樓302室
電話 2545 3635 傳真 2970 2226

[店 舖]
九龍紅磡黃埔花園第一期商場7C
電話 2363 8618, 2363 8622 傳真 2363 8210

Design Firm
 Kan & Lau Design Consultants
Art Directors
 Kan Tai-Keung, Eddy Yu Chi Kong
Designers
 Eddy Yu Chi Kong, Lam Wai Hung
Illustrator
 Eddy Yu Chi Kong
Client
 Fruito Ricci Holdings Co. Ltd.
Software/Hardware
 Freehand 8.0
Paper/Materials
 (Wiggins Teape) Zanders CX700,
 White 250 gsm
Printing
 Offset

Design Firm
 Kan & Lau Design
 Consultants
Art Director
 Freeman Lau Siu Hong
Designer
 Stephen Lau
Client
 Hong Kong Institute of
 Contemporary Culture
Software/Hardware
 Freehand 7.0
Paper/Materials
 260 gsm Art Card
Printing
 Offset 3 x 2 (spot) C

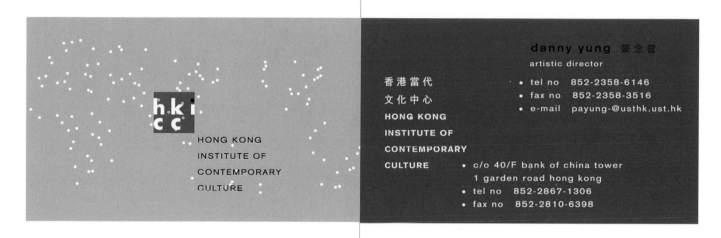

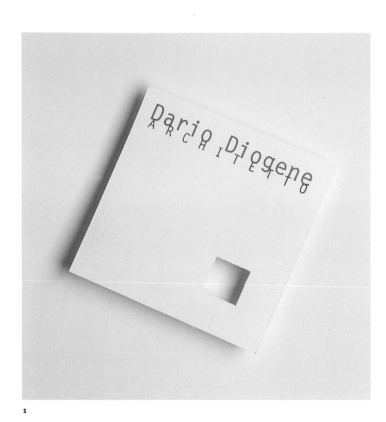

1

1
Design Firm
R & M Associati Grafici
Art Director
Di Somma/Fontanella
Client
Dario Diogene
Software/Hardware
Adobe Illustrator, Macintosh
Printing
Offset

2
Design Firm
Kan & Lau Design Consultants
Art Director
Freeman Lau Siu Hong
Designer
Freeman Lau Siu Hong
Client
Cheung Yee
Software/Hardware
Freehand 7.0 C
Paper/Materials
Gulliver 197 gsm - CL170 1
Printing
Offset

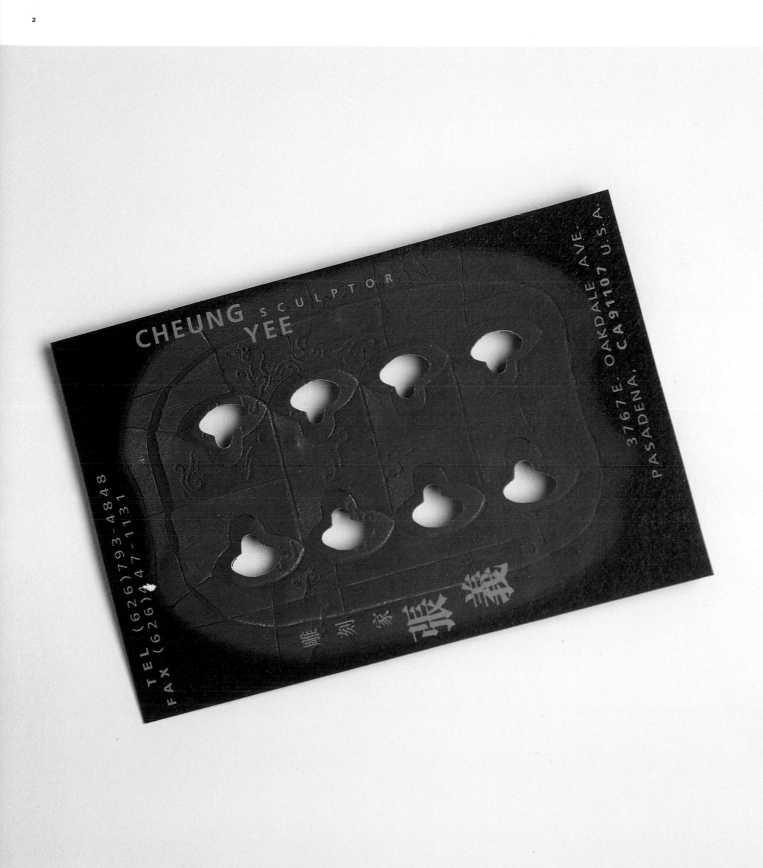

CHEUNG SCULPTOR
YEE

TEL (626)793-4848
FAX (626)47-1131

3767 E. OAKDALE AVE.
PASADENA, CA 91107 U.S.A.

雕刻家張義

OPERA

ELLIS VAN MULLEKOM

ONTWERPERS

Baronielaan 78
4818 RC Breda

T +31 (0)76 514 75 96
F +31 (0)76 514 82 78
e-mail operath@knoware.nl

OPERA

1

1
Design Firm
 Opera Grafisch Ontwerpers
Art Directors
 Marty Schoutsen, Ton Homburg
Designers
 Stefanie Rôsch, Ton Homburg
Client
 Opera Ontwerpers
Software/Hardware
 QuarkXpress, Macintosh
Paper/Materials
 Conqueror Vergé
Printing
 Plantijn Casparie Breda

HOBOKEN

GRAND CAFÉ Ⓗ HOBOKEN BV WESTZEEDIJK 343 3015 AA ROTTERDAM
TELEFOON: 010. 225 05 60 FAX: 010. 225 04 42

ONDERDEEL VAN MÂITRE FRÉDÉRIC CATERING & EVENTS
VOOR RESERVERINGEN KUNT U BELLEN 010. 522 03 40

2

2
Design Firm
 Stang
Art Director
 Stang Gubbels
Designer
 Anneke Van Der Stelt
Client
 Grand Café Hoboken
Software/Hardware
 QuarkXpress, Macintosh
Paper/Materials
 Mat Mc
Printing
 Offset

Design Firm
be
Art Director
Will Burke
Designers
Eric Read, Yusuke Asaka
Client
Self-promotion
Software/Hardware
Adobe Photoshop, Adobe
Illustrator, Macintosh

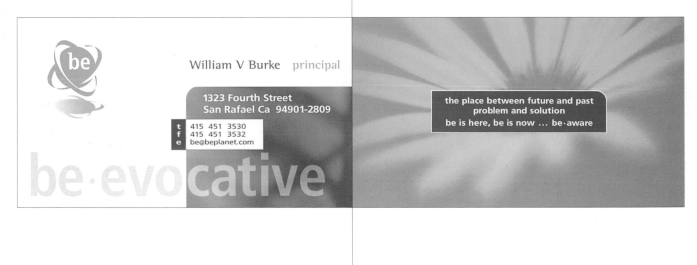

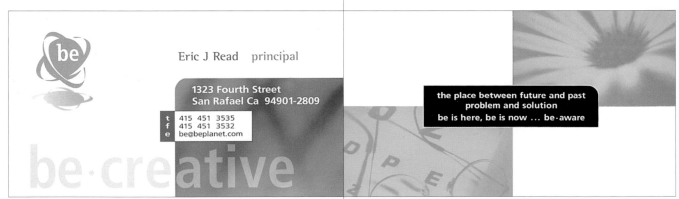

William V Burke

E	will_burke@beplanet.com
T	415 451 3530
F	415 451 3532

1323 Fourth Street
San Rafael · CA · 94901-2809

be.next

Angela Hildebrand

E	angela_hildebrand@beplanet.com
T	415 451 3530
F	415 451 3532

1323 Fourth Street
San Rafael · CA · 94901-2809

be.next

Eric J Read

E	eric_read@beplanet.com
T	415 451 3530
F	415 451 3532

1323 Fourth Street
San Rafael · CA · 94901-2809

be.next

Carissa E Guirao

E	carissa_guirao@beplanet.com
T	415 451 3530
F	415 451 3532

1323 Fourth Street
San Rafael · CA · 94901-2809

be.next

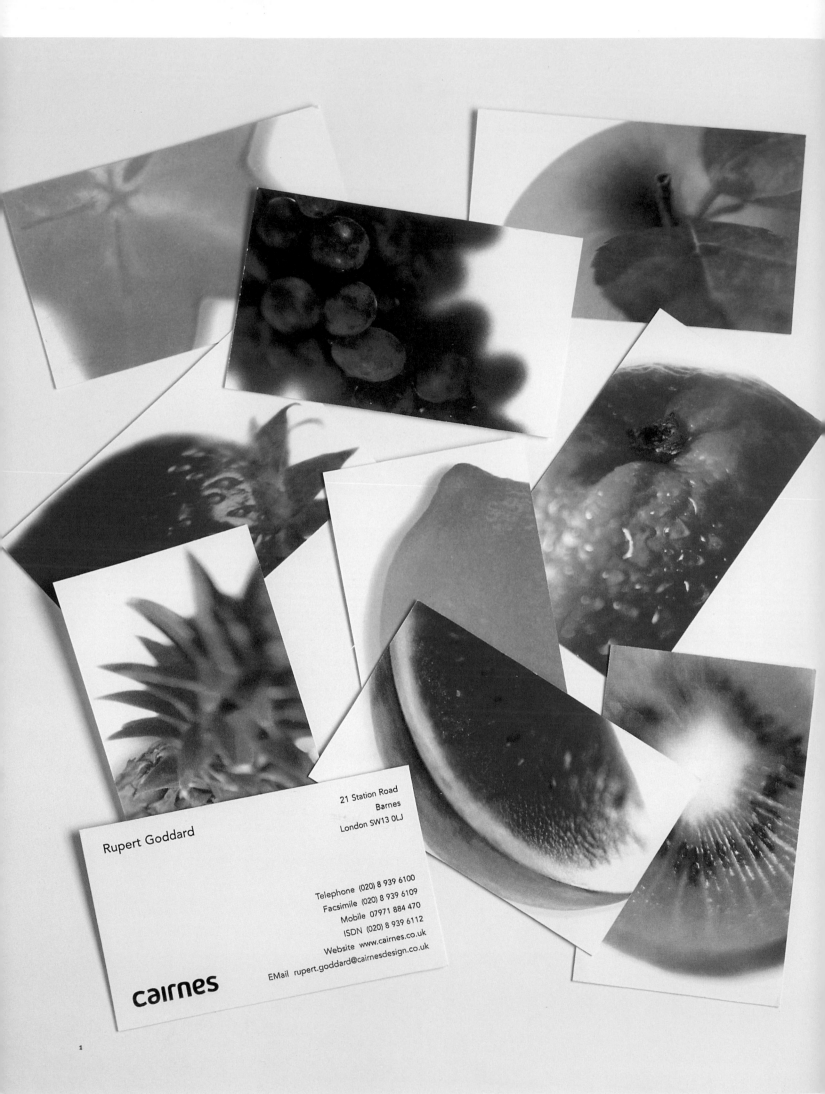

Rupert Goddard

21 Station Road
Barnes
London SW13 0LJ

Telephone (020) 8 939 6100
Facsimile (020) 8 939 6109
Mobile 07971 884 470
ISDN (020) 8 939 6112
Website www.cairnes.co.uk
EMail rupert.goddard@cairnesdesign.co.uk

cairnes

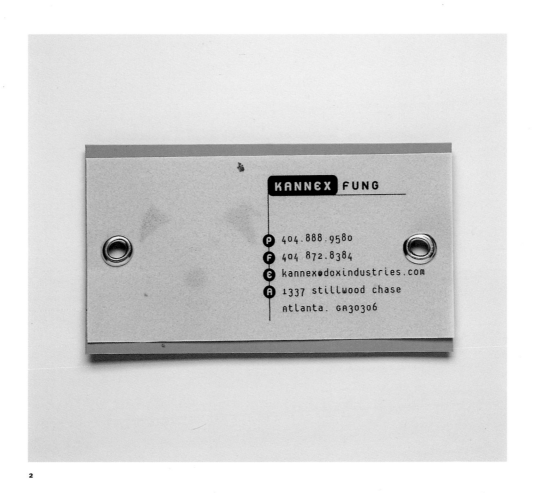

2

1
Design Firm
 Cairnes
Art Director
 Anthony Sharman
Designer
 David Burton
Photographer
 David Burton
Client
 Self-promotion
Software/Hardware
 Quark Xpress
Paper/Materials
 Crane Crest
Printing
 Printed Stationery

2
Design Firm
 DoX Industries
Art Director
 Kannex Fung
Designer
 Kannex Fung
Illustrator
 Kannex Fung
Client
 Self-promotion
Software/Hardware
 Adobe Illustrator
Paper/Materials
 Fox Confetti

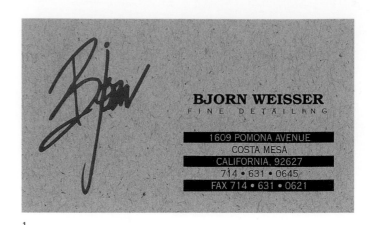

1

1
Design Firm
 Aloha Printing
Art Director
 James Picquelle
Designer
 James Picquelle
Client
 BJorn Weisser Fine Detailing
Software/Hardware
 Corel Draw
Printing
 Offset Sheet Fed Press

2
Design Firm
 Voice Design
Art Director
 Clifford Cheng
Designer
 Clifford Cheng
Client
 Keri Hauser, Hair Stylist
Software/Hardware
 Freehand, Macintosh
Printing
 Offset, 2 Color

KH

keri hauser

2

HAIR STYLIST

KH

SALON MEI

PAN AM BUILDING

1600 KAPIOLANI

SUITE 222

TEL: 955.1600

PGR: 267.0773

HSB

Hengst Streff Bajko Architects

HSB

Kevin Hengst, AIA

1250 Old River Road
Suite 201
Cleveland Ohio 44113-1243
e-mail: hsb@cyberdrive.net
216 586 0440 f
216 586 0229 t

Design Firm
 Nesnadny + Schwartz
Art Directors
 Timothy Lachina,
 Michelle Moehler,
 Gregory Oznowich
Designers
 Timothy Lachina,
 Michelle Moehler,
 Gregory Oznowich
Client
 Hengst Streff Bajko Architects
Software/Hardware
 QuarkXpress
Paper/Materials
 Mohawke Superfine White
 Eggshell 80 lb., Mohawke
 Superfine White Eggshell 70 lb.
Printing
 Master Printing

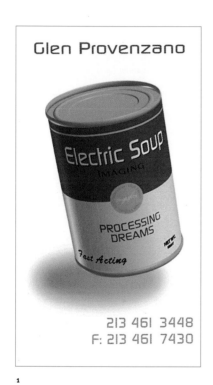

Glen Provenzano

213 461 3448
F: 213 461 7430

1

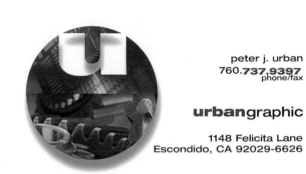

peter j. urban
760.**737.9397**
phone/fax

urbangraphic

1148 Felicita Lane
Escondido, CA 92029-6626

2

1
Design Firm
 Media Bridge
Art Director
 Christopher Sullivan
Designer
 Mark Goss
Client
 Electric Soup
Software/Hardware
 Adobe Illustrator

2
Design Firm
 Urbangraphic
Art Director
 Peter Urban
Designer
 Peter Urban
Illustrator
 Peter Urban
Client
 Self-promotion
Software/Hardware
 Adobe Photoshop,
 Adobe Illustrator
Paper/Materials
 Chromecoat
Printing
 4 Color Process

Design Firm
 Studio Boot
Art Directors
 Petra Janssen, Edwin Vollebergh
Designers
 Petra Janssen, Edwin Vollebergh
Illustrator
 Studio Boot
Client
 Self-promotion
Paper/Materials
 MC on 3mm.Grey Board
Printing
 Full Color and Laminate

Design Firm
Cooper·Hewitt, National
Design Museum

Art Director
Jen Roos

Designer
Jen Roos

Client
Self-promotion

Software/Hardware
QuarkXpress 4.04,
Adobe Photoshop

Paper/Materials
100 lb. Mohawk Navajo
Brilliant White

Printing
Aristographics

OLIVER HUMMEL
Assistant Manager

Design Museum Shop

National **Design** Museum

hummeol@ch.si.edu

2 EAST 91ST STREET
NEW YORK, NEW YORK 10128-9990

T 212 849 8353
F 212 849 8357

DIANNE H. PILGRIM
Director

National **Design** Museum

pilgrdi@ch.si.edu

2 EAST 91ST STREET
NEW YORK, NEW YORK 10128-9990

T 212 849 8370
F 212 849 8367

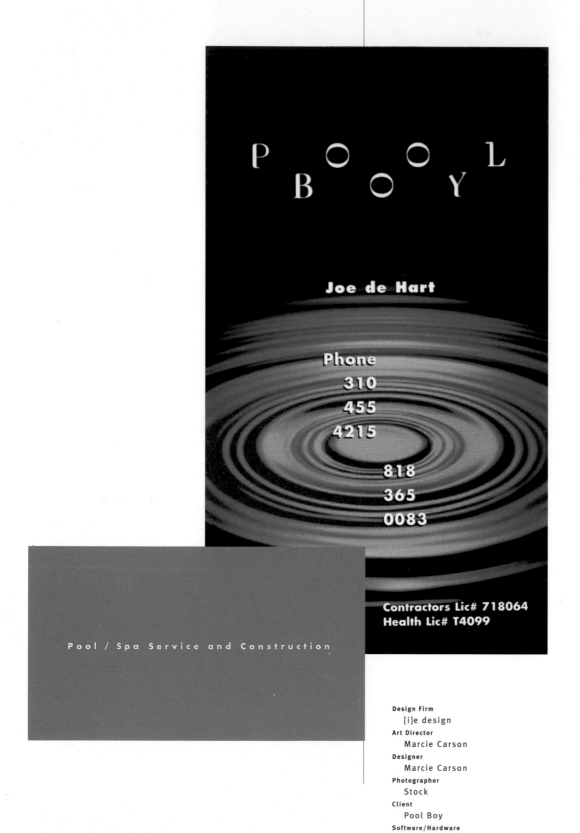

P O O L
B O Y

Joe de Hart

Phone
310
455
4215

818
365
0083

Contractors Lic# 718064
Health Lic# T4099

Pool / Spa Service and Construction

Design Firm
 [i]e design
Art Director
 Marcie Carson
Designer
 Marcie Carson
Photographer
 Stock
Client
 Pool Boy
Software/Hardware
 Adobe Photoshop, Macintosh
Printing
 3 Color Process (Minus Yellow)

PHYSIOTHERAPIE CANERI

AMBULANTE REHA

CRYO-POINT –110°C

Francois Caneri
Physiotherapeut

Kriegsbergstraße 28
70174 Stuttgart

Tel. 0711/163 56-0
Fax 0711/163 56-13

Design Firm
 Michael Kimmerle·Art
 Direction + Design
Art Director
 Michael Kimmerle
Designer
 Michael Kimmerle
Illustrator
 Michael Kimmerle
Client
 Pro-moto
Software/Hardware
 Freehand, Macintosh
Paper/Materials
 Diplomat 250 glm2
Printing
 Offset

1
Design Firm
 Inox Design
Art Director
 Masa Magnoni
Designer
 Masa Magnoni
Illustrator
 Masa Magnoni
Client
 Ca' Del Moro
Software/Hardware
 Adobe Illustrator, QuarkXpress
Paper/Materials
 Fibrone 2 mm.
Printing
 Offset, 2 Colors

2
Design Firm
 Visser Bay Anders Toscani
Art Director
 Hilde Lottuis
Designer
 Hilde Lottuis
Client
 Self-promotion
Paper/Materials
 Hello Silk 300 grams

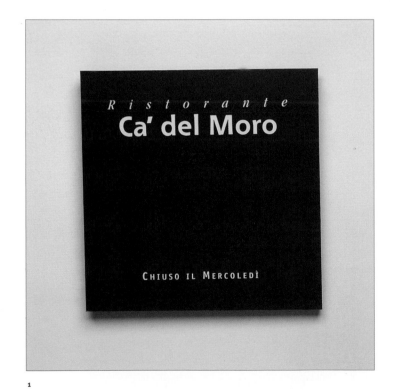

1

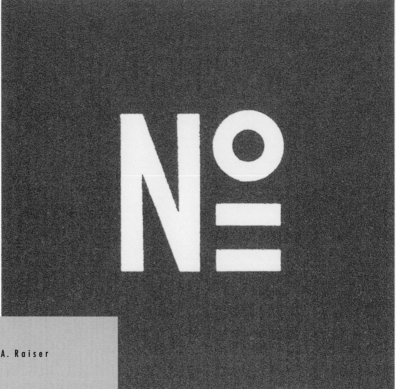

Hartmut A. Raiser

N U M E R O
I n t e r i o r
D E S I G N
Olgastrasse 15
7000 Stuttgart 1
No 0711 · 23 57 57
Fax 0711 · 29 30 35

Design Firm
Michael Kimmerle·Art
Direction + Design
Art Director
Michael Kimmerle
Designer
Michael Kimmerle
Illustrator
Michael Kimmerle
Client
Numero·Interior Design
Software/Hardware
Freehand, Macintosh
Paper/Materials
Conqueror, Römerturm 200
glm2
Printing
Offset, Prägefolie, Stamping

1

Design Firm
 Michael Kimmerle·Art
 Direction + Design
Art Director
 Michael Kimmerle
Designer
 Michael Kimmerle
Illustrator
 Michael Kimmerle
Client
 Antora Selection
Software/Hardware
 Freehand, Macintosh
Paper/Materials
 Conqueror, Römerturm 250 glm2
Printing
 Offset

2

Design Firm
 Ringo W.K. Hui
Art Director
 Ringo W.K. Hui
Designer
 Ringo W.K. Hui
Client
 Pal Pang 100% Mode
Software/Hardware
 Freehand 8.0
Paper/Materials
 Esse, White Green Texture 216 gsm
Printing
 1 Color, 0 Color

ANTORA
SELECTION

Andrea Wontorra
ANTORA SELECTION
Lichtentaler Straße 7 · 76530 Baden-Baden
Tel. 07221/335-25 · Fax -26

1

INTERIOR & SPATIAL DESIGN

PAL PANG. 100% MODE
TELEPHONE (852) 9466 3101 FACSIMILE (852) 2668 4119
E-MAIL palpang@netscape.com

2

1

1

Design Firm
The Hive Design Studio
Art Directors
Laurie Okamura, Amy Stocklein
Designers
Laurie Okamura, Amy Stocklein
Illustrator
Pete Caravalho
Client
Misionero Vegetables
Software/Hardware
Adobe Illustrator, Macintosh
Paper/Materials
Strathmore
Printing
Mission Printers

2

Design Firm
[i]e design
Art Director
Marcie Carson
Designer
David Gilmour
Illustrator
Mirjam Selmi
Client
Sunset Sound
Software/Hardware
Adobe Illustrator, Adobe
Photoshop, Macintosh
Paper/Materials
Star White Vicksburg
Printing
3 PMS, 0 PMS

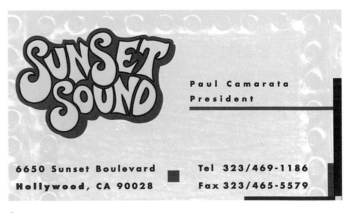

2

Design Firm
 Studio Boot
Art Directors
 Petra Janssen,
 Edwin Vollebergh
Designers
 Petra Janssen,
 Edwin Vollebergh
Illustrator
 Studio Boot
Client
 Sacha Shoes
Paper/Materials
 Sulfaat Karton
Printing
 2 colors, offset
 and perforation

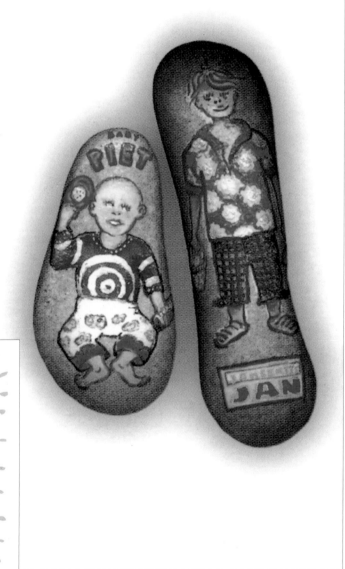

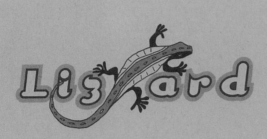

Gespecialiseerd in het maken van:

• historische kleding

• theater- en showbizzkleding

• promotiepakken

• fantasie- en dierenkostuums

• hoeden en maskers

Liesbeth Verbeek P. Kerssemakersdreef 3

4904 WE Oosterhout t/f 0162 429 863 LIZ-ART@hetnet.nl

1

1
Design Firm
 Case
Designer
 Kees Wagenaars
Client
 Lizard

2
Design Firm
 Bettina Huchtemann Art-Direction
 & Design
Designer
 Bettina Huchtemann
Illustrator
 Bettina Huchtemann
Client
 Frank Aschermann·Photography
Software/Hardware
 QuarkXpress
Paper/Materials
 Countryside
Printing
 Offset, Steel-Engraving, Embossing

3
Design Firm
 Belyea
Art Director
 Patricia Belyea
Client
 Meredith & crew

FRANK ASCHERMANN / FOTOGRAF

HOHELUFTCHAUSSEE 139 · 20253 HAMBURG

TELEFON: 040·422 30 60 + 422 30 90

FAX: 040·422 30 70 · MOBIL: 0172·411 07 03

2

Meredith Robinson
technology marketing consultant

15127 NE 24th Street
Suite 466
Redmond, WA 98052

tel **206.369.3274**
fax 425.881.3959
meredith@mcrew.com

Meredith
& crew

Meredith Robinson
principal

15127 NE 24th Street
Suite 466
Redmond, WA 98052

tel **206.369.3274**
fax 425.881.3959
meredith@mcrew.com

Meredith
& crew

Meredith Robinson
designer

15127 NE 24th Street
Suite 466
Redmond, WA 98052

tel **206.369.3274**
fax 425.881.3959
meredith@mcrew.com

Meredith
& crew

Meredith Robinson
columnist/writer

15127 NE 24th Street
Suite 466
Redmond, WA 98052

tel **206.369.3274**
fax 425.881.3959
meredith@mcrew.com

Meredith
& crew

3

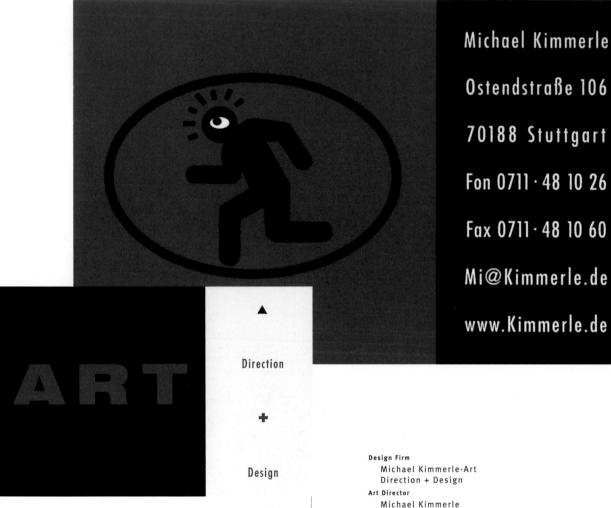

Michael Kimmerle

Ostendstraße 106

70188 Stuttgart

Fon 0711 · 48 10 26

Fax 0711 · 48 10 60

Mi@Kimmerle.de

www.Kimmerle.de

ART

▲

Direction

✚

Design

Design Firm
Michael Kimmerle·Art
Direction + Design
Art Director
Michael Kimmerle
Designer
Michael Kimmerle
Illustrator
Michael Kimmerle
Client
Self-promotion
Software/Hardware
Freehand, Macintosh
Paper/Materials
Ricarta 260 glm2
Printing
Offset

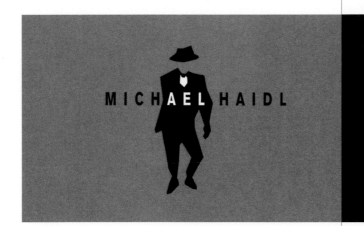

MICHAEL HAIDL

alles, was den Mann anzieht

Rheinstraße 14 B

76185 Karlsruhe-Mühlburg

Tel. 0721 / 55 21 20

1

Altamiro Machado
Gestor de Projectos

Estudos de
Desenvolvimento
Económico e Social, Lda.

Av. Central, 45
Tel. 053. 616510/906
Fax 053. 611872
4710 Braga
Portugal

2

1
Design Firm
Michael Kimmerle·Art
Direction + Design
Art Director
Michael Kimmerle
Designer
Michael Kimmerle
Illustrator
Michael Kimmerle
Client
Michael Haidl
Software/Hardware
Freehand, Macintosh
Paper/Materials
Diplomat/Karton 250 glm2
Printing
Offset

2
Design Firm
Vestígio
Art Director
Emanuel Barbosa
Designer
Emanuel Barbosa
Client
Vector XXI
Software/Hardware
Freehand, Macintosh
Paper/Materials
Torras Paper

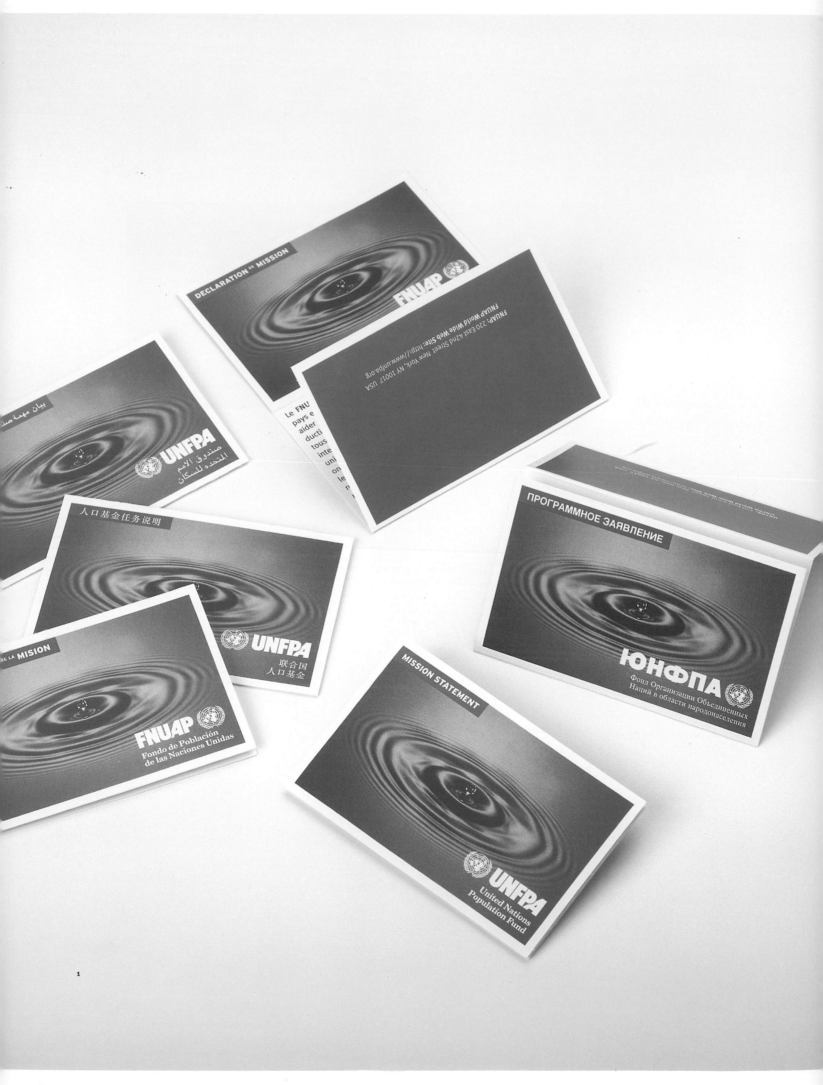

1
Design Firm
"That's Nice" l.l.c.
Art Director
Nigel Walker
Designer
Michael McDevitt
Client
United Nations Population Fund
Software/Hardware
Quark XPress, Adobe
Photoshop, Macintosh
Paper/Materials
Potlach Silk 80 lb.
Printing
3/2 PMS

2
Design Firm
Inkwell Publishing Co.
Art Director
Jimmy Hilario
Designer
Jimmy Hilario
Client
University of Asia and the Pacific
Software/Hardware
Freehand 8, Adobe Photoshop 5,
Macintosh
Paper/Materials
Gilclear Heavy Cream 150 gsm
Printing
Offset

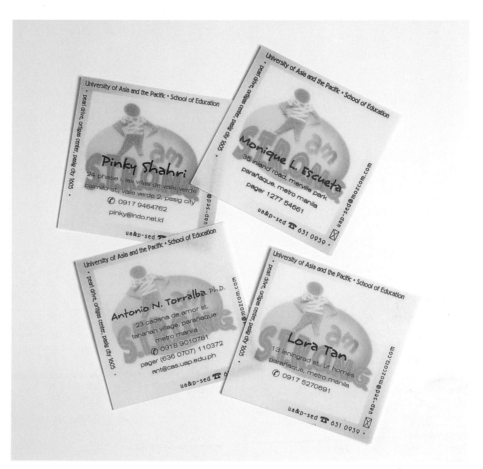

2

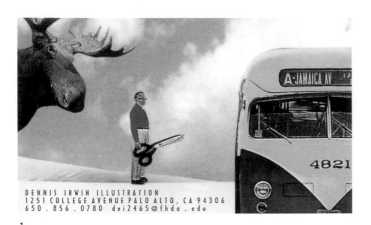

1

Design Firm
 Dennis Irwin Illustration

Art Director
 Dennis Irwin

Designer
 Dennis Irwin

Illustrator
 Dennis Irwin

Client
 Self-promotion

Printing
 Linotext Printing

2

Design Firm
 Studio Boot

Art Directors
 Petra Janssen, Edwin Vollebergh

Designers
 Petra Janssen, Edwin Vollebergh

Illustrator
 Studio Boot

Client
 Sacha Shoes

Paper/Materials
 Sulfaat Karton

Printing
 2 colors, offset and perforation

1

3

SACHA SHOES

TERMEE
SAAL VAN ZWANENBERGWEG 10
5026 RN TILBURG
THE NETHERLANDS
PHONE: +31(0)13 4631115
FAX: +31(0)13 4639091
MOBILE: +31 (0)6 53125641
E-MAIL: sacha@sacha.nl
VAT. nr.: NL 007851509 B03

伯特・特米尔
董事長

sacha°

2

SACHA SHOES

TERMEER SCHOENEN BV
SAAL VAN ZWANENBERGWEG 10
5026 RN TILBURG
THE NETHERLANDS
PHONE: +31(0)13 4631115
FAX: +31(0)13 4639091
MOBILE: +31 (0)6 53125641
E-MAIL: sacha@sacha.nl
VAT. nr.: NL 007851509 B03

BERT TERMEER
PRESIDENT

sacha°

3
Design Firm
 Josh Klenert
Designer
 Josh Klenert
Photographer
 Josh Klenert
Client
 Patricia Brady-Danzig
Software/Hardware
 QuarkXpress, Adobe Photoshop,
 Adobe Illustrator, **Printing**
 2 Color

PATRICIA BRADY
IRISH SOPRANO
POST OFFICE BOX 683
SOUTH ORANGE, N.J. 07079
201.761.0041 | FAX: 201.763.7365

SCOTT STOLL

PHOTOGRAPHY

5013 Pacific Highway East #20

Tacoma, Washington 98424

[253]896-0133

1

1
Design Firm
 Belyea
Art Director
 Patricia Belyea
Client
 Scott Stoll Photography

2
Design Firm
 Cisneros Design
Designer
 Harry M. Forehand III
Photographer
 William Rotsaert
Client
 Leapfrog Integrated
 Technology Solutions
Software/Hardware
 Macintosh
Printing
 Aspen Printing,
 Albuquerque

LEAPFROG
INTEGRATED TECHNOLOGY SOLUTIONS

LEAPFROG

2050 Botulph Rd. Suite B | Santa Fe, New Mexico 87505
505.988.9279 | Fax 505.988.3101
e-mail LJRice@ix.netcom.com

2

belyea.

Patricia Belyea
PRINCIPAL

patricia@belyea.com

1250 Tower Building
1809 Seventh Avenue
Seattle, WA 98101

206.**682.4895**
FAX 206.623.8912
WEB belyea.com

marketing

communication

design

Design Firm
Belyea
Art Director
Patricia Belyea
Client
Self-promotion

Design Firm
 Sb Design-Brazil
Designer
 Ricardo Bastos
Client
 Tortaria-Sweet Shop
Software/Hardware
 Corel Draw, PC
Paper/Materials
 Couché, Dull, 180 gr
Printing
 Offset

Fernando Gomes, 114/A · Moinhos de V.
CEP 90510-010 · Porto Alegre · RS
Fones:(051)395·5599/395·3639

1

2

3

1
Design Firm
 Inox Design
Art Director
 Mauro Pastore
Designer
 Mauro Pastore
Client
 Luca Benetti
Software/Hardware
 Adobe Illustrator
Printing
 Offset, 2 Colors

2
Design Firm
 Izak Podgornik
Designer
 Izak Podgornik
Illustrator
 Izak Podgornik
Client
 Self-promotion
Software/Hardware
 Corel Draw 7, PC
Paper/Materials
 Cordenons Venicelux
 300 glm2
Printing
 2 PMS Colors,
 Plastic Coating

3
Design Firm
 R & M Associati Grafici
Art Director
 Di Somma/Fontanella
Client
 Artemedia
Software/Hardware
 Adobe Illustrator,
 Macintosh
Printing
 Offset

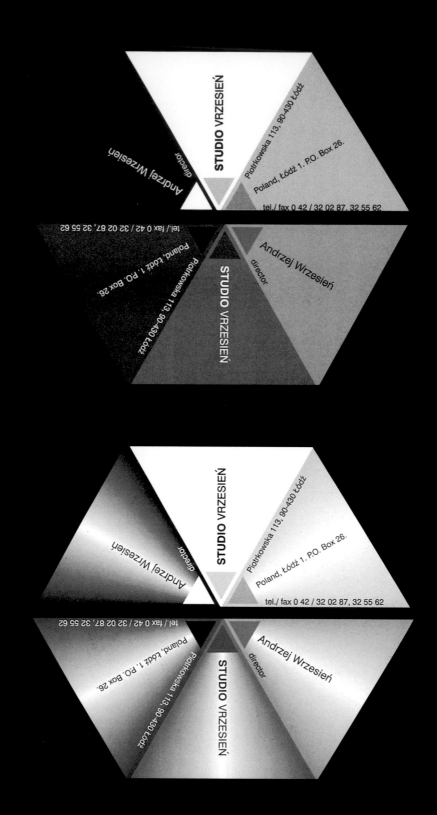

1
Design Firm
 Atelier Tadeusz Piechura
Art Director
 Tadeusz Piechura
Designer
 Tadeusz Piechura
Client
 Studio Vrzesien
Software/Hardware
 Corel 7
Printing
 Offset

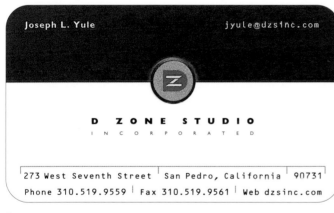

2

2
Design Firm
 D Zone Studio Inc.
Designer
 Joe L. Yule
Client
 Self-promotion
Software/Hardware
 QuarkXpress, Adobe Illustrator
Paper/Materials
 130 lb. Classic Crest -
 Solar White
Printing
 4 Color, Clear Foil, Emboss

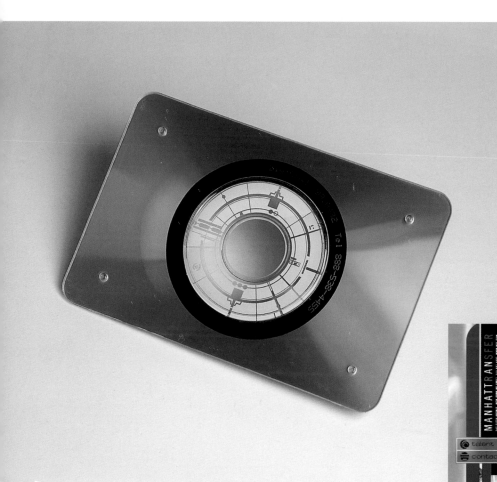

Design Firm
 Manhattan Transfer
Art Director
 Micha Riss
Designer
 Patrick Asuncion
Client
 Self-promotion
Software/Hardware
 Adobe Illustrator, Macintosh
Paper/Materials
 Plastic
Printing
 Digicard

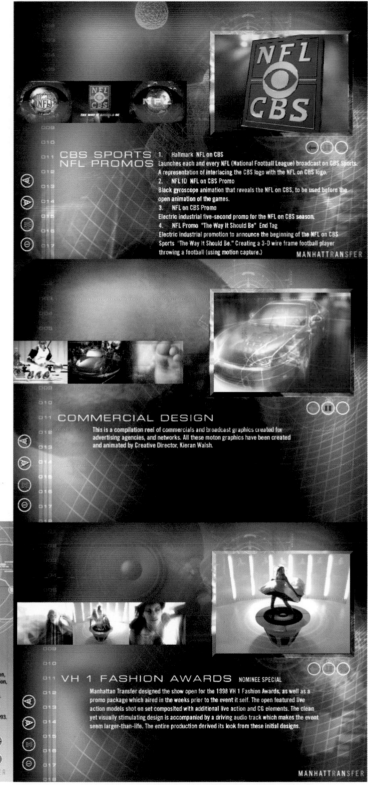

micha RISS CREATIVE DIRECTOR

In 1982, Micha Riss designed imagery for record companies and music publications, among them, the VHS cover for the Rolling Stones "25x5". Since 1984, Micha has been designing for television. He worked on numerous sports, news and entertainment events, including SuperBowl, Olympics, NBA, NCAAHoops, US Open Tennis, and The Masters. As of 1990 Micha has focused on total brand identity for television entities.

PROJECTS
CBS, VH-1, ESPN, SCI-FI, Kodak, Merrill Lynch, Museum of Natural History, CNN, Cartoon Network, WGBH (PBS station), HBO, USA Network, Fox, Life Magazine and Sony Music.

AWARDS
• EMMY award, 1994 Winter Olympics on CBS.
• PROMAX award, 1998 Olympic Downhill Promo on CBS.
• ITS MONITOR award, 1998 Olympic Downhill Promo on CBS.
• TELLY award, 1999 Inside the NFL on HBO.

PUBLICATIONS
Life Magazine, Daily News, Computer Graphics World, Digital Photo Illustration, Graphic Design, Click, Leonardo, AdvertisingAge / Creativity, HOW, Art Direction, Design Journal, Backstage, Videography, Video Magazine, Millimeter, Post Magazine, SPIN, Musician, Billboard, International Musician, and Rock Photo.

EDUCATION
TV Graphic Design Instructor in School of Visual Arts, New York City, since 1993.
BFA Computer Graphics, New York Institute of Technology, New York City

MANHATTRANSFER

Petter Frostell Graphic Design

Roslagsgatan 34
SE-113 55 Stockholm, Sweden
Telephone +46 8 442 94 91
Facsimile +46 8 442 94 99
petter.frostell@telia.com

1

e
Credit.com

Mark S. Hayward
National Account Manager
mark@ecredit.com

www.ecredit.com
1000 Mansell Exchange West, Suite 250 Alpharetta, GA 30022
phone: (770) 645 5257 fax: (770) 645 5258

2

glauer@crescentnets.com

CRESCENT
networks

GREGORY LAUER, PH.D.
founder,
director of product marketing
201 riverneck road chelmsford, ma 01824
t 978 244 9002 x206 c 978 884 4734
f 978 244 9211

3

1
Design Firm
 Petter Frostell Graphic Design
Designer
 Petter Frostell
Client
 Self-promotion
Software/Hardware
 Adobe Illustrator, Macintosh
Paper/Materials
 Scandia 2000
Printing
 Elfströms Tryckeri

2
Design Firm
 Stewart Monderer Design, Inc.
Art Director
 Stewart Monderer
Designer
 Aime Lecusay
Client
 eCredit.com
Software/Hardware
 Adobe Illustrator,
 QuarkXpress, Macintosh
Paper/Materials
 Gilbert Neutech
Printing
 2 Match Colors

3
Design Firm
 Stewart Monderer Design, Inc.
Art Director
 Stewart Monderer
Designer
 Aime Lecusay
Client
 Crescent Networks, Inc.
Software/Hardware
 Adobe Illustrator,
 QuarkXpress, Macintosh
Paper/Materials
 Monadnock Astrolite
Printing
 2 Match Colors

ZEIGLER ASSOCIATES

107 East Cary Street
Richmond, VA 23219
804.780.1132 | C. BENJAMIN DACUS
804.644.2704 [fax]
zeiglera@erols.com

Marketing
Communications

Design Firm
 Zeigler Associates
Art Director
 C. Benjamin Dacus
Designer
 C. Benjamin Dacus
Client
 Self-promotion
Software/Hardware
 QuarkXpress
Paper/Materials
 French Butcher
Printing
 Offset; Business Press,
 Richmond, VA

Doug Bamford
Marketing

Space Needle
Live The View

203 6th Avenue North
Seattle, WA 98109-5005
Main: (206) 443-9700
Direct: (206) 443-2161, ext.1432
Fax: (206) 441-7415
E-mail: doug@bamford.com

1
Design Firm
Hornall Anderson Design Works
Art Director
Jack Anderson
Designers
Mary Hermes, Gretchen Cook,
Andrew Smith
Client
Space Needle
Software/Hardware
Freehand, Macintosh
Paper/Materials
Fox River Confetti

 personify

www.personify.com
50 Osgood Place, Suite 100
San Francisco, California 94133
T 415 / 782 2050
F 415 / 544 0318

personify

[EILEEN HICKEN GITTINS]
ceo

415 / 782 2055
egittins@personify.com

2
Design Firm
Hornall Anderson Design Works
Art Director
Jack Anderson
Designers
Jack Anderson, Debra
McCloskey, Holly Finlayson
Illustrator
Holly Finlayson
Client
Personify
Software/Hardware
Freehand, Macintosh
Paper/Materials
Regalia

Design Firm
Hornall Anderson Design Works
Art Director
Jack Anderson
Designers
Jack Anderson, Heidi Favour,
Margaret Long
Client
Mahlum Architects
Software/Hardware
Freehand, Macintosh
Paper/Materials
Mohawk Superfine Recycled,
White

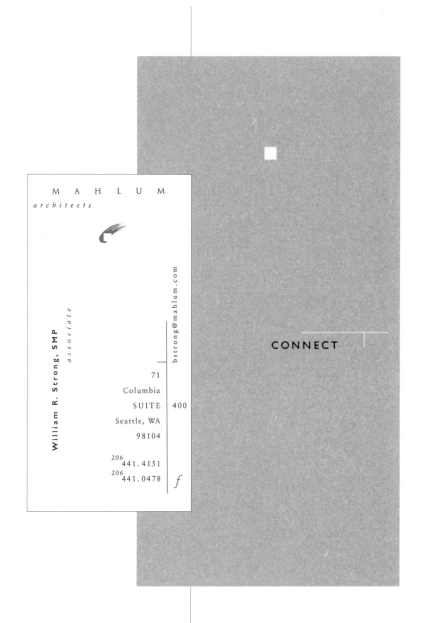

Design Firm
 Visual Marketing Associates
Art Directors
 Jason Selke, Tracy Meiners,
 Ken Botts
Designer
 Jason Selke
Photographer
 Quigley
Client
 C/ND Snowboard Apparel
Software/Hardware
 Freehand 8.0
Paper/Materials
 French Frostone
Printing
 Patented Printing

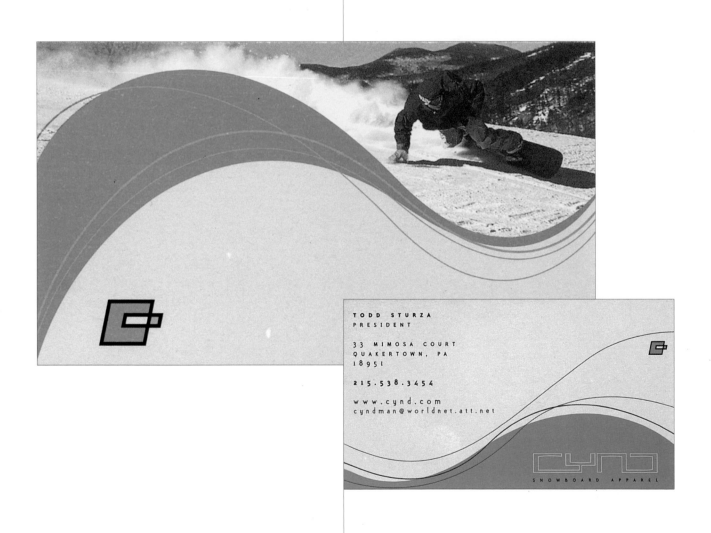

TODD STURZA
PRESIDENT

33 MIMOSA COURT
QUAKERTOWN, PA
18951

215.538.3454

www.cynd.com
cyndman@worldnet.att.net

SNOWBOARD APPAREL

Design Firm
 Form Studio
Art Director
 Jeffrey Burk
Designer
 Jeffrey Burk
Client
 Self-promotion
Software/Hardware
 Strata Studio Pro, Adobe
 Photoshop, Freehand
Paper/Materials
 Havana, Perla 111 lb. Cover
Printing
 Lithography, Letter Press

F O R M S T U D I O I N C .
2900 First Ave P501 Seattle, WA 98121
JEFFREY BURK
TEL 206.448.0275 FAX 206.448.0277
EMAIL jeffrey@formstudio.com WEB www.formstudio.com
PRINT IDENTITY INTERNET
DESIGN

1
Design Firm
O2 Design
Art Director
Peter Dawson
Designer
Peter Dawson
Client
Self-promotion
Software/Hardware
QuarkXpress, Adobe Photoshop,
Macintosh
Paper/Materials
Federal Tait Presentation
300 gsm
Printing
2 Specials and Die cuts

2
Design Firm
Pfeiffer plus Company
Art Director
Jerry Bliss
Designers
Terry Bliss, Katy Fischer
Illustrators
Terry Bliss, Katy Fischer
Client
Self-promotion
Software/Hardware
Adobe Illustrator 8.0,
QuarkXpress 4.0
Paper/Materials
Mohawk Superfine 80 lb. Bright
White Cover
Printing
Reprox

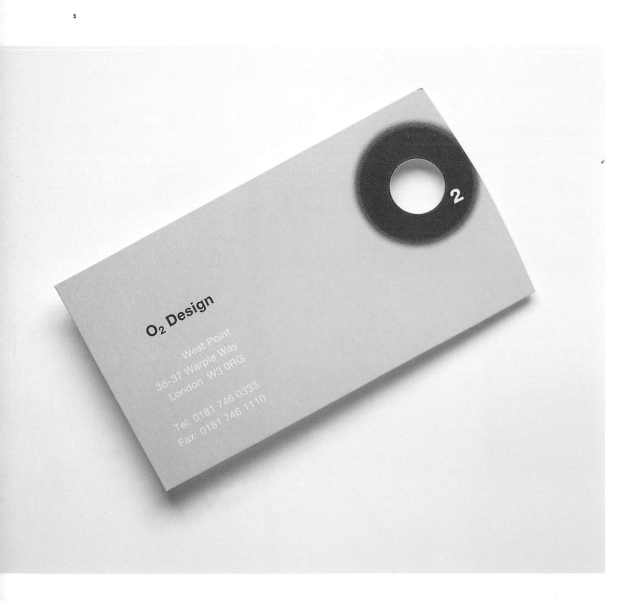

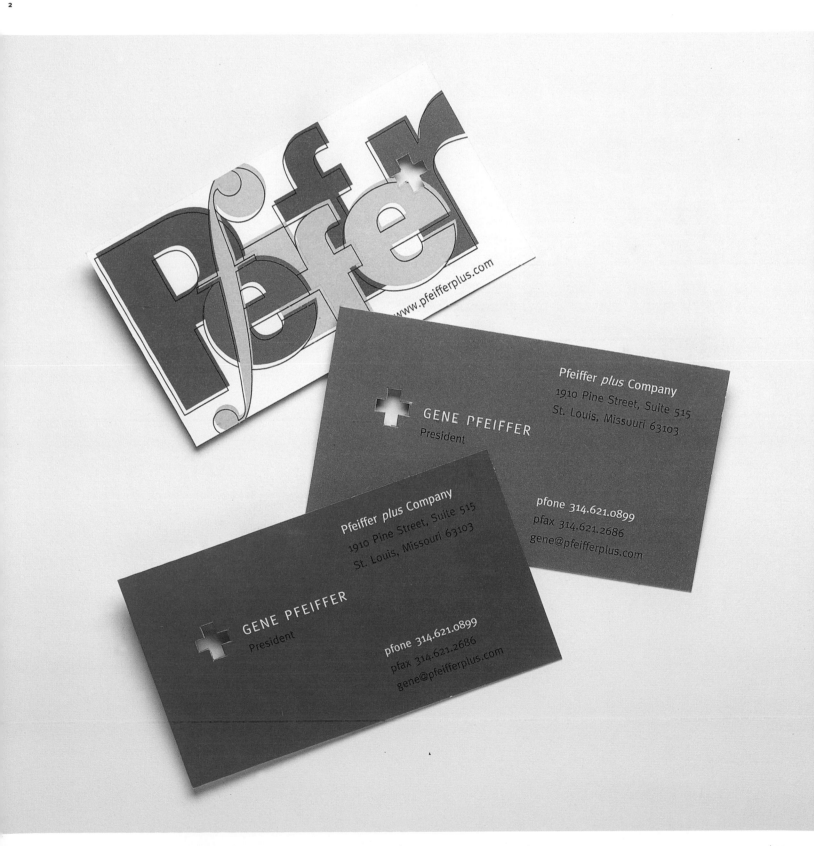

Design Firm
 Becker Design
Art Director
 Neil Becker
Designers
 Neil Becker, Mary Eich
Client
 tesserae
Software/Hardware
 QuarkXpress, Adobe Illustrator

tesserae

custom tables • fireplace facades
lamps • mirrors • frames • planters

mosaics for life

Tammy Leiner
414.385.0320

Design Firm
 Total Creative, Inc.
Art Director
 Rod Dyer
Designer
 John Sabel
Illustrator
 John Sabel
Client
 Farrier's Nature
Software/Hardware
 Adobe Illustrator, Macintosh

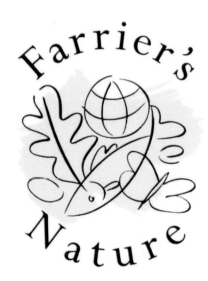

FARRIER'S NATURE
354 HUNTLEY DRIVE
WEST HOLLYWOOD
CALIFORNIA 90048
TEL: 310.289.7701
FAX: 310.289.7719

DENNIS FARRIER

Design Firm
 Greteman Group
Art Director
 Sonia Greteman
Designer
 James Strange
Client
 Self-promotion
Software/Hardware
 Freehand
Paper/Materials
 Light Spec Snow
Printing
 Offset

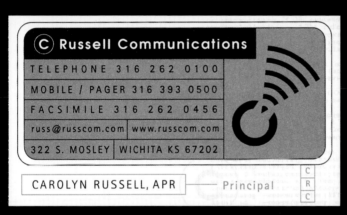

1
Design Firm
 Greteman Group
Art Directors
 Sonia Greteman, James Strange
Designer
 James Strange
Client
 Russell Communications
Software/Hardware
 Freehand
Paper/Materials
 Strathmore Elements
Printing
 Offset

2
Design Firm
 Dean Johnson Design
Art Directors
 Scott Johnson, Bruce Dean
Designers
 Scott Johnson, Bruce Dean,
 Pat Prather
Client
 Expidant

Design Firm
 Opera Grafisch Ontwerpers
Art Directors
 Ton Homburg, Marty
 Schoutsen
Designer
 Sappho Panhuysen
Client
 Werk 3
Software/Hardware
 QuarkXpress, Macintosh
Paper/Materials
 Biotop

Bianca Locker

Rambaldistrasse 27 T +49 (0)89 957 20 172 ISDN +49 (0)89 957 20 173
D - 81929 München F +49 (0)89 957 20 174 e-mail: design@werk3.ccn.de

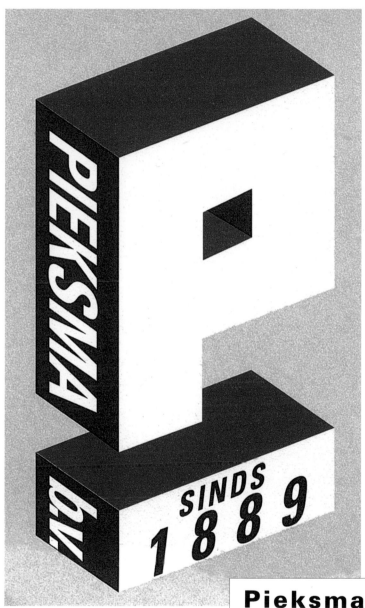

1
Design Firm
 Studio Boot
Art Directors
 Petra Janssen, Edwin Vollebergh
Designers
 Petra Janssen, Edwin Vollebergh
Illustrator
 Studio Boot
Client
 Pieksma bv.
Paper/Materials
 Sulfaat Karton
Printing
 Offset, 3 colors

Pieksma bv.
sinds 1889
Medische divisie

Frank Rooijakkers
Achtergracht 27
1017 WL Amsterdam
T.020-6237754 F.020-6245203
privé 020-6937612

Helen Brennan

Sir John Lyon House
5 High Timber Street
Blackfriars
London
EC4V 3NX

tel +44 (0)207 2484945
fax +44 (0)207 2484946
mob +44 (0)467 785786
helen@chameleonmkg. com

chameleon marketing communications

Sir John Lyon House 5 High Timber Street Blackfriars London **EC4** V 3NX

Paul Burgess
T +44 (0)171 420 7700
F +44 (0)171 420 7701
m 0976 607126
paulb@wilsonharvey.co.uk

Wilson Harvey
Contagious Marketing and Design

1

Uday Radia

lighthouse

- Sir John Lyon House
 5 High Timber Street
 London
 EC4V 3NX
- t 020 7420 7714
 f 020 7420 7723
- e uradia@lighthousepr.com
 www.lighthousepr.com

2

Anthony Berry

AC Networks
12 Astra Drive
Gravesend
Kent
DA12 4PY

Tel 01474 350890
Fax 01474 320400

3

Design Firm
　Studio Boot
Art Directors
　Petra Janssen, Edwin Vollebergh
Designers
　Petra Janssen, Edwin Vollebergh
Illustrator
　Studio Boot
Client
　The Framehouse
Paper/Materials
　Plastic Phone Card
Printing
　Silkscreen, 3 colors

Design Firm
 Studio Boot
Art Directors
 Petra Janssen, Edwin Vollebergh
Designers
 Petra Janssen, Edwin Vollebergh
Illustrator
 Studio Boot
Client
 Self-promotion
Paper/Materials
 MC on 3mm Grey Board
Printing
 Full Color and Laminate

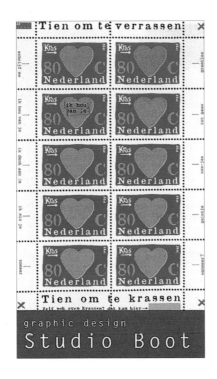

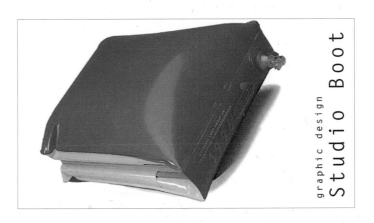

1
Design Firm
 Herman Miller Marketing
 Communications Dept.
Art Director
 Stephen Frykholm
Designer
 Brian Edlefson
Photographers
 Nick Merrick,
 Hedrick Blessing,
 Stock
Client
 Herman Miller, Inc.
Software/Hardware
 Adobe Photoshop 5.0,
 QuarkXpress 4.0
Paper/Materials
 Fox River Coronado
Printing
 Foremost Graphics, Inc.

2
Design Firm
 Atelier Tadeusz Piechura
Art Director
 Tadeusz Piechura
Designer
 Tadeusz Piechura
Client
 Olli Reima
Software/Hardware
 Corel 7
Printing
 Offset, 2nd Edition,
 New Version

2

1
Design Firm
 Case
Designer
 Kees Wagenaars
Client
 Seegers & Emmen
Software/Hardware
 QuarkXpress
Paper/Materials
 Lightning Gold 240 gr.
Printing
 Expel

2
Design Firm
 DMX Design
Art Director
 Petrie Hahn
Designer
 Sara Crivello, Suyeon Park
Client
 Self-promotion
Software/Hardware
 Adobe Illustrator

Joyce Seegers & Paul Emmen

Pelsakker 4, 4834 AG Breda

076-5602835 ✿ mmcgers@casema.net

1

2

Design Firm
 DMX Design
Art Director
 Petrie Hahn
Designer
 Sara Crivello
Client
 Iscom
Software/Hardware
 Adobe Illustrator

ISAAC SALEM
President

Iscom, Inc.
One Silicon Alley Plaza
90 William Street, Suite 1202
New York, NY 10038

p: 212.324.1100
f: 212.324.1101
isaac@iscom.net
www.iscom.net

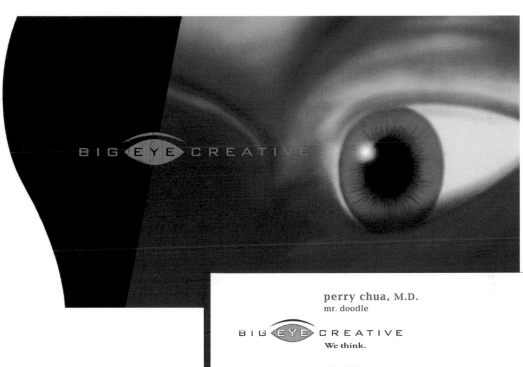

1

Design Firm
Cisneros Design
Art Director
Harry M. Forehand III
Designers
Harry M. Forehand III,
Brian Hurshman
Client
Copygraphics
Software/Hardware
Macintosh
Printing
Local Color, Santa Fe

2

Design Firm
Big Eye Creative
Art Directors
Perry Chua, Dann Ilicic
Designer
Perry Chua
Photographer
Grant Waddell
(digital imaging)
Client
Self-promotion
Software/Hardware
Adobe Illustrator,
Adobe Photoshop
Paper/Materials
Potlatch McCoy
Printing
Clarke Printing

2

perry chua, M.D.
mr. doodle

BIG EYE CREATIVE
We think.

101.1300 richards street
vancouver bc, canada v6b 3g6
e-mail mecium@bigeyecreative.com
fax 604.683.5686

(604.683.5655)

TEL 415·482·9324

digital

FAX 415·482·9314

EMAIL ron@dahothouse.com

1323 Fourth Street · San Rafael · CA · 94901

🏠 hothouse

1

Steve Kimball Principal

2 Magnolia Avenue
San Anselmo Ca 94960

phone 415 453 2828
fax 415 453 0828
e-mail steve@lightrain.com

2

1
Design Firm
 be
Art Director
 Will Burke
Designers
 Eric Read, Enrique Gaston
Client
 hothouse digital
Printing
 Photon Press

2
Design Firm
 be
Art Director
 Will Burke
Designer
 Eric Read
Illustrator
 Coralie Russo
Client
 light rain
Software/Hardware
 Adobe Illustrator, Adobe Photoshop,
 Macintosh
Printing
 Photon Press

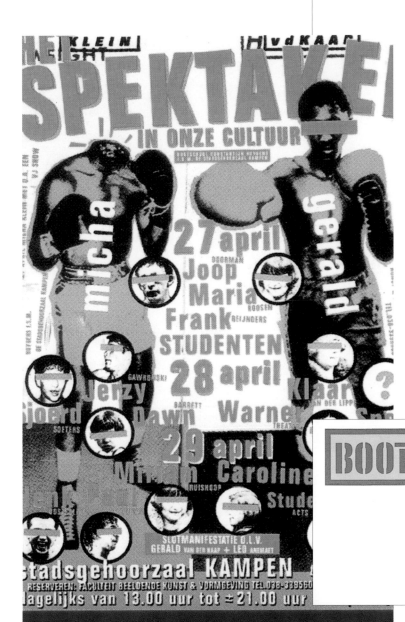

Design Firm
Studio Boot
Art Directors
Petra Janssen, Edwin Vollebergh
Designers
Petra Janssen, Edwin Vollebergh
Illustrator
Studio Boot
Client
Self-promotion
Paper/Materials
MC on 3mm Grey Board
Printing
Full Color and Laminate

studio Boot • Brede Haven 8a
5211 Tl 's-Hertogenbosch
Tel.073-6143593 • Fax 073-6133190
ISDN 073-6129865 • bootst@wxs.nl

graphic design
Studio Boot

Design Firm
IUADOME

Art Director
Sang Han

Designers
Jeeho Kim, Sung
Hyun Park

Photographer
Chang Han

Client
Self-promotion

Software/Hardware
Adobe Illustrator,
Adobe Photoshop, 3D Max

Paper/Materials
65 lb. Cougar White,
Cellophane

Printing
Mcbride Printing

DETERMAN BROWNIE, INC.

Ron Determan
Field Service

1241 72nd Avenue NE
Minneapolis, MN 55432

PHONE: 612.571.8110 | FAX: 612.502.9862

1

DIGITAL MEDIA GROUP

Digital Media Group s.r.l.
Via Tadino 20 - 20124 Milano
tel 02 29.41.21.74 Fax 02 29.41.52.66
e-mail: monti@dmg.it
Punto Vendita Autorizzato Apple Computer
Partita Iva 12365290159

Auro Monti

2

1
Design Firm
Design Center
Art Director
John Reger
Designer
Jon Erickson
Client
Determan Brownie, Inc.
Software/Hardware
Freehand, Macintosh
Paper/Materials
Strathmore Writing

2
Design Firm
Inox Design
Art Director
Sabrina Elena
Designer
Sabrina Elena
Client
Digital Media Group
Software/Hardware
Freehand
Paper/Materials
Zanders Chromolux
Printing
Offset, 1 & 2 Colors

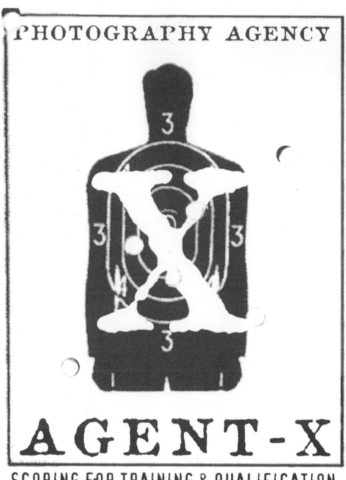

Design Firm
 Studio Boot
Art Directors
 Petra Janssen,
 Edwin Vollebergh
Designers
 Petra Janssen,
 Edwin Vollebergh
Illustrator
 Studio Boot
Client
 AGENT-X
Paper/Materials
 Chromolux
Printing
 Offset

PHILIPPE G. VADALEAU

SCHRÖDERSTIFTSTR. 28 / 20146 HAMBURG / TEL.: 040 · 41 81 11 / FAX: 41 82 10

Design Firm
Bettina Huchtemann Art -
Direction & Design
Designer
Bettina Huchtemann
Illustrator
Bettina Huchtemann
Client
Philippe Vadaleau
Software/Hardware
QuarkXpress, Brush
Paper/Materials
Countryside
Printing
Offset, 2 Colors

Jed Somit, Attorney (415) 839-3215

1440 Broadway, Suite 910
Oakland, California 94612
FAX (415) 272-0711

1

1
Design Firm
Fifth Street Design
Art Director
J. Clifton Meek
Designer
Brenton Beck
Client
Jed Somit
Software/Hardware
Corel Draw
Paper/Materials
Strathmore Writing Laid
Printing
Kerwin Graphic Arts

3
Design Firm
Zeroart Studio
Art Director
Josef Lo
Designer
Simon Tsang
Client
Self-promotion
Software/Hardware
Adobe Illustrator 8.0, Macintosh
Paper/Materials
Rives Paper, Bright White 250 gsm
Printing
Charming Print
Production House

2 (see also page 149, bottom)
Design Firm
Esfera Design
Designers
Cecilia Consolo, Luciano Cardinali
Client
Self-promotion
Software/Hardware
QuarkXpress, Corel Draw
Paper/Materials
Star White Vicksburg, Tiara 216 g
Printing
Offset

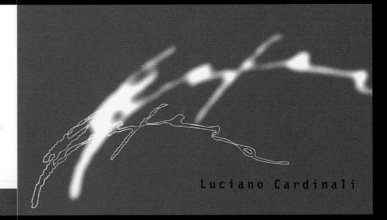

E S F E R A D E S I G N
design & assessoria de imagem
rua barão de santa marta, 519 04372-100 são paulo sp
fone/fax: (0++11) 5563 1454 Cel: (0++11) 9611 3023
esferadg@uol.com.br

Luciano Cardinali

2

creativity-always on my mind

**simon tsang 曾繁荣 chief designer*
zeroart@netvigator.com ** p.o.box 71466, kowloon central post office, hong kong.
*tel / fax 26 09 40 50

93 04 36 09

3

zeroart
zeroart studio

Luciano Cardinali

ESFERA DESIGN
design & assessoria de imagem

rua barão de santa marta 519 são paulo sp 04372-100
fone fax (0++11) **5563 1454** Cel (0++11) 9611.3023
esferadg@uol.com.br

Hans Kliphuis Public Relations & Public Affairs

Telefoon
++31(0)50 527 12 45

Telefax
++31(0)50 529 05 90

Adres
Vechtstraat 9^d

Autotelefoon
++31(0)6 53 47 39 49

E-mail
Kliphuis@pi.net.

9725 CS Groningen

1

Poggibonsi
Brinkhorst 11
9751 AS Haren

T
050-5370227

F
050-3090906

Bert Hamersma

retailer

poggibonsi

2

1
Design Firm
 Erwin Zinger Graphic Design
Designer
 Erwin Zinger
Client
 Hans Kliphuis Public Relations & Public
 Affairs
Software/Hardware
 Adobe Illustrator, QuarkXpress
Paper/Materials
 Countryside
Printing
 2 Colors, Offset

2
Design Firm
 Erwin Zinger Graphic Design
Designer
 Erwin Zinger
Client
 Poggibonsi
Software/Hardware
 Adobe Illustrator
Paper/Materials
 Confetti
Printing
 Black and Silver (PMS 877)

michael BARTALOS *p* 415 863 4569 *f* 415 252 7252

mike@bartalos.com

30 RAMONA AVENUE NO.2 **SAN FRANCISCO** CA 94103

represented in japan by **CWC**
p 03 3496 0745 *f* 03 3496 0747 *e* junko@cwctokyo.com

1

Carolyn E. Larson

*Women's Versatile
Knit Classics*

*3904 Sunnyside Road
Edina, Minnesota 55424
Phone (612) 920-7231
Fax 920-4937*

2

1
Design Firm
Natto Maki
Art Director
Lili Ong
Designer
Lili Ong
Illustrator
Michael Bartalos
Client
Michael Bartalos
Software/Hardware
Adobe Illustrator
Paper/Materials
Strathmore Off-White Cover
Printing
Letter Press By One Heart Press,
San Francisco

2
Design Firm
Design Center
Art Director
John Reger
Designer
Sherwin Schwartzrock
Client
Cameleon
Software/Hardware
Freehand, Macintosh
Paper/Materials
Strathmore Writing
Printing
Pro-Craft

Design Firm
Cincodemayo Design
Art Director
Mauricio H. Alanis
Designer
Adriana Garcia
Client
BAR-CELONA
Software/Hardware
Freehand 8.01, Macintosh
Paper/Materials
Magnomatt 250
Printing
50M Offset Printing

SEQUENCE
PLANNING & DESIGN

INTERIOR DESIGN

SPACE PLANNING

PROJECT MANAGEMENT

MOVE COORDINATION

1

SEQUENCE
PLANNING & DESIGN

DOTTIE BRIGGS
ASID • IFMA

883 NORTH SHORELINE BLVD., SUITE C-120
MOUNTAIN VIEW, CA 94043

TEL 650.967.3394

FAX 650.934.2950

1
Design Firm
Free-Range Chicken Ranch
Art Director
Kelli Christman
Designer
Kelli Christman
Illustrator
Sandy Gin
Client
Sequence
Software/Hardware
QuarkXpress, Adobe Illustrator
Paper/Materials
Starwhite Vicksburg 130 lb.
Cover
Printing
Offset, PMS inks

2
Design Firm
Sb Design - Brazil
Designer
Ricardo Bastos
Client
Le Bistrot Restaurant
Software/Hardware
Corel Draw, PC
Paper/Materials
Esse, Dark Tan (216glm2) Texture
Printing
Offset

Fernando Marins

Fernando Gomes, 58 • 90.510-010 • Porto Alegre • RS
Fone: (051) 346.3812

2

THE
TIME

224 West 49th Street New York, NY 10019

ULRICH R. WALL
General Manager

Tel 212.320.2940
Fax 212.320.2941
E-mail uwalltime@sprynet.com

1

1
Design Firm
Mirko Ilić Corp.
Art Director
Mirko Ilić
Designer
Mirko Ilić
Client
The Time Hotel

2
Design Firm
Sibley Peteet Design
Designers
Donna Aldridge, Tom Kirsch,
David Beck
Client
AGI Klearfold
Software/Hardware
Adobe Illustrator, Macintosh
Printing
Monarch Press

3
Design Firm
Sackett Design Associates
Art Director
Mark Sackett
Designers
George White, James Sakamoto,
Wendy Wood
Photographer
Stock
Client
communities.com
Software/Hardware
QuarkXpress, Adobe Illustrator,
Adobe Photoshop
Paper/Materials
100 lb. Bright White
Vellum Cover
Printing
Forman Lithograph

www.communities.com
www.thepalace.com
www.onlive.com

CAROLYN E. VAN NESS
EXECUTIVE ADMINISTRATOR & OFFICE MANAGER
DIRECT 408.342.9506

10101 NORTH DE ANZA BLVD · SUITE 100
CUPERTINO, CALIFORNIA · 95014.2264
PHONE 408.342.9500 · FAX 408.777.9200

carolyn@communities.com

3

IMPAC
GROUP™

AGI
KLEARFOLD

RICHARD BLOCK
President & CEO

1776 BROADWAY
NEW YORK, NY 10019-2002
TEL 212.489.0973 Ext. 7110
FAX 212.489.0255

rblock@impacgroup.com

2

4
Design Firm
 Free-Range Chicken Ranch
Art Director
 Kelli Christman
Designer
 Kelli Christman
Client
 web•ex by ActiveTouch
Software/Hardware
 QuarkXpress, Adobe Illustrator
Paper/Materials
 Starwhite Vicksburg 130 lb.
Printing
 Offset, Special Inks

Charles J. Orlando
DIRECTOR OF MARKETING
COMMUNICATIONS

5225 Betsy Ross Drive
Santa Clara, California 95054
408.980.5200 x2145
fax: 408.980.5280
charles@webex.com
www.activetouch.com

we've got to start
meeting like this™

www.webex.com

4

z o ë

Pan-Asian Café
and catering company

4753 McPherson
Saint Louis, MO 63108
Phone: 314/361-0013 Fax: 361-4041

1

1
Design Firm
 The Puckett Group
Art Director
 Candy Freund
Designer
 Candy Freund
Illustrator
 Candy Freund
Client
 Zoë Pan-Asian Café
Software/Hardware
 QuarkXpress, Adobe Photoshop
Paper/Materials
 80 lb. Strathmore Ultimate
 White Wove Cover
Printing
 Offset, 4 PMS Colors,
 Printer: Reprox

1

2

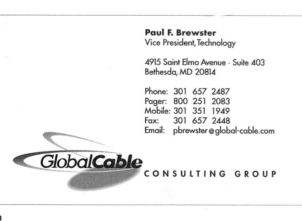

3

1
Design Firm
Vestígio
Art Director
Emanuel Barbosa
Designer
Emanuel Barbosa
Client
Self-promotion
Software/Hardware
Freehand, Macintosh
Paper/Materials
Favini Milho
Printing
1 Color

2
Design Firm
Kelly O. Stanley Design
Art Director
Kelly O'Dell Stanley
Client
Self-promotion
Software/Hsrdware
Freehand, QuarkXpress,
Macintosh
Paper/Materials
Esse Smooth White
Prinitng
2 Color

3
Design Firm
Tim Kenney Design Partners
Art Director
Tim Kenney
Designer
Monica Banko
Client
Global Cable Consulting
Group
Software/Hardware
Freehand, QuarkXpress,
Macintosh
Paper/Materials
Gilbert Neutech Ultra White
Wove
Printing
London Litho

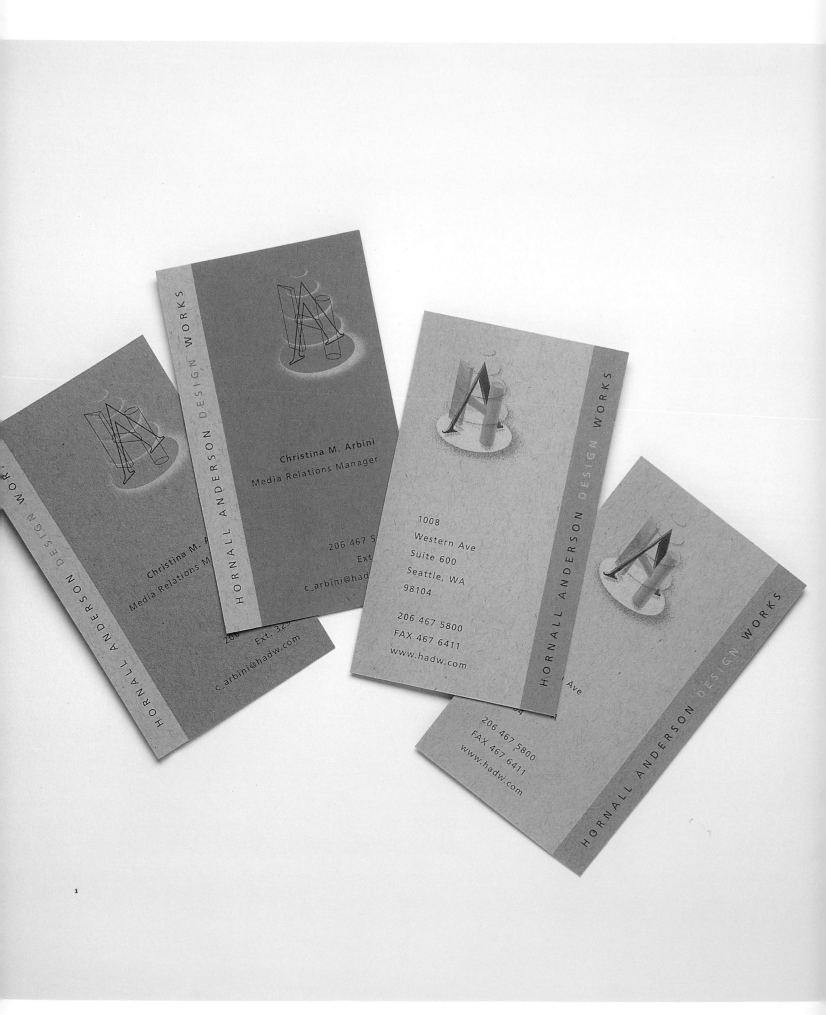

1

Design Firm
Hornall Anderson Design Works

Art Director
Jack Anderson

Designers
Jack Anderson, David Bates

Illustrator
David Bates

Client
Self-promotion

Paper/Materials
French Durotone, Packaging
Gray Liner 80 lb. C

2

Design Firm
Second Floor

Art Director
Warren Welter

Designer
Warren Welter

Illustrator
Lori Powell

Client
5th Avenue Suites Hotel

Software
QuarkXPress, Adobe Illustrator,
Macintosh

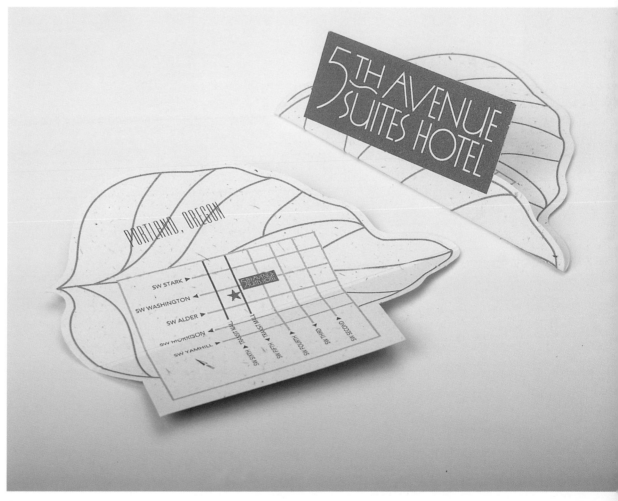

2

Estudio Hache
Diseño Gráfico y Multimedia

Vedia 1682 - 3º
1429 Buenos Aires
República Argentina

4704-0202
4446-1393

info@estudiohache.com
www.estudiohache.com

Laura Lazzeretti

Marcelo Varela

Design Firm
Estudio Hache S.A.
Designers
Laura Lazzeretti,
Marcelo Varela
Photographers
Marcelo Varela,
Laura Lazzeretti
Client
Self-promotion
Software/Hardware
Adobe Photoshop, Adobe
Illustrator, Macintosh
Paper/Materials
4 Color Printing, Water Based
Varnish on 235 g Coated Paper
Printing
Neuhaus S.A.

Lynn Ridenour
Director of
Corporate
Communications
425.519.9313
lynnr@onyx.com

310-120th Ave NE
Bellevue, WA 98005
(T) 425.451.8060
(F) 425.519.4002
www.onyx.com

Design Firm
Hornall Anderson Design Works
Art Director
John Hornall
Designers
Debra McCloskey,
Holly Finlayson,
Jana Wilson Esser
Client
Onyx Software Corporation
Software/Hardware
Freehand, Macintosh

Design Firm
Ricardo Mealha Atelier
Design Estrategico
Art Director
Ricardo Mealha
Designer
Leonel Duarte
Client
Luís De Barros
Software/Hardware
Freehand 8.0
Paper/Materials
Martin Paper
Printing
Ma Artes Graficas

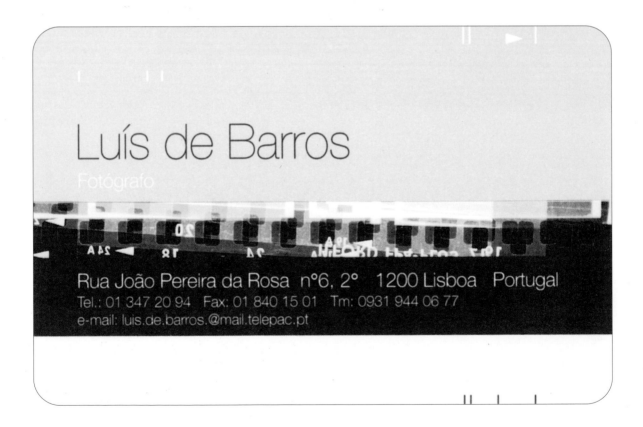

Porto	Administração / Direcção
	av. Mouzinho de Albuquerque,
Póvoa	n.º 184 R/c
	4490 Póvoa de Varzim
Braga	
	tel.: 351 - 52 - 298 0 80
Lisboa	fax: 351 - 52 - 298 0 89

Administração / Direcção
av. Mouzinho de Albuquerque,
n.º 184 R/c
4490 Póvoa de Varzim

tel.: 351 - 52 - 298 0 80
fax: 351 - 52 - 298 0 89

Armazém rua Silveira Campos,
n.º 38, Arm. a — Aver-o-Mar,
4490 Póvoa de Varzim

tel.: 351 - 52 - 61 45 56
fax: 351 - 52 - 61 89 71

Shopping Cidade do Porto
tel.: 02 - 600 91 70

Póvoa de Varzim
tel.: 052 - 298 0 81

Pr. Galiza - Porto
tel.: 02 - 600 95 05

Braga Shopping
tel.: 053 - 267 0 61

Viacatarina Shopping - Porto
tel.: 02 - 200 36 73

Braga Parque
tel.: 053 - 257 9 31

Arrábida Shopping - Porto
tel.: 02 - 374 54 53

Centro Vasco da Gama
Lisboa
tel.: 01 - 895 13 98

Norte Shopping - Porto
tel.: 02 - 955 98 86

Design Firm
Ricardo Mealha Atelier
Design Estrategico
Art Director
Ricardo Mealha
Designer
Ana Margarida Gunha
Client
Prof
Software/Hardware
Freehand 8.0
Paper/Materials
Martin Paper
Printing
M2 Artes Graficas

Design Firm
be
Art Director
Eric Read
Designer
Eric Read
Client
inhaus industries
Software/Hardware
Adobe Illustrator,
Macintosh

FIELD OF DREAMS
FUTURE OF DIABETICS, INC.

T /937.623.9165
F /740.852.0935

P.O. BOX 442200
2201 S. BREIEL BLVD.
MIDDLETOWN, OH
45044

RONDA **SMITH**
PR/MARKETING DIRECTOR

1

LIVING
BY DESIGN

ANNE PROFFITT

1900 E Shore Avenue
Freeland, WA 98249

P 360.321.4675
e livingbydesign@hotmail.com

2

1
Design Firm
Visual Marketing Associates
Art Directors
Jason Selke, Ken Botts
Designer
Jason Selke
Illustrator
Jason Selke
Client
Future of Diabetics, Inc.
Software/Hardware
Freehand 8.0, Photoshop 5.0
Paper/Materials
Proterra
Printing
Thomas Graphics

2
Design Firm
Girvin
Art Director
Gretchen Cook
Designer
Sam Knight
Illustrator
Gretchen Cook
Client
Living by Design
Software/Hardware
Freehand, Adobe Illustrator 8.0,
Macintosh
Paper/Materials
Strathmore Renewal
Smooth, Calm
Printing
2 Color Offset

Design Firm
 1 Horsepower Design
Designer
 Brian Hurshman
Client
 Self-promotion
Software/Hardware
 Macintosh

Tricia Rauen

TREEHOUSE DESIGN

10627 Youngworth Road
Culver City, CA 90230
310.204.2409 tel
310.204.2517 fax
tr_treehouse @ pacbell.net

Design Firm
 Treehouse Design
Art Director
 Tricia Rauen
Designer
 Tricia Rauen
Illustrator
 Tricia Rauen
Client
 Self-promotion
Software/Hardware
 Adobe Illustrator
Paper/Materials
 Classic Crest Duplex Cover,
 (Saw Grass, Natural White)
Printing
 Typecraft, Inc.

SPIN PRODUCTIONS TORONTO/ATLANTA WWW.SPINPRO.COM
620 KING ST WEST TORONTO ONTARIO CANADA M5V 1M6
TELEPHONE 416 504 8333 FACSIMILE 416 504 3876

CONNIE DERCHO
SENIOR PRODUCER
connie@spinpro.com

SPIN PRODUCTIONS

SPIN PRODUCTIONS TORONTO/ATLANTA WWW.SPINPRO.COM
620 KING ST WEST TORONTO ONTARIO CANADA M5V 1M6
TELEPHONE 416 504 8333 FACSIMILE 416 504 3876

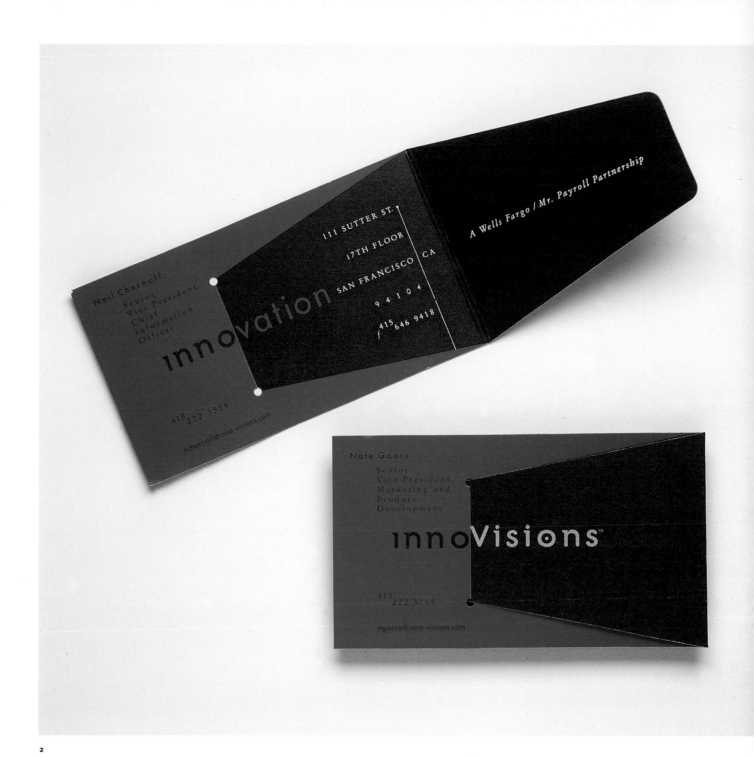

2

1

Design Firm
 Spin Productions
Art Director
 Spin Productions
Designer
 Spin Productions
Illustrator
 Spin Productions
Photographer
 Spin Productions
Client
 Self-promotion
Software/Hardware
 QuarkXpress, Adobe Photoshop,
 Macintosh
Printing
 CJ Graphics

2

Design Firm
 Hornall Anderson
 Design Works
Art Director
 Jack Anderson
Designers
 Jack Anderson, Kathy Saito,
 Alan Copeland
Client
 Wells Fargo "innoVisions"
Software/Hardware
 Freehand, Macintosh
Paper/Materials
 Mohawk Superfine,
 Bright White

**TOWN
HOUSE**
**PROPIEDADES
Y SERVICIOS**

AGUILAR 2436
1426 BUENOS AIRES
TELEFAX: 4780-2200
e-mail: townhouse
@interlink.com.ar

Arq. Abel Trybiarz
Director

**WOHLGEMUTH
TAUBER SA
E M P R E S A
CONSTRUCTORA**

AGUILAR 2436
1426 BUENOS AIRES
TEL.: 4780-2200
e-mail: townhouse
@interlink.com.ar

Daniel Wohlgemuth
Presidente

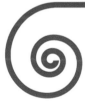

GRUPO TOWN HOUSE

**WAISMAN
TRYBIARZ**
ARQUITECTURA
POR OBJETIVOS

**WOHLGEMUTH
TAUBER S.A.**
E M P R E S A
CONSTRUCTORA

TOWN HOUSE
PROPIEDADES
Y SERVICIOS

Arq. Gerardo Waisman

AGUILAR 2436
1426 BUENOS AIRES
TEL: 4780-2200
e-mail: townhouse
@interlink.com.ar

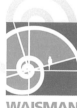

**WAISMAN
TRYBIARZ**
**ARQUITECTURA
POR OBJETIVOS**

AGUILAR 2436
1426 BUENOS AIRES
TEL.: 4780-2200
e-mail: townhouse
@interlink.com.ar

Arq. Abel Trybiarz

1

Design Firm
Estudio Hache S.A.
Designers
Laura Lazzeretti,
Marcelo Varela
Client
Grupo Town House
Software/Hardware
Adobe Illustrator, Macintosh
Paper/Materials
Oreplus 240g
Printing
Bahía Graf SRL

2

Design Firm
Studio Boot
Art Directors
Petra Janssen,
Edwin Vollebergh
Designers
Petra Janssen,
Edwin Vollebergh
Client
Self-promotion
Paper/Materials
MC on 3mm Grey Board
Printing
Full Color and Laminate

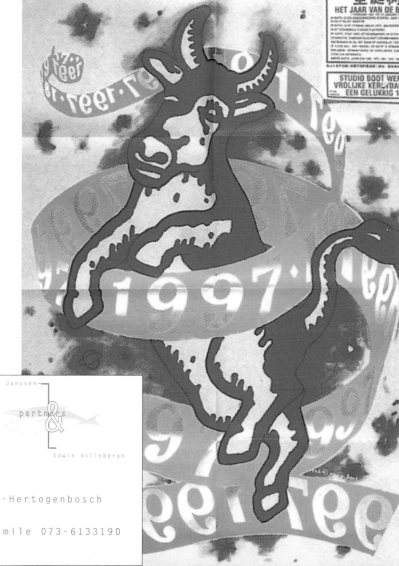

2

Design Firm
Voice Design
Art Director
Clifford Cheng
Designer
Clifford Cheng
Client
Self-promotion
Software/Hardware
Adobe Photoshop,
QuarkXpress, Macintosh
Printing
Offset, 2 Color

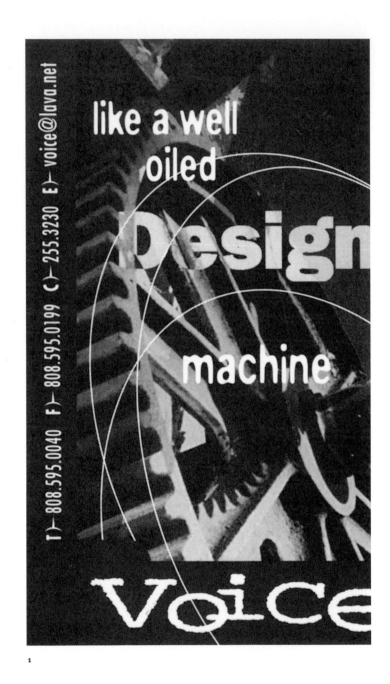

1

TIMBERLINE
INCORPORATED

JAMES CASANOVA

TELEPHONE 505 471 5506 CELLULAR 505 690 9659

PO BOX 633 SANTA FE, NEW MEXICO 87504

timberlineinc@compuserve.com

1

1
Design Firm
 Cisneros Design
Designer
 Eric Griego
Client
 Timberline Inc.
Software/Hardware
 Macintosh
Paper/Materials
 Evergreen
Printing
 Aspen Printing, Albuquerque

2
Design Firm
 Geographics
Designer
 Tanya Doell
Client
 Coyotes Deli & Grill
Software/Hardware
 Adobe Illustrator, Adobe
 Photoshop, QuarkXpress
Paper/Materials
 Genesis Husk
Printing
 3 Spot

2

JobOrder™

maximizing business productivity

Victor Siegle
PRESIDENT

Management Software Inc.
17 Main Street, Suite 313
Cortland, New York 13045
e-mail victor_siegle@joborder.com
Phone 607.**756.4150**
Facsimile 607.756.5550

Design Firm
 Big Eye Creative
Art Director
 Perry Chua
Designers
 Perry Chua, Nancy Yeasting
Client
 Management Software, Inc.
Software/Hardware
 Adobe Illustrator,
 Adobe Photoshop

GROUND
zerø
ROB RINDOS

T 719.955.1100 ext:415
F 719.955.1104
Toll Free: 877.363.8449
CORPORATE OFFICE:
2845 JANITELL ROAD COLORADO SPRINGS COLORADO 80906

www.gzdesign.com

GROUND
ROB RINDOS

rrindos@gzdesign.com

www.gzdesign.com

T 614.764.0227
F 614.764.3796

297 TREE HAVEN NORTH POWELL OHIO 43065

1

Design

Ramona Hutko 4712 South Chelsea Lane 301
 Bethesda Maryland 20814 656 2763

2

1
Design Firm
 Hornall Anderson Design Works
Art Director
 Jack Anderson
Designers
 Kathy Saito, Julie Lock, Ed Lee,
 Heidi Favour, Virginia Le
Client
 Ground Zero
Software/Hardware
 Freehand, Macintosh

2
Design Firm
 Ramona Hutko Design
Art Director
 Ramona Hutko
Designer
 Ramona Hutko
Client
 Self-promotion
Software/Hardware
 QuarkXpress
Paper/Materials
 Mohawk Superfine Cover
Printing
 Bruce Printing

Design Firm
 Skarsgard Design
Designer
 Susan Skarsgard
Hand-lettering
 Susan Skarsgard
Client
 Ann Arbor Street Art Fair
Printing
 Offset 4 Color

Design Firm
 Visser Bay Anders Toscani
Art Director
 Thea Bakker
Designer
 Thea Bakker
Client
 Qi At Vbat
Paper/Materials
 Royal Quadrant High White
 250 gr.

Design Firm
Sayles Graphic Design
Art Director
John Sayles
Designer
John Sayles
Illustrator
John Sayles
Client
Big Daddy Photography
Software/Hardware
Adobe Illustrator 7.0
Paper/Materials
Classic Crest 110 lb. Cover:
Natural White
Printing
Artcraft

Design Firm
Sayles Graphic Design
Art Director
John Sayles
Designer
John Sayles
Illustrator
John Sayles
Client
Barrick Roofing
Software/Hardware
Adobe Illustrator 7.0
Paper/Materials
Classic Crest 100 lb. Cover,
Bright White
Printing
Artcraft

IE DESIGN

[i]e design

13039 VENTURA BLVD
STUDIO CITY, CA 91604
TEL 818 907 8000
FAX 818 907 8830
EMAIL mail@iedesign.net

COREY BAIM
PRINCIPAL/BUSINESS

Design Firm
 [i]e design
Designer
 Marcie Carson
Photographer
 Kevin Merrill
Client
 Self-promotion
Software/Hardware
 Adobe Photoshop,
 QuarkXpress, Macintosh
Paper/Materials
 Esse Paper, 4 Color Tip-in
Printing
 Silver PMS and 4 Color Process

GeoForm Products, LLC
3803 E. 75th Terrace
P.O. Box 320176
Kansas City, MO
64132

GEOFORM
PRODUCTS, LLC

Cell: 816-916-6865

Phone: 816-333-6967

Gale Brattrud
President

Fax: 816-333-6922

Email:
GBrattrud@geoformproducts.com

*Manufacturer of Ashton Bay
Bath & Lighting Accessories*

1

1
Design Firm
 Love Packaging Group
Art Director
 Chris West
Designer
 Lorna West
Illustrator
 Lorna West
Client
 Geoform Products, L.L.C.
Software/Hardware
 Freehand 8.0
Paper/Materials
 White Strathmore 80 lb.
Printing
 Litho Press

2
Design Firm
 Guidance Solutions
Art Director
 Rob Bynder
Designer
 Brad Benjamin
Client
 Self-promotion

guidance solutions

4134 Del Rey Avenue
Marina del Rey, CA 90292
310.754.4000
310.754.4010 fax
www.guidance.com

info@guidance.com

www.guidance.com

2

ANDRESEN

Ben Low
General Manager

T 415.421.2900
F 415.421.5842
P 415.560.2385

ben@planetandresen.com

1500 Sansome St. | Suite 100 | San Francisco | CA 94111
www.planetandresen.com

[service & beyond ™]

1
Design Firm
 be
Art Director
 Will Burke
Designer
 Eric Read
Client
 Andresen
Printing
 Andresen

2
Design Firm
 Atelier Tadeusz Piechura
Art Director
 Tadeusz Piechura
Designer
 Tadeusz Piechura
Client
 Self-promotion
Software/Hardware
 Corel 7
Printing
 Offset

2

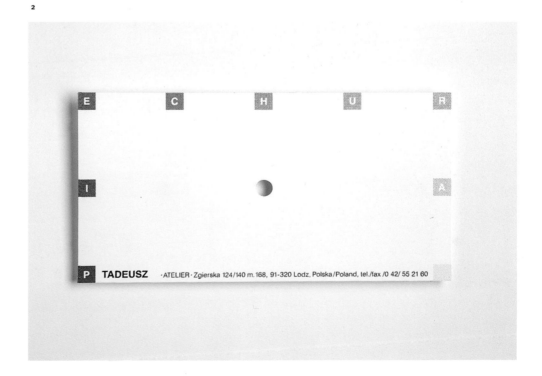

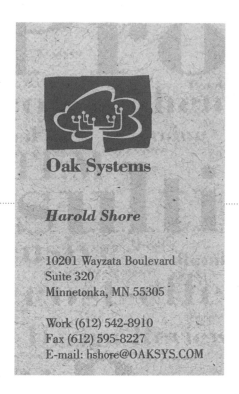

DESIGN FIRM Design Center
ART DIRECTOR John Reger
DESIGNER Sherwin Schwartzrock
CLIENT Oak Systems
TOOLS Macintosh
PAPER/PRINTING Procraft Printing

DESIGN FIRM M-DSIGN
ALL DESIGN Mika Ruusunen
CLIENT Kai Vähäkuopus
TOOLS Macintosh
PAPER/PRINTING Offset

DESIGN FIRM Design Ahead
DESIGNER Ralf Stumpf
CLIENT Ralf Stumpf
TOOLS Macromedia FreeHand, Macintosh

DESIGN FIRM LSL Industries
DESIGNER Elisabeth Spitalny
CLIENT JP Davis & Co.
TOOLS QuarkXPress
PAPER/PRINTING French Newsprint White

DESIGN FIRM Clark Design
ART DIRECTOR Annemarie Clark
DESIGNER Thurlow Washam
CLIENT Sauvage Marketing Group
TOOLS QuarkXPress
PAPER/PRINTING Strathmore Cover

DESIGN FIRM 9 Volt Visuals
ART DIRECTOR/DESIGN Bobby Jones
CLIENT 23 Skateboards
TOOLS Adobe Illustrator
PAPER/PRINTING Twin Concepts

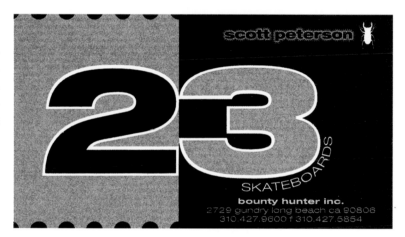

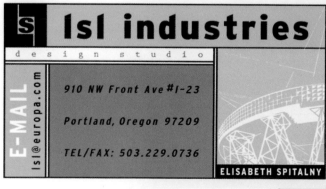

DESIGN FIRM LSL Industries
DESIGNER Elisabeth Spitalny
CLIENT LSL Industries
TOOLS QuarkXPress, Adobe Photoshop
PAPER/PRINTING Encore 130 lb. gloss

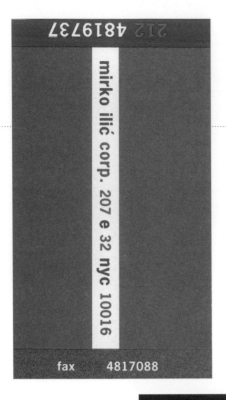

mirko ilić

DESIGN FIRM
Mirko Ilić Corp.
ART DIRECTOR/DESIGNER
Nicky Lindeman
CLIENT
Mirko Ilić Corp.
TOOLS
QuarkXPress
PAPER/PRINTING
Cougar Smooth white 80 lb.
cover/Rob-Win Press

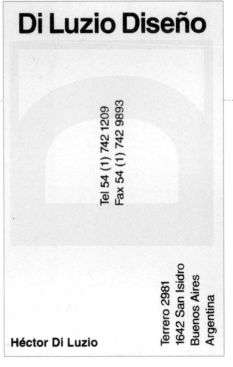

DESIGN FIRM
Di Luzio Diseño
ART DIRECTOR/DESIGNER
Hector Di Luzio
PAPER/PRINTING
Screen-printed

DESIGN FIRM Design Infinitum
ALL DESIGN James A. Smith
CLIENT French Quarter
TOOLS QuarkXPress, Adobe Illustrator

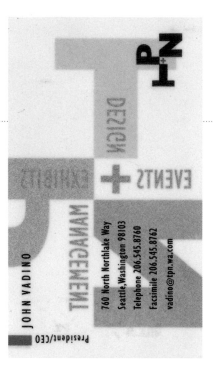
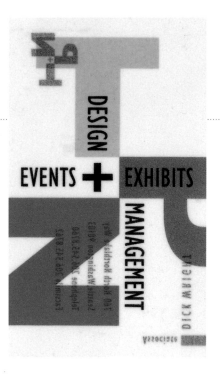

DESIGN FIRM Widmeyer Design
ART DIRECTORS Dale Hart, Tony Secolo
DESIGNER Tony Secolo
ILLUSTRATOR Misha Melikov
CLIENT The Production Network
TOOLS Power Macintosh,
Macromedia FreeHand
PAPER/PRINTING UV Ultra/Offset

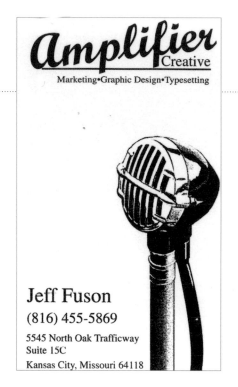
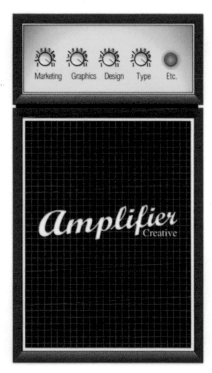

DESIGN FIRM Amplifier Creative
DESIGNER/ILLUSTRATOR Jeff Fuson
CLIENT Amplifier Creative
TOOLS Adobe Photoshop
PAPER/PRINTING Four-color process

DESIGN FIRM Multimedia Asia
ART DIRECTOR G. Lee
ILLUSTRATOR J. E. Jesus
CLIENT Multimedia Asia
TOOLS PageMaker
PAPER/PRINTING Milkweed
Genesis 80 lb./Four-color process

DESIGN FIRM MA&A—Mário Aurélio & Associados
ART DIRECTOR Mário Aurélio
DESIGNERS Mário Aurélio, Rosa Maia
CLIENT Decopaço

DESIGN FIRM Susan Guerra Design
ART DIRECTOR/DESIGNER Susan Guerra
CLIENT Wave Mechanics
TOOLS Adobe Illustrator
PAPER/PRINTING Classic Crest/Two color

DESIGN FIRM Sayles Graphic Design
ART DIRECTOR John Sayles
DESIGNERS John Sayles, Jennifer Elliott
CLIENT Consolidated Correctional Food Service
PAPER/PRINTING Graphika parchment gray riblaid/Offset

DESIGN FIRM Fire House, Inc.
ART DIRECTOR/DESIGNER Gregory R. Farmer
CLIENT Creatures of Habit
TOOLS QuarkXPress, Adobe Photoshop, Macintosh
PAPER/PRINTING Moore Laugen Printing Co.

DESIGN FIRM
Hieroglyphics Art & Design
DESIGNER/ILLUSTRATOR
Christine Osborn Tirotta
PHOTOGRAPHER
John Tirotta
CLIENT
Tirotta Photo Productions
PAPER/PRINTING
Starwhite Vicksburg UV Ultra II

DESIGN FIRM Jeff Fisher Logomotives
ALL DESIGN Jeff Fisher
CLIENT Barrett Rudich, Photographer
TOOLS Macromedia FreeHand
PAPER/PRINTING Fine Arts Graphics

DESIGN FIRM pw design graphics

ART DIRECTOR/DESIGNER Preston Wood

CLIENT pw design graphics

TOOLS Adobe Illustrator

PAPER/PRINTING Domtar Naturals Brick, Neenah Classic Columns Green

4557 46TH AVENUE N.E.
SEATTLE, WASHINGTON 98105

VOICE: 206.527.8286
FAX: 206.524.6641

CARY PILLO LASSEN
ILLUSTRATOR

4557 46TH AVENUE N.E.
SEATTLE, WASHINGTON 98105

VOICE: 206.527.8286
FAX: 206.524.6641

CARY PILLO LASSEN
ILLUSTRATOR

4557 46TH AVENUE N.E.
SEATTLE, WASHINGTON 98105

VOICE: 206.527.8286
FAX: 206.524.6641

CARY PILLO LASSEN
ILLUSTRATOR

4557 46TH AVENUE N.E.
SEATTLE, WASHINGTON 98105

VOICE: 206.527.8286
FAX: 206.524.6641

CARY PILLO LASSEN
ILLUSTRATOR

DESIGN FIRM
Belyea Design Alliance
ART DIRECTOR
Patricia Belyea
DESIGNER
Tim Ruszel
ILLUSTRATOR
Cary Pillo Lassen
CLIENT
Cary Pillo Lassen

F. KENNITH NIXON

President

MENDENHALL LABORATORIES, LLC

1042 MINERAL WELLS AVE.

PARIS, TN 38242

TEL 901-642-9321

1-800-642-9321

FAX 901 644 2398

DESIGN FIRM
Greteman Group
ART DIRECTORS/DESIGNERS
Sonia Greteman, James Strange
CLIENT
Delux
TOOLS
Macromedia FreeHand
PAPER/PRINTING
Cougar white/Two-color offset

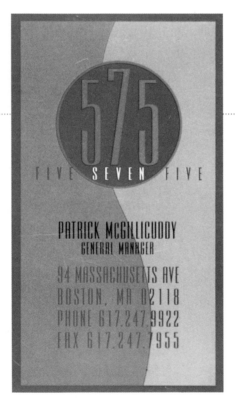

DESIGN FIRM On The Edge
ART DIRECTOR/ILLUSTRATOR Jeff Gasper
DESIGNER Gina Mims
CLIENT Five Seven Five
TOOLS Adobe Illustrator, QuarkXPress
PAPER/PRINTING Karma Natural

HAIKU/Hi-ku/n,:
An unrhymed poem or verse of three lines containing usually (but not necessarily) five, seven, and five syllables respectively.

Haiku was born in 17th century Japan. It was adopted by New York and San Francisco beat poets in the 50's with the publication of Kerouac's "Dharma Bums".

One writes a haiku to recreate an intimate moment and communicate the feelings it inspired to another.

DESIGN FIRM Bluestone Design
ART DIRECTOR Ian Gunningham
ILLUSTRATOR Symon Sweet
TOOLS Macintosh
PAPER/PRINTING Silkscreen on PVC, opaque varnish

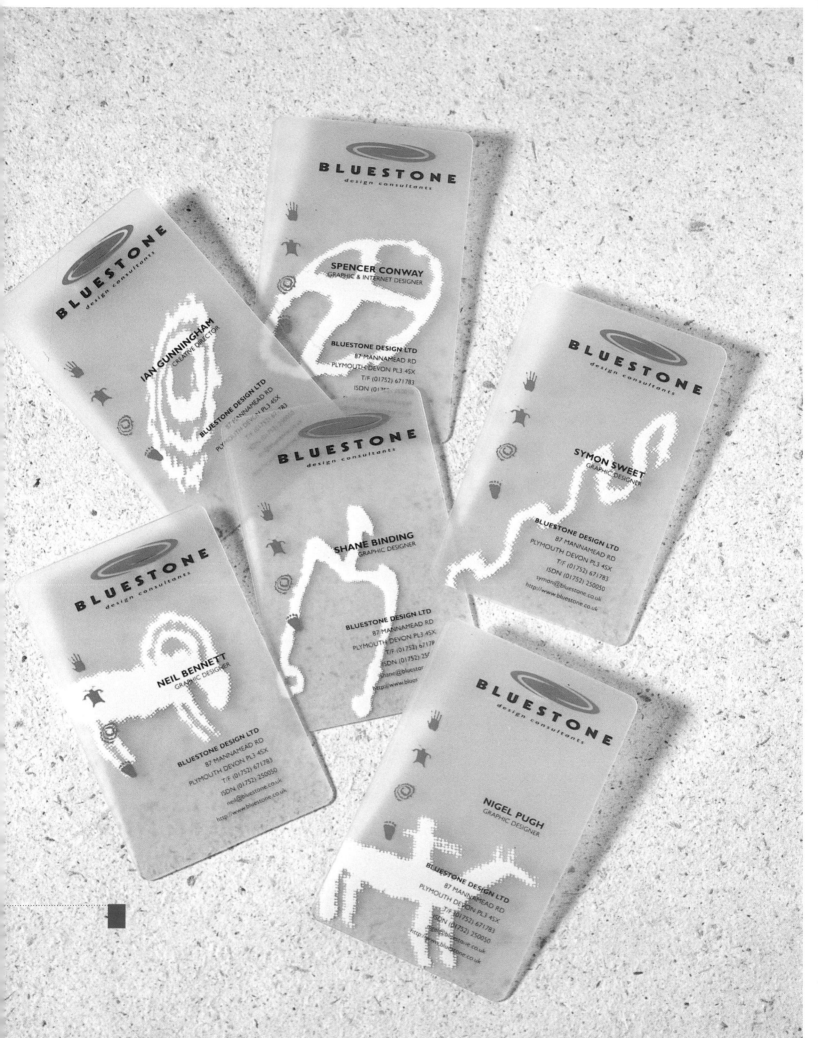

DESIGN FIRM
Hieroglyphics Art & Design
DESIGNER/ILLUSTRATOR
Christine Osborn Tirotta
CLIENT
Hieroglyphics Art & Design
PAPER/PRINTING
Fox River Confetti

DESIGN FIRM Elena Design
ALL DESIGN Elena Baca
CLIENT InterCity Services
TOOLS Adobe Illustrator,
QuarkXPress

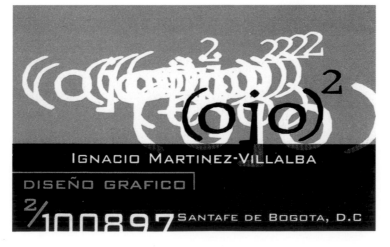

DESIGN FIRM (ojo)2
ALL DESIGN Ignacio Martinez-Villalba
CLIENT (ojo)2
TOOLS Macintosh
PAPER/PRINTING Opaline/Offset

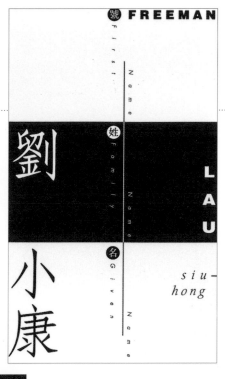

DESIGN FIRM
Kan & Lau Design Consultants
ART DIRECTOR/DESIGNER
Freeman Lau Siu Hong
CLIENT
Freeman Lau Siu Hong
PAPER/PRINTING
Conqueror Diamond White
250 gsm/Offset

DESIGN FIRM
Greteman Group
ART DIRECTORS/DESIGNERS
Sonia Greteman, James Strange
ILLUSTRATORS
James Strange, Sonia Greteman
CLIENT
Furniture Options
PAPER/PRINTING
Speckletone/Offset

DESIGN FIRM Stephen Peringer Illustration
DESIGNER/ILLUSTRATOR Stephen Peringer
CLIENT Paul Mader/DreamWorks
TOOLS Adobe Photoshop, pen, ink
PAPER/PRINTING LaValle Printing

DESIGN FIRM LSL Industries
DESIGNER Franz M. Lee
CLIENT LSL Industries
TOOLS QuarkXPress, Adobe Photoshop
PAPER/PRINTING Encore 130 lb. gloss

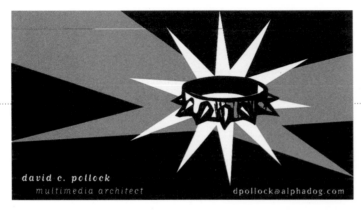

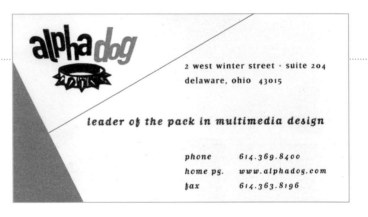

DESIGN FIRM Tanagram
ART DIRECTOR Lance Rutter
DESIGNER David Kaplan
CLIENT Alpha Dog
TOOLS Macromedia FreeHand,
Adobe Streamline
PAPER/PRINTING Strathmore Elements

DESIGN FIRM Mirko Ilić Corp.
ART DIRECTOR/DESIGNER Nicky Lindeman
CLIENT La Paella Restorante
TOOLS Adobe Illustrator
PAPER/PRINTING Cougar 80 lb. white smooth
cover/Rob-Win Press

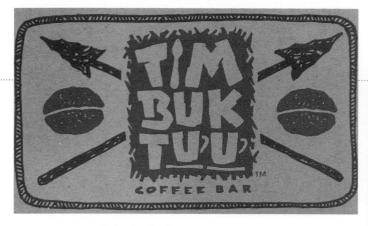

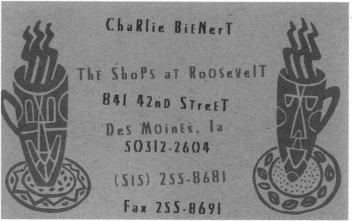

DESIGN FIRM Sayles Graphic Design

ALL DESIGN John Sayles

CLIENT Timbuktuu Coffee Bar

PAPER/PRINTING Cross Pointe Genesis copper/Offset

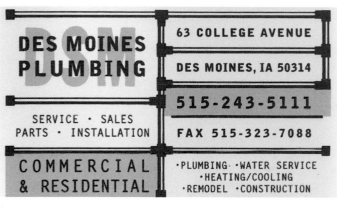

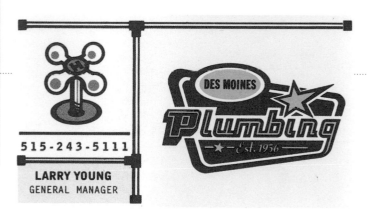

DESIGN FIRM Sayles Graphic Design

ALL DESIGN John Sayles

CLIENT Des Moines Plumbing

PAPER/PRINTING Neenah Classic Crest gray/Offset

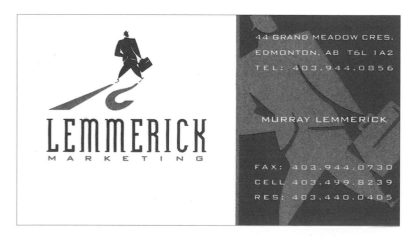

DESIGN FIRM Duck Soup Graphics

ART DIRECTOR/DESIGNER William Doucette

CLIENT Lemmerick Marketing

TOOLS Macromedia FreeHand, QuarkXPress

PAPER/PRINTING Classic Columns/
Two match colors

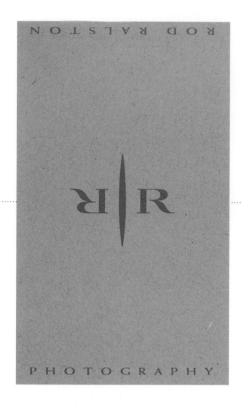

DESIGN FIRM Hornall Anderson
Design Works, Inc.
ART DIRECTOR Jack Anderson
DESIGNERS Jack Anderson, Julie
Keenan, Mary Chin Hutchinson
ILLUSTRATOR George Tanagi
CLIENT Rod Ralston Photography
TOOLS Macromedia FreeHand

DESIGN FIRM Gini Chin Graphics
ART DIRECTOR/DESIGNER Gini Chin
CLIENT 24.7 Marketing Bloc, Inc.
TOOLS Adobe Photoshop, QuarkXPress
PAPER/PRINTING Classic Crest

DESIGN FIRM Greteman Group
ART DIRECTORS/DESIGNERS Sonia Greteman, James Strange
CLIENT Grant Telegraph Centre
TOOLS Macromedia FreeHand
PAPER/PRINTING Genesis, Sticker/Three-color offset

DESIGN FIRM
Insight Design Communications
ART DIRECTORS/DESIGNERS
Sherrie Holdeman, Tracy Holdeman
CLIENT
Insight Design Communications
TOOLS
Power Macintosh 7500,
Macromedia FreeHand, Adobe Photoshop
PAPER/PRINTING
Dull Enamel Coat 65 lb. cover

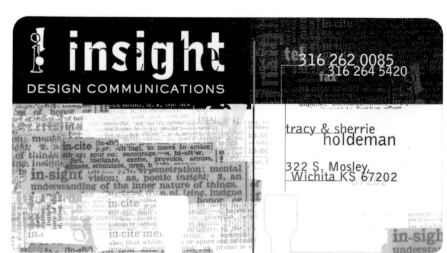
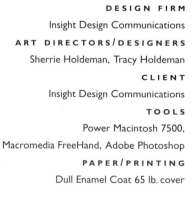

christian tours

post office box 447 blue mountain, ms 38610

barry goolsby
cruise consultant

telephone 800 505 tour facsimile 601 685 9066

DESIGN FIRM David Carter Design
ART DIRECTOR Lori B. Wilson
DESIGNER/ILLUSTRATOR Tracy Huck
CLIENT Christian Tours

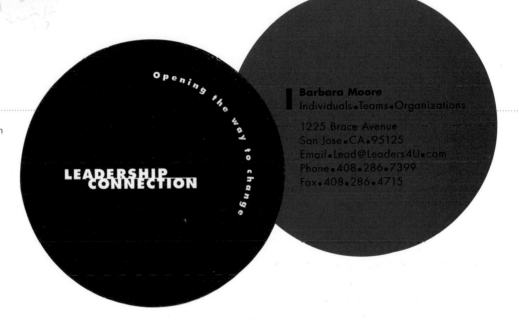

DESIGN FIRM Melissa Passehl Design
ART DIRECTOR Melissa Passehl
DESIGNERS Melissa Passehl,
Charlotte Lambrechts
CLIENT Leadership Connection

Opening the way to change

LEADERSHIP CONNECTION

Barbara Moore
Individuals•Teams•Organizations

1225 Brace Avenue
San Jose•CA•95125
Email•Lead@Leaders4U•com
Phone•408•286•7399
Fax•408•286•4715

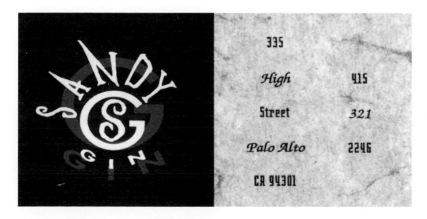

335
High 415
Street 321
Palo Alto 2246
CA 94301

DESIGN FIRM Sandy Gin Design
DESIGNER/ILLUSTRATOR Sandy Gin
CLIENT Sandy Gin Design
TOOLS Macromedia FreeHand
PAPER/PRINTING Simpson Evergreen
80 lb. cover/One-color offset

Post Office Box 781234
Wichita, KS 67278-1234
316.634.6887

DESIGN FIRM Greteman Group
ART DIRECTOR/ILLUSTRATOR Sonia Greteman
DESIGNERS Sonia Greteman, Craig Tomison
CLIENT Amphora
TOOLS Macromedia FreeHand
PAPER/PRINTING Genesis Script/Two-color offset

DESIGN FIRM
Siebert Design Associates
ART DIRECTOR Lori Siebert
DESIGNERS Lori Siebert,
Lisa Ballard
CLIENT Scott Hull Associates
PAPER/PRINTING Starwhite
Vicksburg/Arnold Printing

DESIGN FIRM Insight Design Communications
ART DIRECTORS/DESIGNERS
Sherrie Holdeman, Tracy Holdeman
CLIENT Kendall McMinimy Photography
TOOLS Power Macintosh 7500,
Macromedia FreeHand
PAPER/PRINTING French Speckletone Straw

DESIGN FIRM Michelle Bowers
TOOLS Adobe Photoshop, Macromedia FreeHand

DESIGN FIRM
Icehouse Design
ART DIRECTOR
Pattie Belle Hastings
DESIGNER Bjorn Akselsen
CLIENT Graebel Fine Art
TOOLS Power Macintosh 8100

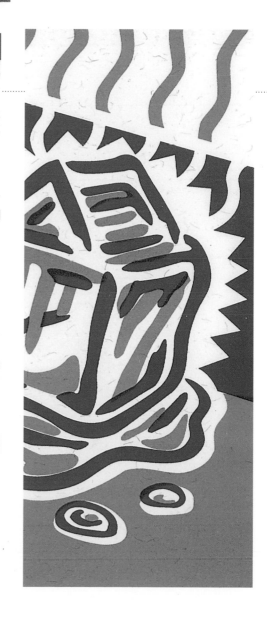

HIGH OCTANE DESIGN

HIGH OCTANE DESIGN

www.commonlink.com\users\zanesroot\default.html

OCTANE DESIGN

OCTANE DESIGN

OCTANE DESIGN

G

Angeline Beckley
DESIGNER

GASOLINE
GRAPHIC DESIGN

5704 COLLEGE AVENUE
DES MOINES, IOWA 50310
PH./FAX (515) 255-7095
GASGRAPHICS@COMMONLINK.COM

DESIGN FIRM Gasoline Graphic Design
ART DIRECTORS/DESIGNERS Zane Vredenburg, Angeline Beckley
TOOLS Adobe Illustrator, Adobe Streamline,
QuarkXPress, Adobe Photoshop
PAPER/PRINTING Neenah/Alpaca Christian Printers

WaterWorks

The Tavern

Summer House

The Oyster Bar

La Bodega

Eating Up The Coast, Inc.

Phil Cocco
Director of Operations

333 Victory Road, Marina Bay, Quincy, MA 02171
617- 786-9600 • Fax 617-786-0700

DESIGN FIRM Flaherty Art & Design
ALL DESIGN Marie Flaherty
CLIENT Eating Up The Coast
TOOLS Adobe Illustrator

DESIGN FIRM Sagmeister, Inc.
ART DIRECTOR Stefan Sagmeister
DESIGNERS Veronica Oh, Stefan Sagmeister
PHOTOGRAPHER Michael Grimm
CLIENT Toto
PAPER/PRINTING Strathmore Writing 25% cotton

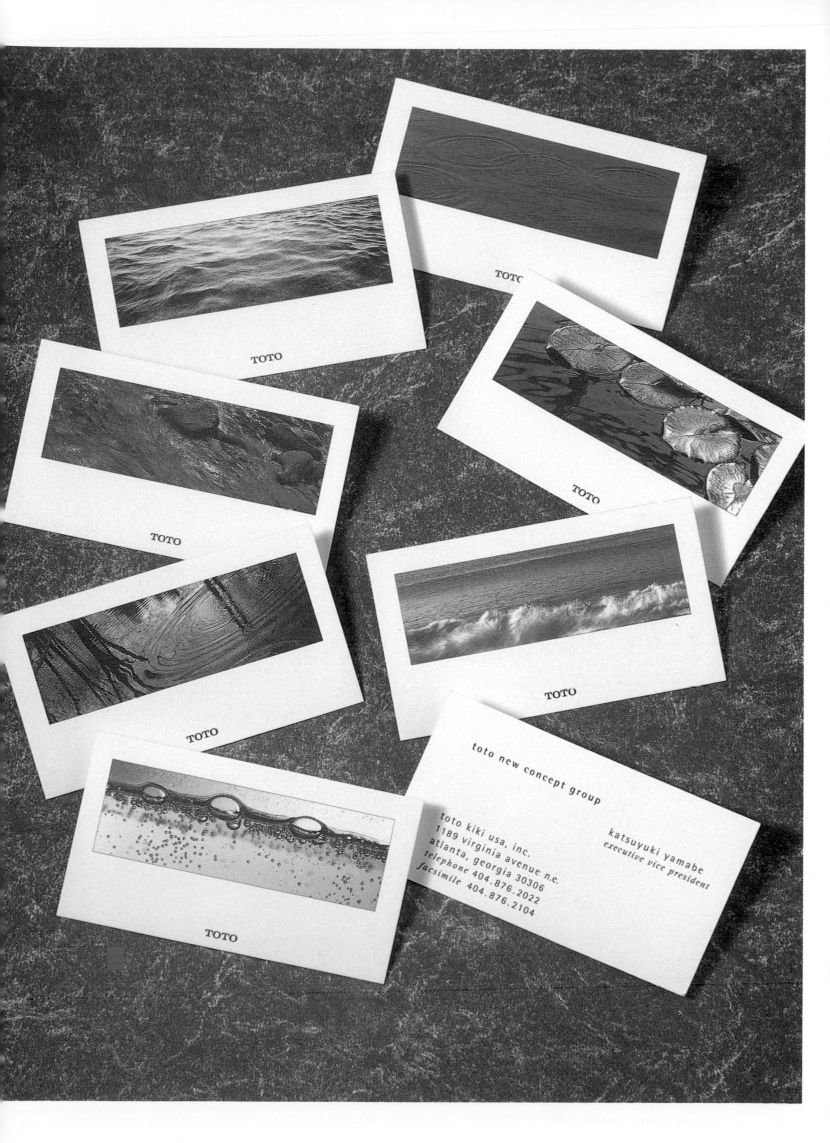

Ⓕ343.5116 Ⓣ206.343.7170 **DALE HART**

Ⓕ343.5116 Ⓣ206.343.7170 **KEN WIDMEYER**

Ⓕ343.5116 Ⓣ206.343.7170 **KEN WIDMEYER**

Ⓕ343.5116 Ⓣ206.343.7170 **ANTHONY SECOLO**

911 WESTERN #305 SEATTLE WA 98104 **WIDMEYERDESIGN**

DESIGN FIRM Widmeyer Design
ALL DESIGN Ken Widmeyer, Dale Hart, Tony Secolo
CLIENT Widmeyer Design
TOOLS Power Macintosh, Adobe Photoshop, Macromedia FreeHand
PAPER/PRINTING Stonehenge 100% cotton/Offset

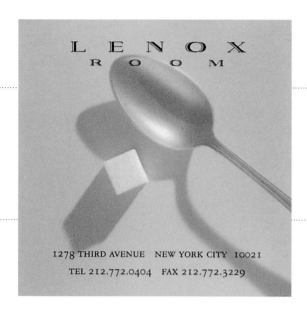

LENOX
R O O M

1278 THIRD AVENUE NEW YORK CITY 10021

TEL 212.772.0404 FAX 212.772.3229

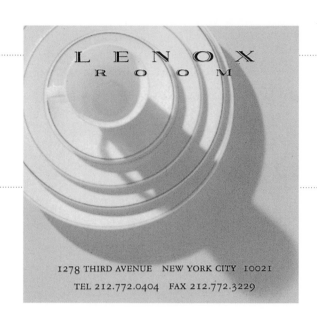

LENOX
R O O M

1278 THIRD AVENUE NEW YORK CITY 10021

TEL 212.772.0404 FAX 212.772.3229

TIP WELL AND PROSPER

LENOX
R O O M

1278 THIRD AVENUE NEW YORK CITY 10021

TEL 212.772.0404 FAX 212.772.3229

LENOX
R O O M

CHARLIE PALMER

1278 THIRD AVENUE NEW YORK CITY 10021

TEL 212.772.0404 FAX 212.772.3229

WWW.LENOXROOM.COM

DESIGN FIRM Aerial
ART DIRECTOR/DESIGNER Tracy Moon
PHOTOGRAPHER R. J. Muna
CLIENT Lenox Room Restaurant
TOOLS Adobe Photoshop, QuarkXPress

DESIGN FIRM Flaherty Art & Design
ALL DESIGN Marie Flaherty
CLIENT Grafton Street
TOOLS Adobe Illustrator

DESIGN FIRM Sagmeister, Inc.
ALL DESIGN Stefan Sagmeister
CLIENT Frank's Disaster Art
PAPER/PRINTING Strathmore Writing 25% cotton

DESIGN FIRM Insight Design Communications
ART DIRECTORS/DESIGNERS Sherrie Holdeman, Tracy Holdeman
CLIENT Clotia
TOOLS Power Macintosh 7500, Macromedia FreeHand, Adobe Photoshop
PAPER/PRINTING French Speckletone Oatmeal 80 lb. cover

DESIGN FIRM Sandy Gin Design
DESIGNER/ILLUSTRATOR Sandy Gin
CLIENT Sandy Gin Design
TOOLS Macromedia FreeHand
PAPER/PRINTING Simpson Starwhite Vicksburg
110 lb. cover/Two-color offset

DESIGN FIRM Stowe Design
ART DIRECTOR/DESIGNER Jodie Stowe
CLIENT Whizdom
PAPER/PRINTING Aztec Printing

DESIGN FIRM
pw design graphics
ART DIRECTOR/DESIGNER
Preston Wood
CLIENT
Fathomworks Industries, Inc.
TOOLS
Adobe Illustrator
PAPER/PRINTING
Domtar Naturals Wicker Brick

DESIGN FIRM Sayles Graphic Design
ALL DESIGN John Sayles
CLIENT Lazarus Corporation
PAPER/PRINTING Curtis Tuscan Terra,
Pacific blue/Offset

DESIGN FIRM Katie Van Luchene & Associates
ART DIRECTOR Katie Van Luchene
DESIGNERS Katie Van Luchene, Jan Tracy
ILLUSTRATOR Jan Tracy
CLIENT Katie Van Luchene
TOOLS Macromedia FreeHand, QuarkXPress
PAPER/PRINTING Zellerbach 90 lb. Riblaid/
Black and spot color

DESIGN FIRM Rick Eiber Design (RED)
ART DIRECTOR/DESIGNER Rick Eiber
CLIENT Lanie Riley
TOOLS Debossing Die
PAPER/PRINTING Two colors over one, watercolor crayon

DESIGN FIRM Charney Design
ALL DESIGN Carol Inez Charney
CLIENT Jeanie Maceri
TOOLS QuarkXPress, Adobe Photoshop
PAPER/PRINTING Vintage/Offset

DESIGN FIRM Jill Morrison Design
ALL DESIGN Jill Morrison
CLIENT A Show of Hands
TOOLS Adobe Photoshop, Macromedia
FreeHand, QuarkXPress
PAPER/PRINTING Two color

DESIGN FIRM Prestige Design
ALL DESIGN Sarah Harris
CLIENT Creative Surfaces
TOOLS Adobe Illustrator, Adobe
Photoshop, QuarkXPress
PAPER/PRINTING Speckletone
Oatmeal/One PMS

APPLICATORS OF CONCRETE STAIN
SPECIALIZING IN UNIQUE DESIGNS

SARAH HARRIS
ARTIST

602 JOHNS DRIVE
EULESS, TX 76039
METRO 817.540.1560
FAX 817.540.1680
VM/PAGER 817.858.1510

CREATIVE SURFACES

SIERRA SUITES℠
Stay Awhile℠

Sierra Suites Hotel
2010 Powers Ferry Road
Atlanta, Georgia 30339
Tel 770-933-8010
Fax 770-933-8181
For Reservations
Tel 800-474-3772

Maura Dube
Assistant Manager

DESIGN FIRM Greteman Group
ART DIRECTOR Sonia Greteman
DESIGNERS Sonia Greteman, James Strange
CLIENT Sierra Suites
TOOLS Macromedia FreeHand
PAPER/PRINTING Passport/Two-color offset

Hard Drive Design Inc.

260 King Street East

Suite 204 B

Toronto Ontario

Canada M5A 4L5

T 416 363 9902

F 416 363 1705

e hddesign@istar.ca

MAUREEN
bradshaw

DESIGN FIRM Hard Drive Design
ART DIRECTOR Maureen Bradshaw
DESIGNERS Eymard Angulo, Maureen Bradshaw
CLIENT Hard Drive Design
TOOLS QuarkXPress
PAPER/PRINTING Domtar Naturals
Jute 80 lb. cover

DESIGN FIRM
Angry Porcupine Design
DESIGNER/ILLUSTRATOR
Cheryl Roder-Quill
CLIENT
QV Design
TOOLS
Macintosh, QuarkXPress
PAPER/PRINTING
Strathmore Script/Two color

DESIGN FIRM Bartels & Company, Inc.
ART DIRECTOR David Bartels
DESIGNER/ILLUSTRATOR Brian Barclay
CLIENT A-Train Jazz Cafe
PAPER/PRINTING DeVere Printing

DESIGN FIRM Design Ahead
DESIGNER Ralf Stumpf
CLIENT Detlef Odenhausen
TOOLS Macromedia FreeHand, Macintosh

SHAWNA

YOUR NEXT APPOINTMENT

This time is reserved exclusively for you. 24 hours notice is appreciated if you are unable to keep your appointment.

DESIGN FIRM Greteman Group
ART DIRECTOR/DESIGNER Sonia Greteman
CLIENT Eric Fisher Salon
TOOLS Macromedia FreeHand
PAPER/PRINTING Genesis/Two-color offset

DESIGN FIRM Design Ahead
DESIGNER Ralf Stumpf
CLIENT Fiction Factory
TOOLS Macromedia FreeHand, Macintosh

DESIGN FIRM Michael Stanard Design, Inc.
ART DIRECTOR Michael Stanard
DESIGNERS Marc C. Fuhrman, Kristy
Vandekerckhove
CLIENT Lionel Trains
PAPER/PRINTING Strathmore Bright
White/Engraved, offset

Barbara Pyle
Board Member

Captain Planet Foundation
One CNN Center
Atlanta GA 30303
Phone 404 827 1918
Fax 404 827 4292
Internet: barbara.pyle@turner.com

Printed with vegetable based inks on 100% recycled paper

DESIGN FIRM Icehouse Design
ART DIRECTOR Pattie Belle Hastings
DESIGNER Bjorn Akselsen
ILLUSTRATOR Turner Broadcasting
System inhouse
CLIENT TBS
TOOLS Power Macintosh 8100
PAPER/PRINTING Benefit Natural Flax

DESIGN FIRM Cahoots
ART DIRECTOR Carol Lasky
DESIGNER Erin Donnellan
ILLUSTRATORS Bill Mayers, Mark Allen
CLIENT Cahoots
TOOLS Adobe Illustrator, QuarkXPress
PAPER/PRINTING Strathmore Elements/The Ink Spot

Where Design and Marketing Fly

DESIGN FIRM Fordesign
ALL DESIGN Frank Ford
TOOLS Adobe Illustrator, Macromedia
Fontographer, Macromedia FreeHand,
Adobe Photoshop
PAPER/PRINTING
Various papers/Aluminum printing plate

DESIGN FIRM Sayles Graphic Design
ALL DESIGN John Sayles
CLIENT Cutler Travel Marketing
PAPER/PRINTING Curtis Brightwater riblaid slate/Offset

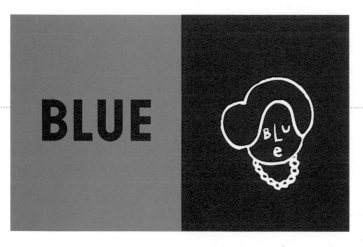

DESIGN FIRM Sagmeister, Inc.
ART DIRECTOR Stefan Sagmeister
DESIGNERS Stefan Sagmeister, Eric Zim
ILLUSTRATOR Stefan Sagmeister
CLIENT Blue Fashion Retail
PAPER/PRINTING Strathmore Writing 25% cotton

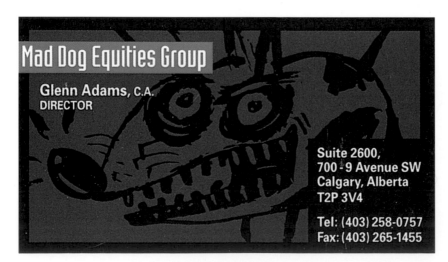

DESIGN FIRM Black Letter Design, Inc.
ART DIRECTOR/DESIGNER Ken Bessie
ILLUSTRATOR Rick Sealock
CLIENT Mad Dog Equities Group
TOOLS Adobe Illustrator, QuarkXPress
PAPER/PRINTING Expression Iceberg/Offset

DESIGN FIRM Gillis & Smiler

ART DIRECTORS/DESIGNERS Cheryl Gillis, Ellen Smiler

CLIENT Gillis & Smiler

TOOLS Adobe Illustrator

PAPER/PRINTING Neenah Classic Crest 3/1

DESIGN FIRM Icehouse Design

ART DIRECTOR Pattie Belle Hastings

DESIGNER Bjourn Akselsen

CLIENT Graebel Fine Art

TOOLS Power Macintosh 8100

DESIGN FIRM Design Ahead

DESIGNER Ralf Stumpf

CLIENT Digital Audio Design

TOOLS Macromedia FreeHand, Macintosh

DESIGN FIRM Storm Design &
Advertising Consultancy
ART DIRECTORS/DESIGNERS Dean Butler,
David Ansett
ILLUSTRATOR Dean Butler
CLIENT Printelligent People
TOOLS Adobe Photoshop
PAPER/PRINTING Three PMS colors, Saxton
Smoothe, special varnish/Embossed

$$PP = MG^2$$

PRINTELLIGENT
PEOPLE

Garry Furzer

SUITE ONE, 20
COMMERCIAL RD
MELBOURNE 3004
PH: 03) 9866 4966
FAX: 03) 9866 4164
MOBILE 018 352 827

DESIGN FIRM Design Ahead
DESIGNER Theo Decker
CLIENT Frank Buchheister
TOOLS Macromedia FreeHand, Macintosh

DESIGN FIRM Kiku Obata & Company
ART DIRECTOR Pam Bliss
DESIGNER John Schetel
CLIENT Plaza Frontenac
PAPER/PRINTING Reprox

DESIGN FIRM Gackle Anderson Henningsen, Inc.
DESIGNER Jason Bramer
CLIENT Gackle Anderson Henningsen, Inc.
TOOLS QuarkXPress, Adobe Illustrator

655 Fort Street
Victoria BC
v8w 1g6

PH 250.382.8838
FX 250.382.8878

Michael
Burr, CCIM
PRESIDENT

DESIGN FIRM Suburbia Studios
ART DIRECTOR Russ Williams
DESIGNER/ILLUSTRATOR Jeremie White
CLIENT Burr Properties Ltd.
TOOLS Adobe Illustrator, QuarkXPress
PAPER/PRINTING Classic Columns/Two
color one side, one color one side

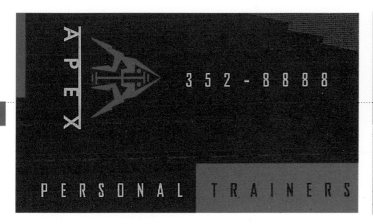

DESIGN FIRM Greteman Group
ART DIRECTOR Sonia Greteman
DESIGNERS Sonia Greteman, James Strange
CLIENT Apex
TOOLS Macromedia FreeHand
PAPER/PRINTING Genesis/Two-color offset

DESIGN FIRM Bruce Yelaska Design
ART DIRECTOR/DESIGNER Bruce Yelaska
CLIENT La Rotonda sul Mare
TOOLS Adobe Illustrator
PAPER/PRINTING Strathmore Writing/Offset

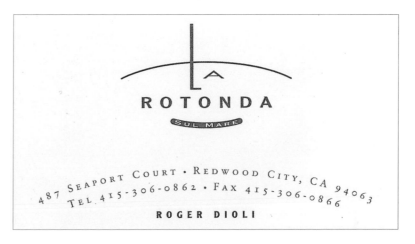

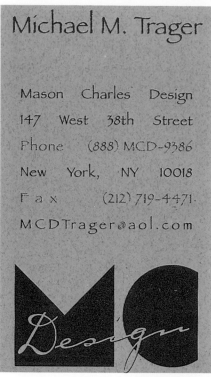

DESIGN FIRM
Mason Charles Design
ART DIRECTOR/DESIGNER
Jeffrey Speiser
CLIENT
Mason Charles Design
TOOLS
QuarkXPress,
Adobe Illustrator
PAPER/PRINTING
Neenah Classic Columns Duplex
cover flat/Foil

DESIGN FIRM
Foco Media Digital Media Design &
Production GmbH. & Cie.
ART DIRECTOR/DESIGNER
Steffen Janus
CLIENT
Foco Media Digital Media Design &
Production GmbH. & Cie.
TOOLS
Adobe Photoshop, QuarkXPress
PAPER/PRINTING
Luxosatin 300gsm; Two-color offset

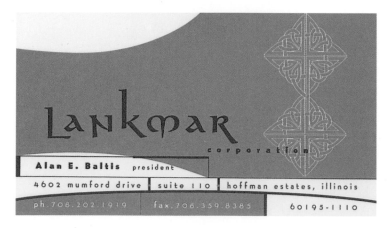

DESIGN FIRM Tanagram
DESIGNER/ILLUSTRATOR Anthony Ma
CLIENT Lankmar Corp.
TOOLS Macromedia FreeHand

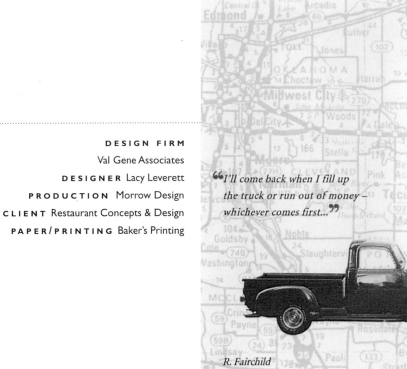

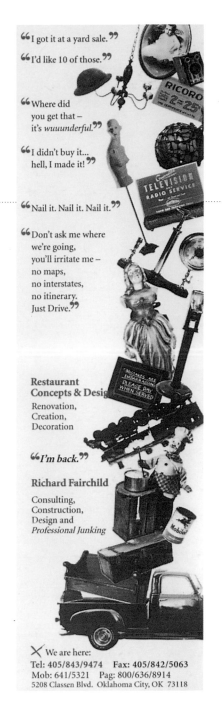

DESIGN FIRM
Val Gene Associates
DESIGNER Lacy Leverett
PRODUCTION Morrow Design
CLIENT Restaurant Concepts & Design
PAPER/PRINTING Baker's Printing

DESIGN FIRM Tracy Design
ART DIRECTOR Jan Tracy
DESIGNERS Jan Tracy, Jason Lilly
CLIENT Tracy Design
PAPER/PRINTING Black on Duplex "Environment"

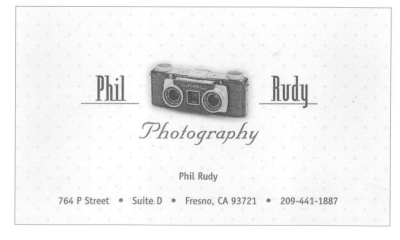

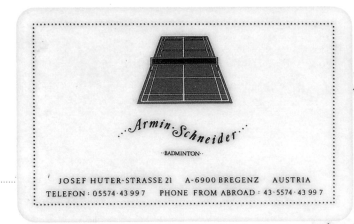

DESIGN FIRM Sagmeister, Inc.

ALL DESIGN Stefan Sagmeister

CLIENT Armin Schneider

PAPER/PRINTING Strathmore Writing 25% cotton

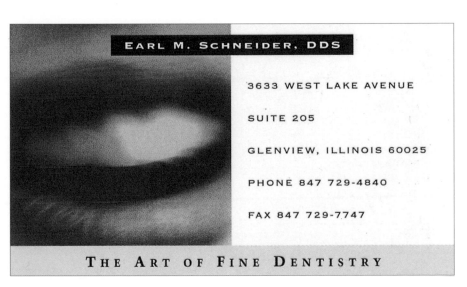

DESIGN FIRM
Borchew Design Group, Inc.

ART DIRECTOR/DESIGNER
Anne Bahan

CLIENT
Earl Schneider, DDS

TOOLS
QuarkXPress, Adobe Photoshop

PAPER/PRINTING
Neenah Classic Columns

DESIGN FIRM Gardiner & Nobody, Inc.

ART DIRECTOR/DESIGNER Diana Gardiner

CLIENT Gardiner & Nobody, Inc.

TOOLS QuarkXPress, Adobe Illustrator

PAPER/PRINTING Strathmore Writing

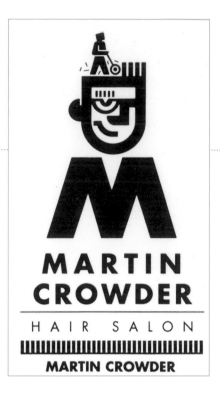

DESIGN FIRM Sayles Graphic Design
ALL DESIGN John Sayles
CLIENT Martin Crowder Hair Salon
PAPER/PRINTING Springhill tag coated one side/Offset

DESIGN FIRM Vrontikis Design Office
ART DIRECTOR Petrula Vrontikis
DESIGNER Kim Sage
CLIENT Resolve Consulting
PAPER/PRINTING Neenah Classic Crest

DESIGN FIRM Vrontikis Design Office
ART DIRECTOR Petrula Vrontikis
DESIGNER Samuel Lising
CLIENT Greenhold and Company
PAPER/PRINTING Duratone/rubber stamp
and laser printing

DESIGN FIRM Design Ahead
DESIGNER Ralf Stumpf
CLIENT Fritzen & Partner
TOOLS Macromedia FreeHand, Macintosh

DESIGN FIRM MA&A—Mário Aurélio & Associados
ART DIRECTOR Mário Aurélio
DESIGNERS Mário Aurélio, Rosa Maia
CLIENT Rui Soares Esteves/Fotografia

6170 Cornerstone Court East, Suite 380 San Diego, CA 92121
ph:619 622 1411 fx:619 622 1214 e-mail:csimunec@verdestyle.com
http://www.verdestyle.com

Cindy Simunec
Vice President, Sales and Marketing

DESIGN FIRM Mires Design
ART DIRECTOR John Ball
DESIGNERS John Ball, Miguel Perez
CLIENT Verde Communications

DESIGN FIRM Mires Design
ART DIRECTOR John Ball
DESIGNERS John Ball, Miguel Perez
CLIENT Mires Design
PAPER/PRINTING Gilbert Correspond
heavy watercolor board

MIRES DESIGN INC

2345 KETTNER BLVD SAN DIEGO CA 92101

PHONE: 619 234 6631 FAX: 619 234 1807

E MAIL: MIRES@MIRESDESIGN.COM

SCOTT MIRES

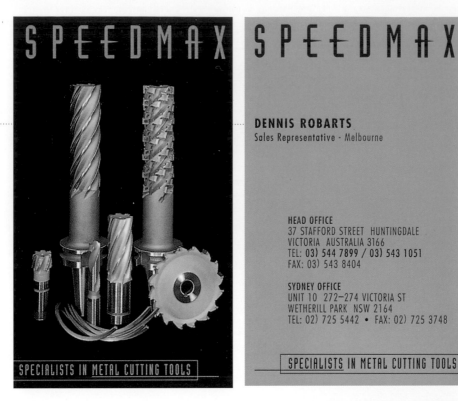

DENNIS ROBARTS
Sales Representative - Melbourne

HEAD OFFICE
37 STAFFORD STREET HUNTINGDALE
VICTORIA AUSTRALIA 3166
TEL: 03) 544 7899 / 03) 543 1051
FAX: 03) 543 8404

SYDNEY OFFICE
UNIT 10 272–274 VICTORIA ST
WETHERILL PARK NSW 2164
TEL: 02) 725 5442 • FAX: 02) 725 3748

SPECIALISTS IN METAL CUTTING TOOLS

DESIGN FIRM
Mammoliti Chan Design
ART DIRECTOR/DESIGNER
Tony Mammoliti
CLIENT Speeedmax
TOOLS Adobe Illustrator, QuarkXPress
PAPER/PRINTING Four-color plus
two PMS reverse

DESIGN FIRM Greteman Group
ART DIRECTOR Sonia Greteman
DESIGNERS Sonia Greteman, James Strange
CLIENT Greteman Group
TOOLS Macromedia FreeHand
PAPER/PRINTING Conquest/Two-color offset

DESIGN FIRM Nancy Yeasting Design & Illustration
ALL DESIGN Nancy Yeasting
CLIENT Zoey Ryan
TOOLS Brush, QuarkXPress
PAPER/PRINTING Genesis husk/One color

DESIGN FIRM
The Design Company
ART DIRECTOR
Marcia Romanuck
DESIGNER/ILLUSTRATOR
Alison Scheel
CLIENT
Snelling Real Estate
PAPER/PRINTING
Champion Carnival 80 lb. Ivory

DESIGN FIRM Cahoots
ART DIRECTOR Carol Lasky
DESIGNERS Kerri Bennett, Laura Herrmann
ILLUSTRATOR Richard Goldberg
CLIENT Sandra Kimball Photography
TOOLS Macromedia FreeHand, QuarkXPress
PAPER/PRINTING Curtis Brightwater

DESIGN FIRM Sagmeister, Inc.
ART DIRECTOR/DESIGNER
Stefan Sagmeister
ILLUSTRATOR Veronica Oh
CLIENT Aguilar
PAPER/PRINTING Strathmore
Writing 25% cotton

29140 Buckingham Ave. Suite 5

Livonia, MI 48154

313 261-2001

Fax: 313 261-3282

email: epicnode@aol.com

12330 Conway Road

St. Louis, MO 63141

314 205-2266

Fax: 314 205-2540

Corbett Heimburger

National Outreach Director

Evangelical Presbyterian Church

DESIGN FIRM Jacque Consulting & Design
DESIGNER/ILLUSTRATOR Janelle Sayegh
CLIENT Evangelical Presbyterian Church
TOOLS Adobe FreeHand
PAPER/PRINTING Neenah Classic Crest

DESIGN FIRM 9 Volt Visuals
ART DIRECTOR/DESIGNER Bobby June
CLIENT 9 Volt Visuals
TOOLS Adobe Photoshop, Adobe Illustrator
PAPER/PRINTING Twin Concepts

DESIGN FIRM Elena Design
ART DIRECTOR/DESIGNER Elena Baca
CLIENT Wendy Thomas
TOOLS Adobe Photoshop, QuarkXPress
PAPER/PRINTING French Speckeltone

DESIGN FIRM Duck Soup Graphics
ART DIRECTOR/DESIGNER William Doucette
CLIENT Sunbaked Software
TOOLS Macromedia FreeHand, QuarkXPress
PAPER/PRINTING Circa select/
Two match colors, blowtorch

DESIGN FIRM Design Center
ART DIRECTOR John Reger
DESIGNER Sherwin Schwartzrock
CLIENT AvonLea
TOOLS Macintosh
PAPER/PRINTING Procraft Printing

DESIGN FIRM Mother Graphic Design
ALL DESIGN Kristin Thieme
CLIENT Art House

DESIGN FIRM Moos Design
ALL DESIGN Moos Kuppers
CLIENT Dennis Dwinger
TOOLS Macintosh, numbering by printer

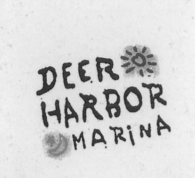

Craig Webster

PO Box 344
Deer Harbor, WA 98243
Fax (360) 376-6091
Tel (360) 376-3037
VHF Channel 78

DESIGN FIRM Widmeyer Design
ART DIRECTORS Ken Widmeyer, Dale Hart
DESIGNER/ILLUSTRATOR Dale Hart
CLIENT Deer Harbor Marina
TOOLS Power Macintosh, Macromedia
FreeHand, Adobe Photoshop
PAPER/PRINTING Proterra Flecks/Offset

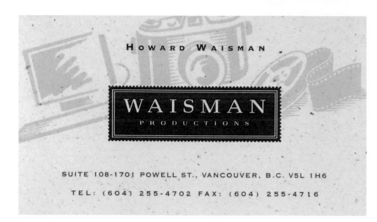

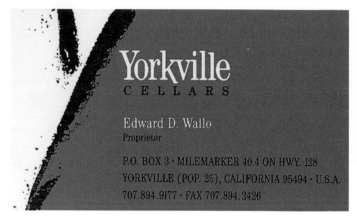

DESIGN FIRM Blue Suede Studios
ALL DESIGN Justin Baker
CLIENT Waisman Photography
PAPER/PRINTING Genesis/Hemlock Express

DESIGN FIRM Tharp Did It
ART DIRECTOR Rick Tharp
DESIGNERS Rick Tharp, Jana Heer
ILLUSTRATOR Georgia Deaver
CLIENT Yorkville Cellars
TOOLS Ink, traditional typography
PAPER/PRINTING Simpson Paper Company/Simon Printing

DESIGN FIRM Corridor Design
ART DIRECTOR/DESIGNER
Ejaz Saifullah
CLIENT Corridor Design
TOOLS Adobe Illustrator, QuarkXPress
PAPER/PRINTING French construction,
pure white/Rooney Printing Co.

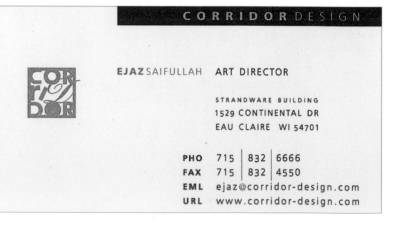

DESIGN FIRM Imagine That, Inc.
ART DIRECTOR/DESIGNER Sue Manian
CLIENT Sue Manian Graphic Design
TOOLS Adobe Illustrator
PAPER/PRINTING Classic Crest/Clark's Litho

A

AMEER DESIGN 16 KEYES ROAD LONDON NW2 3XA

TELEPHONE AND FAX 0181 450 0464 **JANET AMEER**

DESIGN FIRM Ameer Design
ART DIRECTOR/DESIGNER Janet Ameer
CLIENT Ameer Design

apple graphics
& advertising, inc.

ALLISON SCHNEIDER

2314 merrick road

merrick, ny 11566

tel.: 516. 868. 1919

fax: 516. 868. 1982

apple graphics & advertising, inc.

DESIGN FIRM Apple Graphics & Advertising of Merrick, Inc.
DESIGNER Allison Blair Schneider
ILLUSTRATOR Michael Perez
CLIENT Apple Graphics
TOOLS Macromedia FreeHand, QuarkXPress,
Power Macintosh 7500
PAPER/PRINTING Fox River Circa Select Moss/Foil, offset

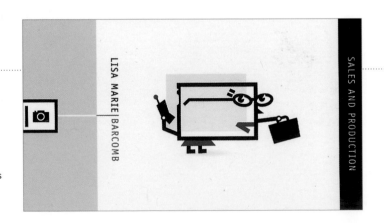

DESIGN FIRM Phoenix Creative
ART DIRECTOR/DESIGNER Eric Thoelke
ILLUSTRATORS Eric Thoelke, Kathy Wilkinson
CLIENT Bruton/Stroube Studios
TOOLS QuarkXPress
PAPER/PRINTING Strathmore/Six PMS, two sides

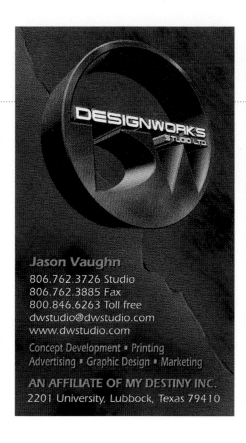

RESTAURANT DESIGN
INTERIOR DESIGN
CONCEPT DEVELOPMENT
GRAPHIC DESIGN
MARKETING / ADVERTISING
TELEVISION / RADIO
COPYRIGHTING
BILLBOARD ADVERTISING
APPAREL DESIGN
FUND RAISING
PROMOTIONAL PRODUCTS
CHRISTIAN APPAREL
LOGO CREATION
TRADEMARKING
ANIMATION
WEB PAGE DESIGN
TRADITIONAL PAINTING
MURAL DESIGN
FULL COLOR PRINTING
SCREEN PRINTING
LARGE FORMAT PRINTING
DIGITAL PRINTING
PHOTO COPY
CD • JCARD DESIGN
PHONE BOOK AD DESIGN
SIGN PAINTING
BUMPER STICKERS
SCANNING
PHOTOGRAPHY
PHOTO RETOUCHING
COMPUTER TRAINING
MINOR COMPUTER REPAIR
AND SO MUCH MORE!

1.800.846.6263
2201 UNIVERSITY, LUBBOCK, TEXAS 79410

DESIGN FIRM Designworks Studio, Ltd.
ALL DESIGN Jason Vaughn
CLIENT Designworks Studio, Ltd.
TOOLS Adobe Photoshop, Adobe Illustrator,
Adobe Dimensions
PAPER/PRINTING 10 pt. gloss/Four color

HESED BIOMED

Larry J. Smith, Ph.D.

7824 Jackson Street
Omaha, Nebraska 68114
TEL | 402-398-0230
FAX | 402-398-0455
E-mail | hesedbio@ne.uswest.net

DESIGN FIRM Geffert Design
DESIGNER/ILLUSTRATOR Gerald Geffert
CLIENT Kees-Kieren/Weingut

DESIGN FIRM
Nagorny Design
ALL DESIGN
Andrey Nagorny
CLIENT
Hesed Biomed
TOOLS
Macromedia FreeHand
PAPER/PRINTING
Neenah Classic Laid/Two-color

Richard Kehl

DESIGN FIRM Rick Eiber Design (RED)

ART DIRECTOR/DESIGNER Rick Eiber

CLIENT Sam A. Angeloff

TOOLS Macintosh

PAPER/PRINTING Cougar/Four-color process over black

DESIGN FIRM Lynn Wood Design

ART DIRECTOR/DESIGNER Lynn Wood

CLIENT Floyd Johnson

TOOLS QuarkXPress, Adobe Illustrator

PAPER/PRINTING Benefit

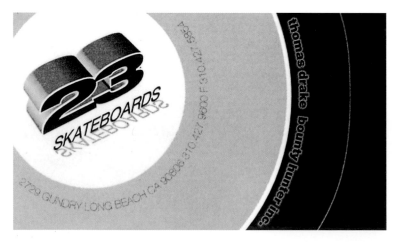

DESIGN FIRM 9 Volt Visuals

ART DIRECTOR/DESIGNER Bobby June

CLIENT 23 Skateboards

TOOLS Adobe Illustrator

PAPER/PRINTING Twin Concepts

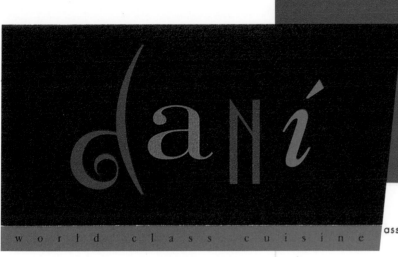

DESIGN FIRM David Carter Design
ART DIRECTORS Sharon LeJeune, Randall Hill
DESIGNER Sharon LeJeune
ILLUSTRATOR Tracy Huck
CLIENT Dani, Kent Rathbun

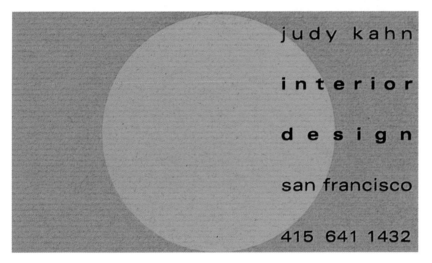

DESIGN FIRM Judy Kahn
DESIGNER Judy Kahn
CLIENT Judy Kahn
TOOLS Adobe Illustrator
PAPER/PRINTING Champion Benefit
Vertical 80 lb. cover/Cactus

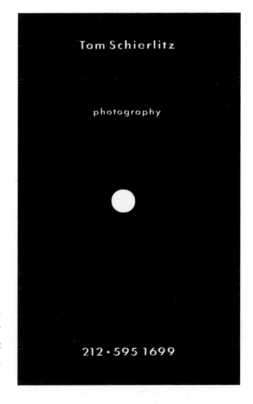

DESIGN FIRM Sagmeister, Inc.
ALL DESIGN Stefan Sagmeister
CLIENT Tom Schierlitz
PAPER/PRINTING Strathmore Writing 25% cotton

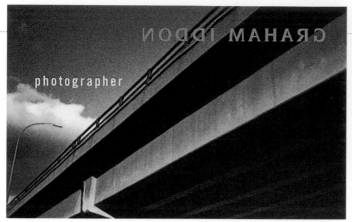

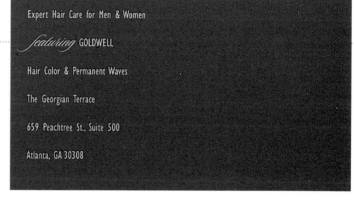

DESIGN FIRM Teikna
ART DIRECTOR/DESIGNER Claudia Neri
PHOTOGRAPHER Graham Iddon
CLIENT Graham Iddon
TOOLS QuarkXPress
PAPER/PRINTING Strathmore Elements/Two color

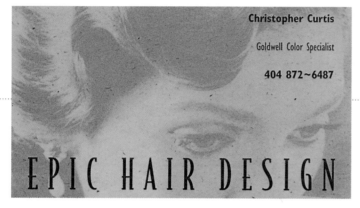

DESIGN FIRM The Design Company
ART DIRECTOR Marcia Romanuck
CLIENT Epic Hair Design
PAPER/PRINTING Fraser Genesis Dawn 80 lb. cover

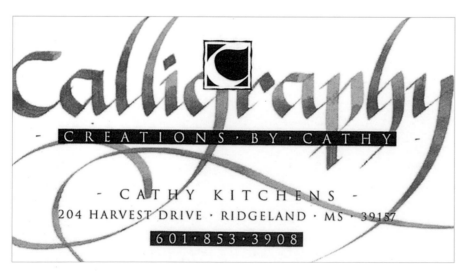

DESIGN FIRM Communication Arts Company
ART DIRECTOR/DESIGNER Mary Kitchens
ILLUSTRATOR Cathy Kitchens
CLIENT Creations by Cathy
TOOLS Calligraphy, pen, ink, Macintosh
PAPER/PRINTING Offset lithography

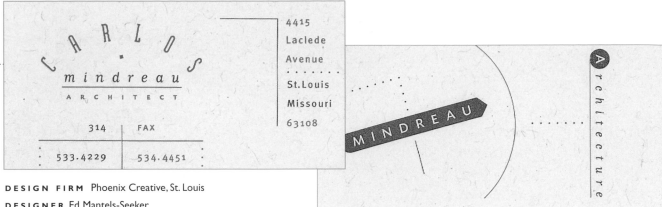

DESIGN FIRM Phoenix Creative, St. Louis

DESIGNER Ed Mantels-Seeker

CLIENT Carlos Mindreau, Architect

TOOLS Adobe Illustrator

PAPER/PRINTING Two-color litho

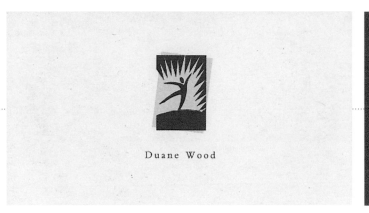

DESIGN FIRM WDG Communications

ALL DESIGN Duane Wood

CLIENT WDG Communications

TOOLS Pencil, paper, Adobe Illustrator, QuarkXPress

PAPER/PRINTING Neenah Classic Crest
Sawgrass 80 lb. cover/Cedar Graphics

stubblefield

PROPERTIES, INC.

Fee Stubblefield

JOHN'S LANDING WATER TOWER
5331 SW MACADAM AVE • SUITE 260 • PORTLAND, OR 97201
TELE: 503-827-3366 • FAX: 503-827-3466

DESIGN FIRM Oakley Design Studios

ART DIRECTOR/DESIGNER Tim Oakley

CLIENT Stubblefield Properties

TOOLS QuarkXPress

PAPER/PRINTING Proterra flecks/Two color

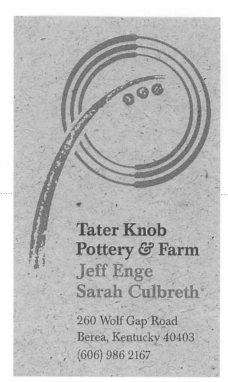

Hand thrown earthwares in the fine Berea Crafts tradition.

Tater Knob Pottery & Farm
Jeff Enge
Sarah Culbreth

260 Wolf Gap Road
Berea, Kentucky 40403
(606) 986 2167

DESIGN FIRM
Kirby Stephens Design, Inc.
ART DIRECTOR Kirby Stephens
DESIGNER/ILLUSTRATOR William V. Cox
CLIENT Tater Knob Pottery & Farm
TOOLS Pencil, Macintosh PPC, Camera, Adobe Photoshop, Macromedia FreeHand
PAPER/PRINTING Environment Recycled

OBJECT ENTERPRISES INCORPORATED

Jesse Tayler

OBJECT ENTERPRISES INCORPORATED
2608 2nd Avenue Suite 119
Seattle, WA 98121-1276 USA

Tel 206.217.0891
Fax 206.217.0394
Cel 206.954.3284

Jesse.Tayler@OEinc.com
www.oeinc.com

DESIGN FIRM Widmeyer Design
ART DIRECTORS Ken Widmeyer, Christopher Downs
DESIGNER Christopher Downs
ILLUSTRATOR Misha Melikov
CLIENT Object Enterprises, Inc.
TOOLS Power Macintosh, Adobe Photoshop, QuarkXPress
PAPER/PRINTING Mead Signature Satin/Four-color offset

DESIGN FIRM Melissa Passehl Design
ART DIRECTOR Melissa Passehl
DESIGNERS Melissa Passehl, Jill Steinfeld
CLIENT Alka Joshi Marketing

ALKA JOSHI
MARKETING
.....................
Building Brands
Through Creative
Marketing

128 Middlefield Road, Palo Alto, CA 94301
Vox 415.326.7130 **Fax** 415.326.7044

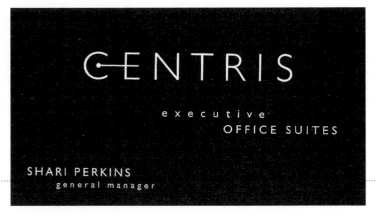

Centris, LLC

10900 NE 4th Street

Suite 2300

Bellevue, Washington 98004

Tel 206.635.7700

Fax 206.635.7799

Email sharip@centris.net

DESIGN FIRM Widmeyer Design
ART DIRECTORS Ken Widmeyer, Dale Hart
DESIGNER Dale Hart
CLIENT Centris
TOOLS Power Macintosh, Macromedia FreeHand
PAPER/PRINTING Environment/Three-color offset

DESIGN FIRM Susan Guerra
ART DIRECTOR/DESIGNER Susan Guerra
CLIENT Robert Guerra
TOOLS Adobe Photoshop, Adobe Illustrator
PAPER/PRINTING One-color offset

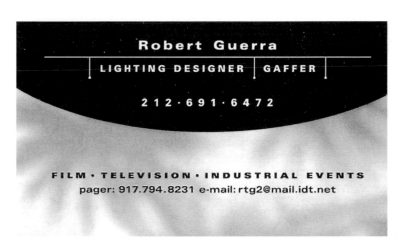

DESIGN FIRM Able Design, Inc.
ART DIRECTORS Stuart Harvey Lee, Martha Davis
DESIGNER Martin Perrin
CLIENT Able Design
TOOLS Power Macintosh, QuarkXPress
PAPER/PRINTING Ikonofix 80 lb./Two-color printing, matte varnish

ON THE WALL

Mike Bascom

Painting, Finishing, and Wallcoverings.

1054 North 39th St.
Seattle, WA 98103

Tel. (206) 632-4250
Fax (206) 632-9626

DESIGN FIRM
Rick Eiber Design (RED)
ART DIRECTOR/DESIGNER
Rick Eiber
ILLUSTRATORS
Cave Dweler, Gary Vock
CLIENT
On The Wall
PAPER/PRINTING
Speckletone/Two color

josef lo 鷹宇軒 illustrator 94521650
zeroart@hkstar.com 7/f 567 canton road kowloon hongkong fax 26094050

DESIGN FIRM Zeroart Studio
ART DIRECTORS/DESIGNERS Lo Yu Hin, Josef
TOOLS Apple computer, Adobe Illustrator
PAPER/PRINTING 216 gsm recycled paper/Two spot colors
plus black, ink stamp

Jerrod Philipps
800 435 6509
541 488 2259
541 482 6491 fax
worldboy@teleport.com
www.teleport.com/~worldboy

DESIGN FIRM Blackfish Creative
ALL DESIGN Drew Force
CLIENT Jerrod Philipps Illustration
TOOLS QuarkXPress, Adobe Photoshop

DESIGN FIRM
Heart Graphic Design/Bull's Eye Marketing
ART DIRECTOR Clark Most
DESIGNERS Clark Most, Joan Most
CLIENT Bull's Eye Marketing
TOOLS Macromedia FreeHand

501 George St.
Midland, MI
48640
517 832 9710
Fax: 832 9420

Joan Most

a division of Heart graphics

501 George St.
Midland, MI
48640
517 832 9710
Fax: 832 9420

Jill Suchy

a division of Heart graphics

BAC-GROUND

groundwater

consulting

support

B

ernesto baca

3216 georgetown

houston texas 77005 usa

713.664.8452

ebaca@delphi.com

DESIGN FIRM Elena Design
ALL DESIGN Elena Baca
CLIENT Bac-Ground
TOOLS Adobe Illustrator, Adobe Photoshop
PAPER/PRINTING Simpson Quest

DESIGN FIRM Melissa Passehl Design
ART DIRECTOR Melissa Passehl
DESIGNERS Melissa Passehl,
Charlotte Lambrechts
CLIENT Melissa Passehl Design

MELISSA PASSEHL DESIGN CHARLOTTE LAMBRECHTS. DESIGNER

1275 LINCOLN AVE. #7. SAN JOSE. CA 95125. F 408.294.4104. T 408.294.4422.

DESIGN FIRM Melissa Passehl Design
ART DIRECTOR Melissa Passehl
DESIGNERS Melissa Passehl, Charlotte Lambrechts
CLIENT Paradise Printing

DESIGN FIRM M-DSIGN
ALL DESIGN Mika Ruusunen
CLIENT M-DSIGN
TOOLS Macintosh
PAPER/PRINTING Offset

DESIGN FIRM Toni Schowalter Design
ART DIRECTOR/DESIGNER Toni Schowalter
CLIENT Commercial Furniture Interiors
TOOLS Macintosh, QuarkXPress, Adobe Illustrator
PAPER/PRINTING Strathmore Writing/
Three-color offset, Soho Services

DESIGN FIRM CR Design
ART DIRECTOR Jan Knutsen
DESIGNER Chad Ridgeway
CLIENT Fountainhead
PAPER/PRINTING Antique Black
130 lb/Two color

DESIGN FIRM Nancy Stutman Calligraphics
ALL DESIGN Nancy Stutman
CLIENT Sherman Adelman

DESIGN FIRM Design Ranch
ART DIRECTOR Gary Gnade
DESIGNERS Danette Angerer, Gary Gnade
CLIENT Terpsichore School of Dance
PAPER/PRINTING Wausau Royal
Fiber/Goodfellow Printing

DESIGN FIRM éng Tang Design
ART DIRECTOR/DESIGNER éng Tang
CLIENT éng Tang
TOOLS Adobe Illustrator

DESIGN FIRM Sagmeister, Inc.
ART DIRECTOR Stefan Sagmeister
DESIGNERS Stefan Sagmeister, Veronica Oh
ILLUSTRATOR Veronica Oh
CLIENT Green City
PAPER/PRINTING Strathmore Writing
25% cotton

DESIGN FIRM
Kanokwalee Design

ART DIRECTOR/DESIGNER
Kanokwalee Lee

CLIENT
Austin Film Works

TOOLS
QuarkXPress

PAPER/PRINTING
Protera fleck

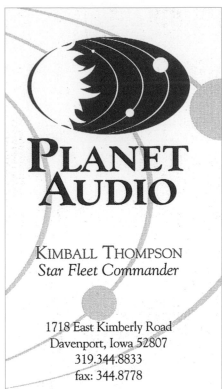

DESIGN FIRM
Gackle Anderson Henningsen, Inc.

DESIGNER
Wendy Anderson

CLIENT
Planet Audio

TOOLS
QuarkXPress, Adobe Illustrator

PAPER/PRINTING
Neenah Classic Laid
Solar White/Two PMS

16580 Harbor Blvd., Suite G · Fountain Valley, CA 92708

DESIGN FIRM Cordoba Graphics
ALL DESIGN éng Tang
CLIENT Pacific Coast
TOOLS Adobe Illustrator
PAPER PRINTING Flomar

DEBRA ROBERTS

15345 VIA SIMPATICO

AND ASSOCIATES

RANCHO SANTA FE

INCORPORATED

CALIFORNIA 92091

DEBRA J. ROBERTS, CFA

TEL 619-759-2649

PRESIDENT AND CEO

FAX 619-759-2653

DESIGN FIRM Mires Design
ART DIRECTOR Scott Mires
DESIGNERS Deborah Horn, Scott Mires
CLIENT Debra Roberts and Associates

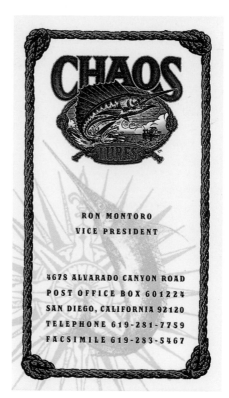

DESIGN FIRM
Mires Design
ART DIRECTOR/DESIGNER
José Serrano
ILLUSTRATOR
Tracy Sabin
CLIENT
Chaos Lures

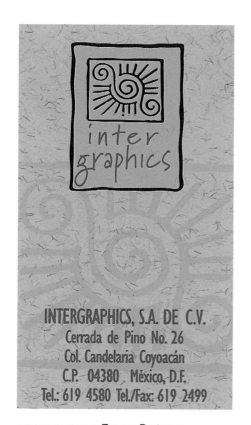

DESIGN FIRM Zappata Designers
ART DIRECTOR Ibo Angulo
DESIGNERS Ibo, Ana, Claudio
CLIENT Intergraphics Printing
TOOLS Macromedia FreeHand
PAPER/PRINTING Cambric/Silkscreen

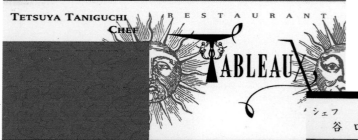

DESIGN FIRM Vrontikis Design Office
ART DIRECTOR Petrula Vrontikis
DESIGNER/ILLUSTRATOR Kim Sage
CLIENT Hasegawa Enterprises
PAPER/PRINTING Potlatch Korma/Four-color, Login Printing

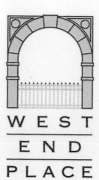

DESIGN FIRM Phillips Design Group
ART DIRECTOR Steve Phillips
DESIGNER Alison Goudreault
CLIENT West End Place
TOOLS Adobe Illustrator
PAPER/PRINTING Strathmore
Natural White/Peacock Press

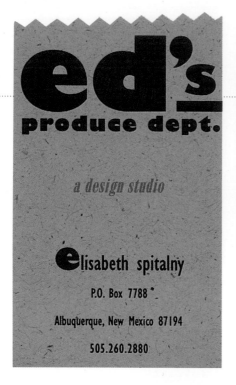

DESIGN FIRM ed's produce dept.
DESIGNERS Donna Cohen,
Elizabeth Spitalny
CLIENT ed's produce dept.
TOOLS QuarkXPress, Adobe Photoshop
PAPER/PRINTING French Speckeltone, Kraft

DESIGN FIRM jk design
ALL DESIGN Jeanne Knobbe
CLIENT jk design
TOOLS Macromedia FreeHand
PAPER/PRINTING Hopper Protera Chalk/Three-color offset

GARRETT SOLOMON

DESIGN FIRM Barbara Brown Marketing & Design
DESIGNER Barbara Brown
CLIENT Channel Islands Properties
PRINTING Ventura Printing

▲ CHANNEL ISLANDS PROPERTIES

500 ESPLANADE DRIVE · SUITE 400
OXNARD CALIFORNIA 93030
PHONE 805·278·6600 FAX 805·278·6606

PHOTOGRAPHY | 415/731-2524

JUSTIN CURTIS

1222 8th Avenue, San Francisco, CA 94122

PHOTOGRAPHY

DESIGN FIRM Charney Design
ART DIRECTOR/DESIGNER Carol Inez Charney
CLIENT Justin Curtis Photography
TOOLS QuarkXPress
PAPER/PRINTING Vintage/Offset

DeCurtis McMillan

Hair & Beauty

1497 YONGE STREET TORONTO, M4T 1Z2
TELEPHONE (416) 323 1739

DESIGN FIRM Teikna
ART DIRECTOR/DESIGNER Claudia Neri
CLIENT DeCurtis McMillan Hair Salon
TOOLS QuarkXPress
PAPER/PRINTING Roll and evolution/One color

To look and feel good

To take better care of each

other and our Planet

HAMILTON HOP ASSET MANAGEMENT GROUP

DESIGN FIRM Highwood Communications
ART DIRECTOR/DESIGNER Darcy Parke
CLIENT Hamilton Hop Asset Management Group
TOOLS Adobe Photoshop, QuarkXPress
PAPER/PRINTING Classic Crest cover

R. Darol Hamilton, CLU, Ch.F.C.,CFP
Principal
Estate • Succession • Retirement

1100, 734 - 7 Avenue S.W.
Calgary, Alberta T2P 3P8
Tel 403.262.2080
Fax 403.262.2074
www.hamilton-hop.com

still | moving | pictures

still | moving | pictures

still | moving | pictures

R J MUNA

PICTURES

GISELA HERMELING

225 INDUSTRIAL STREET
SAN FRANCISCO, CALIFORNIA
ZIP 94124-8975

415.468.8225 TEL
415.468.8295 FAX
pictures@rjmuna.com NET

DESIGN FIRM Aerial
ART DIRECTOR/DESIGNER
Tracy Moon
PHOTOGRAPHER R. J. Muna
CLIENT R. J. Muna Pictures
TOOLS Adobe Photoshop,
Adobe Illustrator, QuarkXPress
PAPER/PRINTING Strathmore
Natural White/Leewood Press

**HALSTED
COMMUNICATIONS
INC.**

WENDY P. BASIL
EXEC. VICE PRESIDENT

FONE
800.600.7111
X222
FAX
800.600.7112
E-MAIL
HALSTED@IX.NETCOM.COM

DESIGN FIRM Vrontikis Design Office
ART DIRECTOR Petrula Vrontikis
DESIGNER/ILLUSTRATOR Kim Sage
CLIENT Halsted Communications
PAPER/PRINTING Starwhite
Vicksburg Vellum/Two-color offset, Login Printing

DESIGN FIRM Aerial
ART DIRECTOR/DESIGNER Tracy Moon
PHOTOGRAPHER R. J. Muna
CLIENT Aerial
TOOLS Adobe Photoshop, Live Picture, QuarkXPress

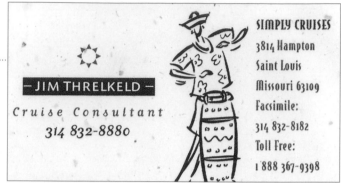

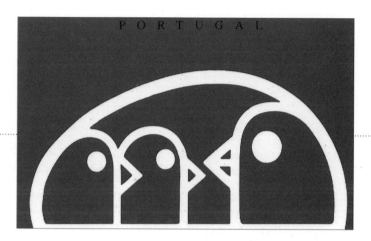

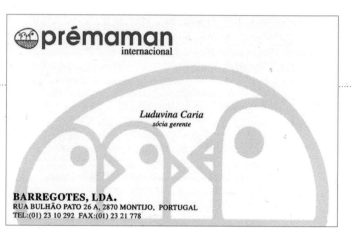

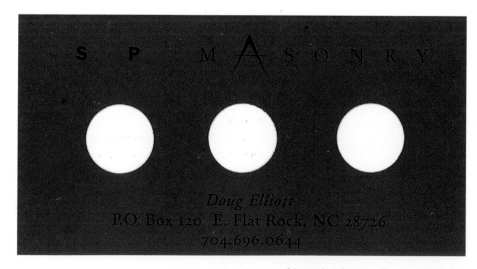

DESIGN FIRM Phoenix Creative
DESIGNER Ed Mantels-Seeker
CLIENT Simply Cruises
TOOLS QuarkXPress, Adobe Illustrator
PAPER/PRINTING Two-color litho with one color change

DESIGN FIRM MA&A—Mário Aurélio & Asscociados
ART DIRECTOR Mário Aurélio
DESIGNERS Mário Aurélio, Rosa Maia
CLIENT Prémaman

DESIGN FIRM Tower of Babel
DESIGNER Eric Stevens
CLIENT SP Masonry
TOOLS Macromedia FreeHand
PAPER/PRINTING Confetti Rust/Groves Printing

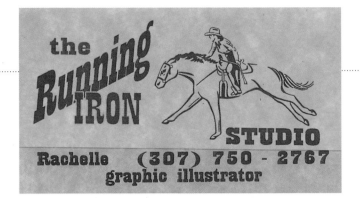

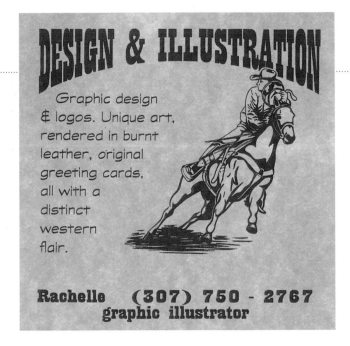

DESIGN FIRM The Running Iron Studio

ALL DESIGN Rachelle Kolby

CLIENT The Running Iron Studio

TOOLS Pen and ink

PAPER/PRINTING Astroparche Ancient
Gold 65 lb./Offset printing

DESIGN FIRM MA&A—Mário Aurélio Associados

ART DIRECTOR Mario Aurélio

DESIGNERS Mario Aurélio, Rosa Maia

CLIENT DecoPaço

DESIGN FIRM Charney Design

ART DIRECTOR/DESIGNER Carol Inez Charney

CLIENT Darla Parr, D.C.

TOOLS QuarkXPress, Adobe Photoshop

PAPER/PRINTING Starwhite Vicksburg/Offset

DESIGN FIRM Corridor Design

ALL DESIGN Ejaz Saifullah

CLIENT Stout's Lodge

TOOLS Adobe Photoshop,
Adobe Illustrator, QuarkXPress

PAPER/PRINTING French Speckletone,
Oatmeal/Rooney Printing Co.

DESIGN FIRM Hornall Anderson
Design Works, Inc.

ART DIRECTOR John Hornall

DESIGNERS John Hornall,
Debra Hampton, Mary Chin Hutchinson

ILLUSTRATOR Jerry Nelson

CLIENT Columbia Crest Winery

TOOLS QuarkXPress

PAPER/PRINTING Neenah Environment
Recycled, Desert Storm, Wove, Woodstock Wove

DESIGN FIRM
Stowe Design

ART DIRECTOR/DESIGNER
Jodie Stowe

CLIENT
Symmetry Productions

PAPER/PRINTING
Aztec Printing

DESIGN FIRM Dogstar
ART DIRECTOR/DESIGNER Jennifer Martin
ILLUSTRATOR Rodney Davidson
CLIENT Roaring Tiger Films
TOOLS Adobe Photoshop, Macromedia FreeHand, QuarkXPress

D'Angelo

Construction Ltd.

Franco D'Angelo

34628 Ascott Avenue
Abbotsford, B.C. V2S 4V9
Telephone (604) 556-3727
Facsimile (604) 556-3728

DESIGN FIRM Blue Suede Studios
ALL DESIGN Justin Baker
CLIENT D'Angelo Construction
PAPER/PRINTING Classic Laid/Ultratech Printers

COPYWRITING REPORTING

EDITING SALES
PROMOTION

DOUGLAS C. SHIBUT
6210 ELLIS AVENUE | RICHMOND, VA | 23228
804 | 264 | 1168

DESIGN FIRM The Home Studio
ART DIRECTOR/DESIGNER C. Benjamin Dacus
CLIENT Douglas C. Shibut
TOOLS QuarkXPress, Adobe Photoshop, Adobe Illustrator
PAPER/PRINTING Classic Crest/Offset

DENNIS
HAYES
&
associates
incorporated

305 East 46 Street New York NY 10017-3058
telephone 212 980 0300 fax 212 755 1737

DESIGN FIRM Sagmeister, Inc.
ART DIRECTOR Stefan Sagmeister
DESIGNERS Stefan Sagmeister, Eric Zim
ILLUSTRATOR Eric Zim
CLIENT Dennis Hayes
PAPER/PRINTING Strathmore Writing 25% cotton

Robert F. Hernandez
Investigator
Post Office Box 9910
San Diego, CA 92109
Phone 619 488-4044

DESIGN FIRM Mires Design
ART DIRECTOR/DESIGNER José Serrano
ILLUSTRATOR Tracy Sabin
CLIENT Midland Research
PAPER/PRINTING Speckletone

Joel Morgenstern

444 Columbus Avenue
San Francisco, CA 94133

Tel: 415.433.9111
Fax: 415.362.6292

Email: HotelBoheme@
MCIMail.com

DESIGN FIRM Aerial
ART DIRECTOR/DESIGNER Tracy Moon
ILLUSTRATOR John Mattos (logotype)
PHOTOGRAPHERS Jerry Stoll, R. J. Muna
CLIENT Hotel Bohème
TOOLS Adobe Photoshop, QuarkXPress

Peter Comitini principal

Peter Comitini: Design
611 Broadway
Suite 206
New York, NY 10012
212.228.2727
Fax 212.260.9058
comitini@mindspring.com

Peter Comitini principal

Peter Comitini: Design
611 Broadway
Suite 206
New York, NY 10012
212.228.2727
Fax 212.260.9058
comitini@mindspring.com

Peter Comitini principal

Peter Comitini: Design
611 Broadway
Suite 206
New York, NY 10012
212.228.2727
Fax 212.260.9058
comitini@mindspring.com

DESIGN FIRM Peter Comitini Design
ART DIRECTOR/DESIGNER Peter Comitini
TOOLS Adobe Illustrator, QuarkXPress, Power PC
PAPER/PRINTING Neenah UV Ultra

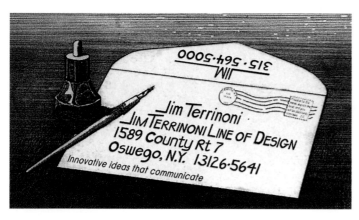

DESIGN FIRM Jim Terrinoni Line of Design
ART DIRECTOR Jim Terrioni
TOOLS Freehand artwork, Adobe Photoshop,
QuarkXPress, Adobe Illustrator
PAPER/PRINTING 80 lb. cover

DESIGN FIRM Witherspoon Advertising
ALL DESIGN Rishi Seth
TOOLS Adobe Illustrator
CLIENT RaceFest Fort Worth
PAPER/PRINTING Starwhite Vicksburg Tiara High-Tech Finish Cover Plus

RACEFEST FORT WORTH

RaceFest Fort Worth, Inc.
777 Taylor Street, Suite 1080
Fort Worth, Texas 76102
817.335.RACE (7223)
FAX 817.335.2626
RaceFest@downiepro.com

Gary Cumbie
Steering Committee
Chairman

DESIGN FIRM
Widmeyer Design
ART DIRECTORS
Ken Widmeyer, Dale Hart
DESIGNER
Dale Hart
CLIENT
Progenesis
TOOLS
Power Macintosh,
Macromedia FreeHand
PAPER/PRINTING
Environment/Offset

DESIGN FIRM
Clearpoint Communications
ART DIRECTOR/DESIGNER
Lynn Decouto
CLIENT
Perron Family Chiropractic
PAPER/PRINTING
Reacraft Press

DESIGN FIRM Insight Design Communications
ALL DESIGN Sherrie Holdeman, Tracy Holdeman
CLIENT Jitters
TOOLS Power Macintosh 7500, Macromedia
FreeHand, Adobe Photoshop
PAPER/PRINTING French Speckletone Oatmeal
70 lb. text, Classic Crest Solar White 80 lb. cover

DESIGN FIRM Alison Goudreault, Inc.
ALL DESIGN Alison Goudreault
CLIENT Bloomer's Upholstery
TOOLS Adobe Illustrator
PAPER/PRINTING Strathmore Ultimate
White/Copy Cop

COONARA
PRIVATE HOSPITAL

LORETO DAVEY CEO

6TH FLOOR
ALFRED HOSPITAL
COMMERCIAL ROAD
PRAHAN VICTORIA 3181
PHONE (03) 9520 9200
Fax (03) 9521 2775

A meeting place for quality health care

DESIGN FIRM
Watts Graphic Design
**ART DIRECTORS/
DESIGNERS**
Helen Watts, Peter Watts
CLIENT
Coonara Private Hospital
TOOLS
Macintosh
PAPER/PRINTING
Two color

DESIGN FIRM Watts Graphic Design
ART DIRECTORS/DESIGNERS Helen Watts,
Peter Watts
CLIENT The Knowledge Navigators
TOOLS Macintosh
PAPER/PRINTING Teton/one color

Virtual Garden

Shirley Read-Jahn
communications manager

221 Main Street
Suite 480
San Francisco, CA 94105
P 415.908.4967
F 415.908.2010
E readjahns@tpv.com

http://vg.com

DESIGN FIRM Tharp Did It
ART DIRECTOR Rick Tharp
DESIGNERS Rick Tharp, Nicole Coleman
ILLUSTRATOR Rick Olson
CLIENT Time Warner
TOOLS Ink, Macintosh

t 310 204 1995 f 310 204 4879

4445 overland avenue
culver city california 90230
evensoninc@aol.com

Stan Evenson
principal

edg

evenson design group

DESIGN FIRM Evenson Design Group
ART DIRECTOR Stan Evenson
DESIGNER Amy Hershman
PAPER/PRINTING Anderson Printing

Leslie Vasquez

...nnex

...prises
...ue, Santa Cruz CA 95062
...4-6456 Fax 408/477-0289

DESIGN FIRM Charney Design
ALL DESIGN Carol Inez Charney
CLIENT Annex Enterprises
TOOLS QuarkXPress, Adobe Photoshop
PAPER/PRINTING Vintage/Offset

lumiforma
iluminação, lda

telemóvel 0931 57 97 69
tel/fax +351.2.454 20 63
rua das valas de cima 49, jovim
4420 gondomar
portugal

DESIGN FIRM
MA&A—Mário Aurélio & Associados
ART DIRECTOR Mário Aurélio
DESIGNERS Mário Aurélio, Rosa Maia
CLIENT Lumiforma/Iluminage, LDA

DESIGN FIRM Sivustudio
ART DIRECTOR Jaana Aartomaa
CLIENT Pirjo Lindstrom
TOOLS Macromedia FreeHand, Macintosh
PAPER/PRINTING Offset

DESIGN FIRM One, Graphic Design & Consulting
ART DIRECTOR/DESIGNER Aliya S. Khan
CLIENT One, Graphic Design & Consulting
TOOLS CorelDraw, PC
PAPER/PRINTING Neenah Paper
Classic Crest New Sawgrass

DESIGN FIRM Tharp Did It
ART DIRECTOR Rick Tharp
DESIGNERS
Rick Tharp, Amy Bednarek, Susan Craft
CLIENT Ladbrokes/London
TOOLS Macintosh
PAPER/PRINTING
Simpson Starwhite Vicksburg/Simon Printing

DESIGN FIRM Tower of Babel
DESIGNER Eric Stevens
CLIENT Tower of Babel
TOOLS Macromedia FreeHand
PAPER/PRINTING Groves Printing

DESIGN FIRM

Melinda Thede

DESIGNER

Melinda Thede

CLIENT

Melinda Thede

TOOLS

Adobe Illustrator

PAPER/PRINTING

Transparency film/handmade

DESIGN FIRM MA&A—Mário Aurélio & Associados

ART DIRECTOR Mário Aurélio

DESIGNERS Mário Aurélio, Rosa Maia

CLIENT Bizance Interiors

DESIGN FIRM

Lucy Walker Graphic Design

ART DIRECTOR/DESIGNER Lucy Walker

CLIENT Williams MacKay Advertising

TOOLS Adobe Illustrator

PAPER/PRINTING Coated artboard

DESIGN FIRM Charney Design
ALL DESIGN Carol Inez Charney
CLIENT Heinz Communications
TOOLS Adobe Illustrator
PAPER/PRINTING Environment
Duplex/Offset

HEINZ COMMUNICATIONS
ZIGI Z. HEINZ

VIDEO PRODUCTION

6950 HIGHWAY 9
FELTON, CA 95018
PHONE 408/335-3456
FAX 408/335-0722
PAGER 408/989-7777

Mark
Freedman

FUSION MEDIA

President
619 490 5182

7 Morena Boulevard, Suite 302
n Diego, California 92117
il: mark@fusionmedia.com
p://www.fusionmedia.com
telephone 619 490 5182
fax 619 490 5185

DESIGN FIRM Mires Design
ART DIRECTOR John Ball
DESIGNERS John Ball, Deborah Horn
CLIENT Fusion Media
PAPER/PRINTING Starwhite

Franciscan Health Community

1925
Norfolk Avenue
St. Paul, MN
55116-2699
(612) 699-3952
Fax 698-7322

Sally Staggert, PHN
Director of Community Services

Services for
Seniors and their
Families

DESIGN FIRM Design Center
ART DIRECTOR John Reger
DESIGNER Sherwin Schwartzrock
CLIENT Franciscan Health Company
TOOLS Macintosh
PAPER/PRINTING Procraft Printing

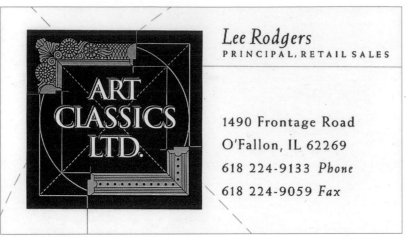

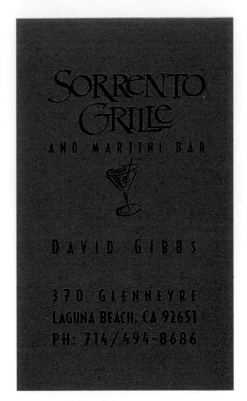

DESIGN FIRM Phoenix Creative, St. Louis
ART DIRECTOR/DESIGNER
Ed Mantels-Seeker
ILLUSTRATORS Ed Mantels-Seeker, Ann Guillot
TOOLS Macromedia FreeHand
PAPER/PRINTING Four-color offset

DESIGN FIRM On The Edge
ART DIRECTOR Jeff Gasper
DESIGNER Gina Mims
CLIENT Sorrento Grille
TOOLS Adobe Illustrator,
QuarkXPress, Adobe Photoshop
PAPER/PRINTING Quest brown

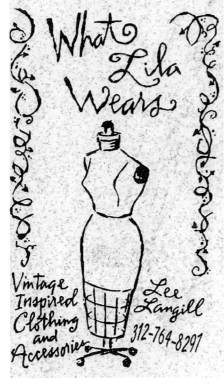

DESIGN FIRM Jim Lange Design
ALL DESIGN Jim Lange
CLIENT Lee Langill
TOOLS Pen and ink

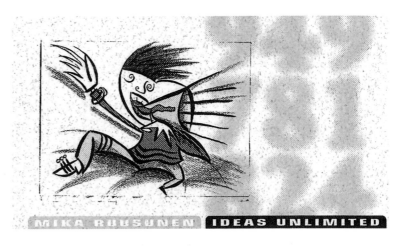

DESIGN FIRM M-DSIGN
ALL DESIGN Mika Ruusunen
CLIENT M-DSIGN
TOOLS Macintosh
PAPER/PRINTING Offset

Ida Linnet

REKLAMEAFDELINGEN

LØVENS KEMISKE FABRIK

Industriparken 55

2750 Ballerup

Telefon 44 94 58 88

Direkte 44 92 36 66 ⟶ 2563

Privat 44 68 05 40

Fax 44 92 35 95

DESIGN FIRM
Department 058
ART DIRECTOR/DESIGNER
Vibeke Nødskov
CLIENT
Løvens Kemiske Fabrik
TOOLS
Adobe Illustrator, QuarkXPress
PAPER/PRINTING
Green cardboard/One color

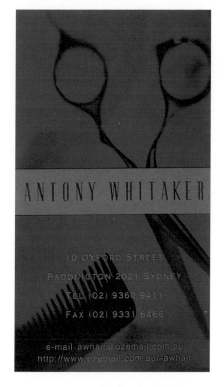

DESIGN FIRM Mother Graphic Design
ART DIRECTOR/DESIGNER Kristin Thieme
PHOTOGRAPHER Petrina Tinslay
CLIENT Antony Whitaker Hairdressing

Kimberly Bykerk, ASID

ASSOCIATE

THE RETAIL GROUP

2025 FIRST AVENUE, SUITE 470
SEATTLE, WASHINGTON 98121
FACSIMILE 206.441.8710
TELEPHONE 206.441.8330

DESIGN FIRM Widmeyer Design
ART DIRECTORS Ken Widmeyer, Dale Hart
DESIGNER/ILLUSTRATOR Dale Hart
CLIENT The Retail Group
TOOLS Power Macintosh, Adobe Photoshop,
Macromedia FreeHand
PAPER/PRINTING Environment/Offset

ART DIRECTOR/ILLUSTRATOR Ralf Huss
TOOLS Macintosh, Adobe Photoshop, QuarkXPress

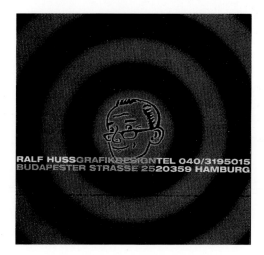

lima design

215 hanover street

boston, massachusetts 02113

617-FOR-BEAN [367-2326]

617-367-1255 [FAX]

LIMADE@aol.com

mary a. kiene
owner

lima design

DESIGN FIRM Lima Design
DESIGNERS L. McKenna, M. Kiene
TOOLS QuarkXPress, Macromedia FreeHand
PAPER/PRINTING Potlatch Paper

TV | RADIO | PRINT | WEB

Kurt Shore
A Helluva Nice Guy

4100 Main Street, Suite 210
Philadelphia, PA 19127-1623
215.483.4555 fax 215.483.4554
http://www.d4tv.com

DESIGN FIRM D4 Creative Group
ALL DESIGN Wicky Lee
CLIENT D4 Creative Group
TOOLS Adobe Photoshop, Adobe Illustrator, QuarkXPress
PAPER/PRINTING Strathmore Writing/Five
colors over one color

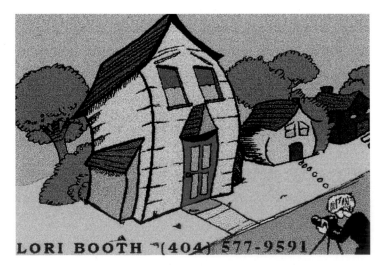

LORI BOOTH (404) 577-9591

DESIGN FIRM Bumbershoot, CSC
ILLUSTRATOR Chris Thorne
CLIENT Lori Booth, Architectural Photography
TOOLS Pen and Ink, Adobe Photoshop
PAPER/PRINTING Watercolor paper/Ink jet

NAME
BARRY LAWSON
CHIEF FINANCIAL OFFICER

ADDRESS
5497 170TH PLACE SE
BELLEVUE, WA 98006

PHONE
VOICE 206.649.0346
FAX 206.649.0122

TICKETING

TOURS & CRUISES

PASSPORT & CURRENCY SERVICES

TRAVEL BOOKS, GUIDES & VIDEOS

LUGGAGE & ACCESSORIES

BON VOYAGE BASKETS

ON-LINE INFORMATION

GIFT CERTIFICATES

DESIGN FIRM Rick Eiber Design (RED)
ALL DESIGN Rick Eiber
CLIENT Today's Traveler
PAPER/PRINTING Three-colors,
over two-colors offset

DESIGN FIRM Sayles Graphic Design
ALL DESIGN John Sayles
CLIENT Alphabet Soup
PAPER/PRINTING Neenah Environment
white wove, double cover/Offset

Planet Comics

Smith Haven Mall, Space E-15

Middle Country Road

Lake Grove, New York 11755

516-724-4096

John A. Gagliardi, CEO

DESIGN FIRM Kiku Obata & Company
ART DIRECTOR/DESIGNER Rich Nelson
CLIENT Planet Comics

DESIGN FIRM Duck Soup Graphics
ART DIRECTOR/DESIGNER William Doucette
CLIENT French Meadow Bakery
TOOLS Macromedia FreeHand, QuarkXPress
PAPER/PRINTING Classic Laid/Three match colors

DESIGN FIRM Creech Creative
ALL DESIGN Tim Creech
CLIENT Creech Creative
TOOLS Adobe Photoshop, Adobe Illustrator

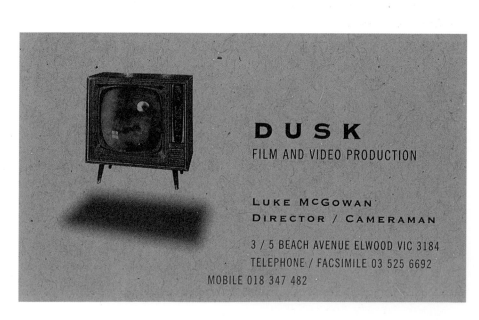

DESIGN FIRM
Storm Design & Advertising Consultancy
ART DIRECTORS/DESIGNERS
Dean Butler, David Ansett
CLIENT
Dusk Film and Video Production
TOOLS
Adobe Photoshop, QuarkXPress
PAPER/PRINTING
One color, duotone, packing brown wrap

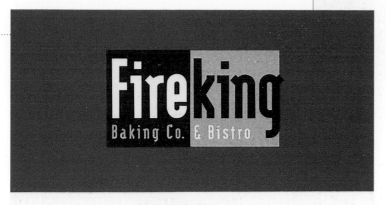

DESIGN FIRM Flaherty Art & Design
ALL DESIGN Marie Flaherty
CLIENT Fireking Baking Company of Eat Well, Inc.
TOOLS Adobe Illustrator

Patty Kane
owner

15 North Street • Hingham • MA • 02043
617-740-9400 • Fax 617-740-0440

An Eat Well Production

Todd Burgard Design
342 Walnut Street
Columbia, PA 17512
717·684·5896
gideon@redrose.net

Burgard Design
342 Walnut Street
Columbia, PA 17512
717·684·5896
gideon@redrose.net

DESIGN FIRM Burgard Design
ART DIRECTOR/DESIGNER Todd Burgard
CLIENT Burgard Design
TOOLS Hand-perfed using antique wheel punch
PAPER/PRINTING Neenah classic laid mahogany, camel hair duplex/
Letterpress with linotype typesetting, two color over one

DESIGN FIRM Solo Grafica
ART DIRECTOR/DESIGNER Yelena Suleyman
CLIENT Extrema Software International
TOOLS Macintosh
PAPER/PRINTING Neenah, Two color

DESIGN FIRM Teikna
ART DIRECTOR/DESIGNER Claudia Neri
CLIENT Michael Bogart
TOOLS QuarkXPress
PAPER/PRINTING Graphika/Two color

DESIGN FIRM Chris St. Cyr Graphic Design
ART DIRECTOR/DESIGNER Chris St. Cyr
CLIENT Chris St. Cyr Graphic Design
TOOLS QuarkXPress, Adobe Illustrator,
rubber stamp

DESIGN FIRM Widmeyer Design
ART DIRECTORS Ken Widmeyer, Dale Hart
DESIGNER/ILLUSTRATOR Dale Hart
CLIENT Rolling Cones
TOOLS Power Macintosh, Adobe Photoshop,
Macromedia FreeHand
PAPER/PRINTING Mead paper/Offset

DESIGN FIRM Nancy Yeasting
Design & Illustration
ALL DESIGN Nancy Yeasting
CLIENT Nancy Yeasting Design
& Illustration
TOOLS Hand drawn on marker pad,
QuarkXPress
PAPER/PRINTING Genesis
Milkweed/Two-color thermography

DESIGN FIRM Dhruvi Art & Design
ALL DESIGN Dhruvi Acharya
CLIENT Druvi Art & Design
PAPER/PRINTING 80/100 lbs. card
stock/Screen

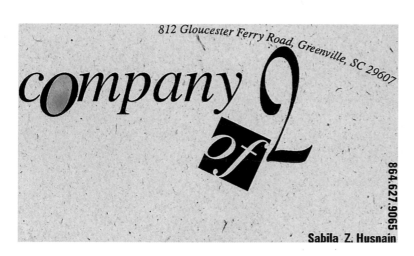

DESIGN FIRM One, Graphic Design & Consulting
ART DIRECTOR/DESIGNER Aliya S. Khan
CLIENT Sabila Zakir Husnain
TOOLS CorelDraw, PC
PAPER/PRINTING Genesis Tallow

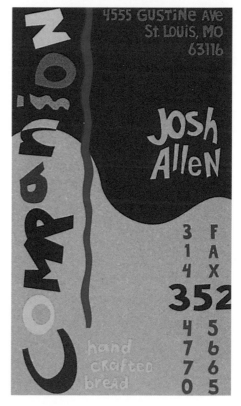

DESIGN FIRM Bartels & Company, Inc.
ART DIRECTOR David Bartels
DESIGNER/ILLUSTRATOR Aaron Segall
CLIENT Companion Baking Company
PAPER/PRINTING Mid West Printing

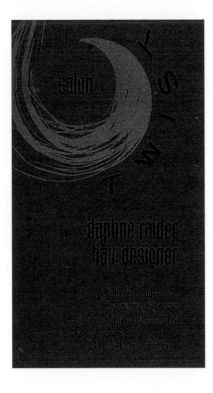

DESIGN FIRM
Fire House, Inc.
ART DIRECTOR/DESIGNER
Gregory R. Farmer
CLIENT
Twist Salon, Daphne Raider
TOOLS
QuarkXPress, Macromedia
FreeHand, Macintosh
PAPER/PRINTING
Schulze Printing

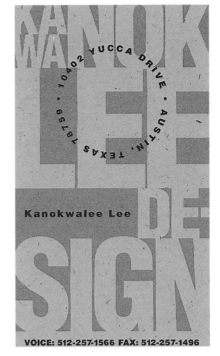

DESIGN FIRM Kanokwalee Design
ART DIRECTOR/DESIGNER Kanokwalee Pusitanun
CLIENT Kanokwalee Design
TOOLS Adobe Illustrator, QuarkXPress
PAPER/PRINTING Speckletone/Kraft

DESIGN FIRM Transparent Office
ART DIRECTOR/DESIGNER Vibeke Nødskov
CLIENT Ventana Europe
TOOLS Adobe Illustrator, QuarkXPress
PAPER/PRINTING Copper Cromalux/Two color

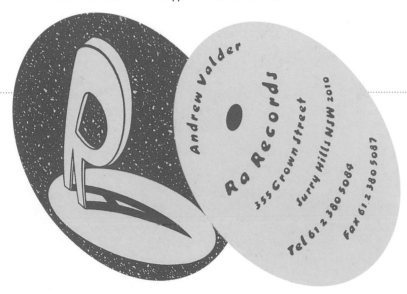

DESIGN FIRM Mother Graphic Design
ART DIRECTOR/DESIGNER Kristin Thieme
ILLUSTRATOR Melinda Dudley
CLIENT RA Records

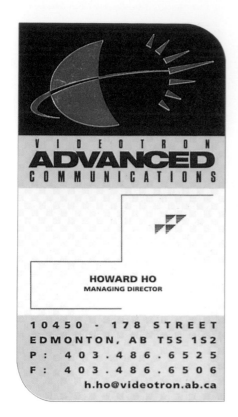

DESIGN FIRM
Duck Soup Graphics
ART DIRECTOR/DESIGNER
William Doucette
CLIENT
Videotron
TOOLS
Adobe Illustrator, QuarkXPress
PAPER/PRINTING
Strathmore Elements/One match color,
foil embossed

DESIGN FIRM
Raven Madd Design
ART DIRECTOR/DESIGNER
Mark Curtis
CLIENT
Bowerman School

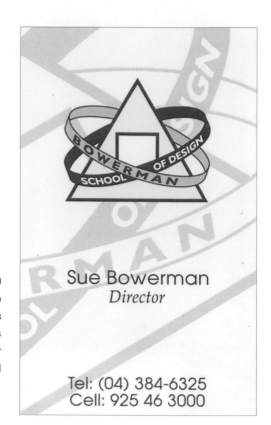

DESIGN FIRM Anton Design
ALL DESIGN Diana Anton
CLIENT Anton Design
TOOLS QuarkXPress, Adobe Illustrator

DESIGN FIRM Aldeia Design
ART DIRECTORS Marcus Padilha, Tatiana Brugalli
DESIGNERS Luis Barros, Fabiano Finger
ILLUSTRATOR Gladimir Dutra
CLIENT Aldeia Design
TOOLS CorelDraw
PAPER/PRINTING Couche 180 gsm/Silkscreen

Bischoff & Thiede

Fassaden & Bausanierung
Dualweg 10
28239 Bremen
Telefon / Telefax
(0421) 64 49 018

DESIGN FIRM Charney Design
ART DIRECTOR/DESIGNER Carol
Inez Charney
PHOTOGRAPHER Carol Charney
CLIENT Jose McKanobb
TOOLS QuarkXPress, Adobe Photoshop
PAPER/PRINTING Vintage Velvet
Creme/Offset

DESIGN FIRM
Büro B.
DESIGNER/ILLUSTRATOR
Daniel Bastian
CLIENT
Bischoff & Thiede
TOOLS
QuarkXPress, Adobe Photoshop
PAPER/PRINTING
Karten Karton/Offset

Jose McKanobb

FITNESS COORDINATOR
CERTIFIED PERSONAL TRAINER
24 HOUR NAUTILUS
1261 SOQUEL AVENUE
SANTA CRUZ, CA 95062
408.454.0333

Fransbal
sociedade de representações de produtos e derivados metálicos, lda.

Francisco J. R. Barbosa
Direcção Comercial

Rua Gonçalo Cristóvão, 347 · sala 310 · 4000 Porto Portugal
Tel:(02)208 88 01 · Fax:(02)208 88 01

Acessórios para a indústria
e matéria-primas
Sociedade de representações
para metalo-mecânica
de produtos e derivados metálicos
Manutenção industrial
Acessórios para a indústria
e matéria-primas
para metalo-mecânica
Sociedade de representações
de produtos e derivados metálicos
Manutenção industrial

DESIGN FIRM MA&A—Mário Aurélio & Associados
ART DIRECTOR Mário Aurélio
DESIGNERS Mário Aurélio, Rosa Maia
CLIENT Fransbal

David M. Chandler
President

(319) 377-9245
(319) 377-9541 Fax
chandler @ iwork.net
http://www.iwork.net

5250 North Park Place NE
Suite 111
Cedar Rapids, IA 52402

Internet
AT WORK

DESIGN FIRM Marketing and Communications
Strategies, Inc.
ART DIRECTOR/DESIGNER Lloyd Keels
CLIENT Internet at Work
TOOLS Adobe Illustrator, QuarkXPress, Power
Macintosh 8100
PAPER/PRINTING Two color

form fünf

Verbale und
visuelle
Kommunikation

Daniel Henry Bastian

Alexanderstraße 9B
28203 Bremen

Telefon
0421 782 26
Fax
0421 70 06 17
Isdn
0421 70 30 74

DESIGN FIRM Form 5
DESIGNERS Daniel Bastian,
Ulysses Voecker, Martin Veicht
CLIENT Form 5
TOOLS QuarkXPress, Macromedia
Fontographer, Adobe Photoshop, Stamp
PAPER/PRINTING Karten Karton

DESIGN FIRM The Design Company
ART DIRECTOR/ILLUSTRATOR Marcia Romanuck
CLIENT E. Claire Therapy
PAPER/PRINTING Champion Carnival Wove

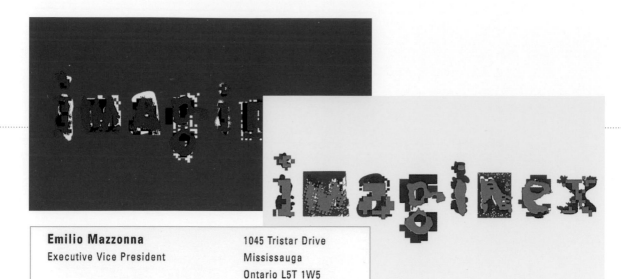

Emilio Mazzonna
Executive Vice President

1045 Tristar Drive
Mississauga
Ontario L5T 1W5

imaginex

Fax 905 795-5550
Telephone 905 795-5555
Toll Free 1 800 468-CYAN

DESIGN FIRM Eskind Waddell
ART DIRECTOR Malcolm Waddell
DESIGNERS Maggi Cash, Nicola Lyon
Florence Ngan, Gary Mansbridge
CLIENT Imaginex, Inc.
TOOLS Adobe Photoshop,
Adobe Illustrator, QuarkXPress

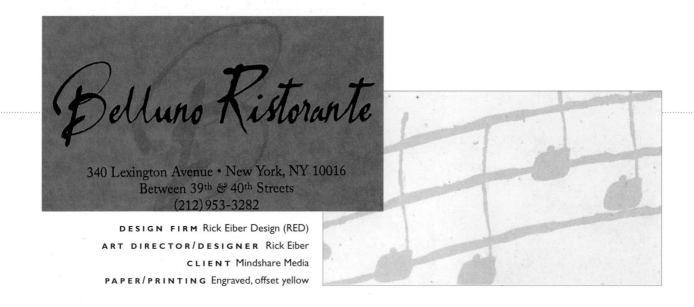

Belluno Ristorante

340 Lexington Avenue • New York, NY 10016
Between 39th & 40th Streets
(212) 953-3282

DESIGN FIRM Rick Eiber Design (RED)
ART DIRECTOR/DESIGNER Rick Eiber
CLIENT Mindshare Media
PAPER/PRINTING Engraved, offset yellow

DESIGN FIRM Angry Porcupine Design
DESIGNER/ILLUSTRATOR Cheryl Roder-Quill
CLIENT Cheryl Roder-Quill
TOOLS Macintosh, QuarkXPress

cheryl roder.quill

industrial strength design

4662 hidden pond drive allison park pa 15101

fax [412] 492 9975

[412] tel 492 9973

cheryl roder.quill

industrial strength design

492 9973

DESIGN FIRM Animus Comunicação
ART DIRECTOR Rique Nitzsche
DESIGNER Victal Caesar
CLIENT Neisa Nitzsche Teixeira
TOOLS Macromedia FreeHand,
Adobe Photoshop
PAPER/PRINTING
Opaline 180 gsm/Five color

DESIGN FIRM Büro B.
DESIGNER Daniel Bastian
CLIENT Caro Fotoagentur
TOOLS QuarkXPress
PAPER/PRINTING Karten
Karton/Offset

DESIGN FIRM Tanagram
DESIGNER Lance Rutter
CLIENT Aero Internet Services
TOOLS Macromedia FreeHand

DESIGN FIRM Held Diedrich
ART DIRECTOR Dick Held
DESIGNER Sander Leech
CLIENT Grand Slam
TOOLS Adobe Illustrator, QuarkXPress
PAPER/PRINTING Neenah, Classic Crest,
Solar White/Offset

DESIGN FIRM Steve Trapero Design
ART DIRECTOR/DESIGNER Steve Trapero
CLIENT Franz & Company, Inc.
TOOLS QuarkXPress, Adobe Illustrator
PAPER/PRINTING Graphica Lineal/Two-color offset

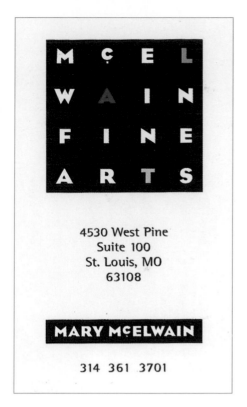

DESIGN FIRM Bartels & Company, Inc.
ART DIRECTOR David Bartels
DESIGNER/ILLUSTRATOR Aaron Segall
CLIENT McElwain Fine Arts
PAPER/PRINTING Mid West Printing

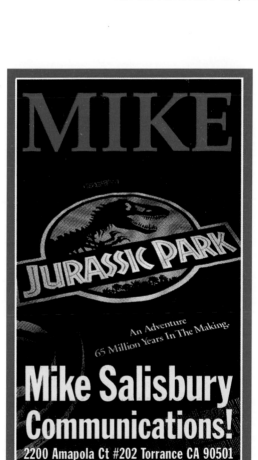

DESIGN FIRM Mike Salisbury Communications
ART DIRECTOR Mike Salisbury
DESIGNER Mary Evelyn McGough
CLIENT Mike Salisbury

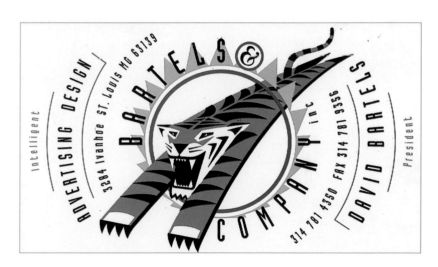

DESIGN FIRM Bartels & Company, Inc.
ART DIRECTOR David Bartels
DESIGNER/ILLUSTRATOR Bob Thomas
CLIENT Bartels & Company, Inc.
PAPER/PRINTING Chromecoat/Devere Printing

HIROKO TANAKA
One Irving Place U-12b
New York, NY 10003
Tel 212·995·8489 Fax 212·254·8233

DESIGN FIRM Mirko Ilić Corp.
ART DIRECTOR/DESIGNER Nicky Lindeman
CLIENT Mirko Ilić Corp.
TOOLS QuarkXPress
PAPER/PRINTING Cougar Smooth white
80 lb. cover/Rob-Win Press

DESIGN FIRM
Carl Chiocca Creative Designs
ALL DESIGN
Carl Chiocca
TOOLS
Adobe Photoshop, QuarkXPress
PAPER/PRINTING
Lustro Gloss 80 lb. cover/
Two color offset

CARL CHIOCCA
CREATIVE DESIGNS
& PRINT PRODUCTION

10 renwick street pittsburgh pa 15210

PHONE 412 431·2095 FACSIMILE 412 431·7750

GRAPHIC IDEAS
949781824

mika ruusunen

DESIGN FIRM M-DSIGN
ALL DESIGN Mika Ruusunen
CLIENT M-DSIGN
TOOLS Macintosh
PAPER/PRINTING Offset

DESIGN FIRM Judy Wheaton
ART DIRECTOR/DESIGNER Judy Wheaton
ILLUSTRATOR Creative Collection
CLIENT Al-Pack
TOOLS Adobe Photoshop, Adobe PageMaker
PAPER/PRINTING Classic Laid/TK Printing

327 Newport Center Dr.
Fashion Island
Newport Beach, California 92660
Tel 714•640•2700

DESIGN FIRM On The Edge
ART DIRECTOR Jeff Gasper
DESIGNER Jon Nedry
ILLUSTRATOR Robert Wilhelm
CLIENT Chimayo Grill
TOOLS Adobe Illustrator, QuarkXPress, Adobe Photoshop
PAPER/PRINTING Luna White coated/Four color

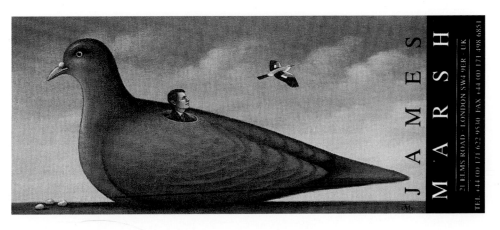

ALL DESIGN James Marsh
CLIENT James Marsh
TOOLS Acrylic
PAPER/PRINTING Four color

DESIGN FIRM Charney Design
ART DIRECTOR/DESIGNER
Carol Inez Charney
ILLUSTRATOR Kim Ferrell
CLIENT Village Bakehouse
TOOLS Adobe Illustrator,
Adobe Photoshop
PAPER/PRINTING
Environment/Offset

DESIGN FIRM Kerrickters
ALL DESIGN Christine Kerrick
CLIENT Christine Kerrick
TOOLS Graphite, Adobe Illustrator

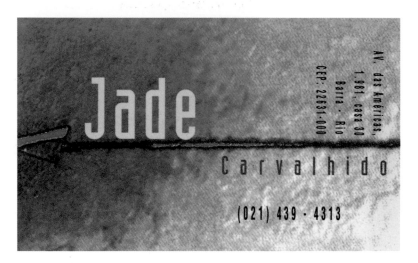

DESIGN FIRM Animus Comunicaçáo
ART DIRECTOR Rique Nitzsche
DESIGNER Victal Caesar
CLIENT Jade Carvalhido
TOOLS Macromedia FreeHand, Adobe Photoshop
PAPER/PRINTING Opaline 180 gsm/Four color

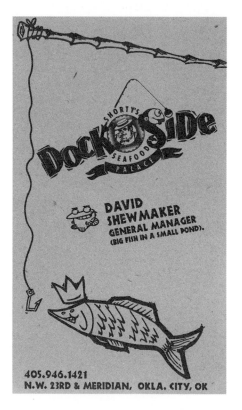

DESIGN FIRM Val Gene Associates
ART DIRECTOR/DESIGNER Lacy Leverett
ILLUSTRATOR Christopher Jennings
CLIENT Dockside
PAPER/PRINTING Baker's Printing

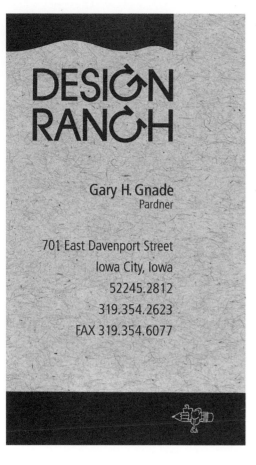

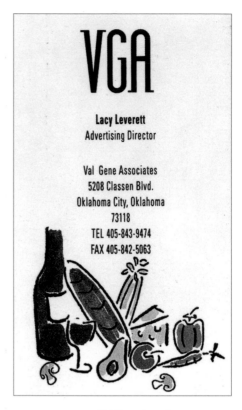

DESIGN FIRM
Design Ranch
ART DIRECTOR/DESIGNER
Gary Gnade
CLIENT
Design Ranch

DESIGN FIRM Val Gene Associates
ALL DESIGN Lacy Leverett
PRODUCTION Shirley Morrow
CLIENT Val Gene Associates
PAPER/PRINTING Baker's Printing

DESIGN FIRM Judy Wheaton
ART DIRECTOR/DESIGNER Judy Wheaton
CLIENT Judy Wheaton
TOOLS Adobe PageMaker
PAPER/PRINTING Kromekote/TK Printing

STRATEGIC CHURCH PLANTING

7913 N.E. 58TH AVENUE
VANCOUVER, WA 98665

TEL 360.694.4985
FAX 360.694.0219

MATT HANNAN
DIRECTOR OF CHURCH PLANTING
COLUMBIA BAPTIST CONFERENCE

DESIGN FIRM Rick Eiber Design (RED)
ART DIRECTOR Rick Eiber
CLIENT Columbia Baptist Conference
PAPER/PRINTING Brightwater/Two colors over two colors

GOLF TV

SUZANNE STEEVES
SENIOR VICE-PRESIDENT
AND GENERAL MANAGER

● ● ● ● ● ● ●

P.O. BOX 9, STATION "O",
TORONTO, ONTARIO, CANADA M4A 2M9
TEL: (416) 299-2070
FAX: (416) 299-2076

DESIGN FIRM
BBS In House Design
ALL DESIGN
Joyce Woollcot
CLIENT
BBS/Golf TV
TOOLS
Adobe Illustrator
PAPER/PRINTING
Strathmore Elements Dots

SUSAN BIERZYCHUDEK
SENIOR ACCOUNTS DIRECTOR

A X I O N image solutions for brand success

415 258 6807 T
415 457 8227 F
susanb@axionsf.com e

DESIGN FIRM Axion Design, Inc.
ART DIRECTOR/DESIGNER Kenn Lewis
CLIENT Axion Design
TOOLS Adobe Illustrator
PAPER/PRINTING Environment Ivory 80 lb./Offset, embossed

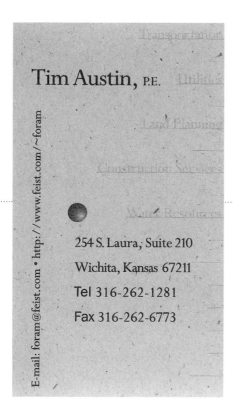

DESIGN FIRM Greteman Group
ART DIRECTORS/DESIGNERS Sonia Greteman, James Strange
CLIENT Austin Miller Engineering Services
TOOLS Macromedia FreeHand
PAPER/PRINTING Genesis/Two-color offset

DESIGN FIRM Sivustudio
ART DIRECTOR Jaana Aartomaa
CLIENT Kim Haukatsalo
TOOLS Macromedia FreeHand, Macintosh
PAPER/PRINTING Flannel/Offset

DESIGN FIRM D2 Design
ALL DESIGN Dominique Duval
CLIENT D2 Design
TOOLS Adobe Illustrator, Adobe Photoshop, Macintosh
PAPER/PRINTING Two-color offset

DESIGN FIRM
JWK Design Group, Inc.
ALL DESIGN Jennifer Kompolt
CLIENT Maternal Concepts Ltd.
TOOLS Adobe Illustrator
PAPER/PRINTING Simpson
Evergreen Script Aspen

DESIGN FIRM Design Source
ALL DESIGN Cari Johnson
CLIENT Dr. Thomas Suzuki
TOOLS Adobe Illustrator
PAPER/PRINTING Karma
Natural/Two-color offset

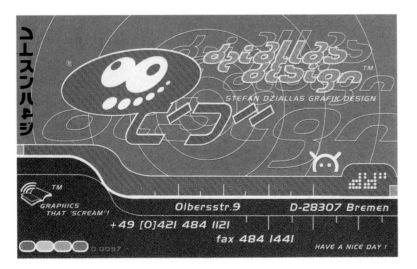

DESIGN FIRM Stefan Dziallas Design
DESIGNER/ILLUSTRATOR Stefan Dziallas
CLIENT Stefan Dziallas
TOOLS Adobe Photoshop, QuarkXPress, Macintosh
PAPER/PRINTING 300gsm Matt/Schneidersöhne

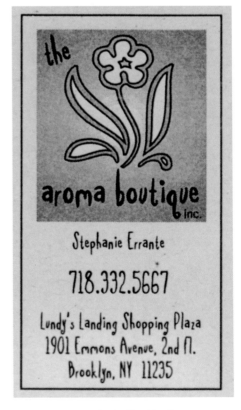

DESIGN FIRM Apple Graphics &
Advertising of Merrick, Inc.
DESIGNER Allison Blair Schneider
CLIENT The Aroma Boutique
TOOLS Macromedia FreeHand,
Power Macintosh 7500
PAPER/PRINTING Fox River Circa Select
Moss/One-color themography

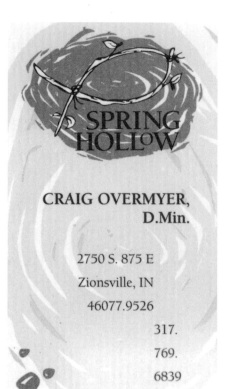

DESIGN FIRM
Held Diedrich

ART DIRECTOR
Doug Diedrich

DESIGNER/ILLUSTRATOR
Megan Snow

CLIENT
Spring Hollow

TOOLS
QuarkXPress, Adobe Illustrator

PAPER/PRINTING
Neenah, Classic Laid,
Natural White/Offset

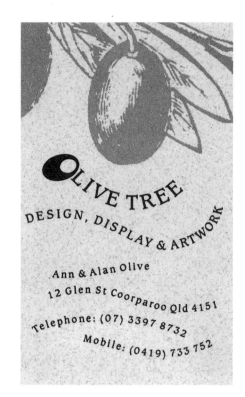

DESIGN FIRM Olive Tree
ART DIRECTOR/DESIGNER Alan Olive
ILLUSTRATOR Kent Smith
TOOLS CorelDraw
PAPER/PRINTING Edwards Dunlop
Recycled Evergreen

DESIGN FIRM Sayles Graphic Design
ALL DESIGN John Sayles
CLIENT Sbemco International
PAPER/PRINTING Curtis Retreeve white/Offset

DESIGN FIRM Gardner Graphics
ALL DESIGN Dianne Gardner
CLIENT Dianne Gardner
TOOLS Adobe Photoshop
PAPER/PRINTING Coated

KRISTY ANN KUTCH

Colored Pencil Artwork/Instruction
11555 West Earl Road
Michigan City, IN 46360

219 · 874 · 4688

Berry Bounty, 16" x 18"

DESIGN FIRM Kristy A. Kutch
ILLUSTRATOR Kristy A. Kutch
TOOLS Colored pencil painting
PAPER/PRINTING Perfect Picture

PROGRESSIVE CENTER
FOR INDEPENDENT LIVING INC.

MEG NORTH
EXECUTIVE DIRECTOR

831 PARKWAY AVENUE, B-2
EWING, NJ 08618
PHONE: (609) 530-0006
FAX: (609) 530-1166
TTY: (609) 530-1234

DESIGN FIRM Howard Levy Design
ART DIRECTOR/DESIGNER Howard Levy
CLIENT Progressive Center for Independent Living, Inc.
TOOLS QuarkXPress, Adobe Illustrator
PAPER/PRINTING Two-color offset

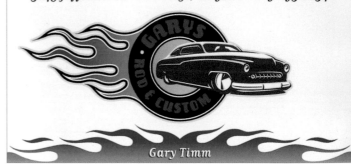

Complete Street Rod Chassis and Suspension
3045 Jefferson St. • San Diego, CA 92110 • 619 293 0834

Gary Timm

DESIGN FIRM Mires Design
ART DIRECTOR/DESIGNER John Ball
ILLUSTRATOR Tracy Sabin
CLIENT Gary's Hot Rods

DESIGN FIRM Keiler Design Group
ART DIRECTOR Jeff Lin
DESIGNERS Jeff Lin
ILLUSTRATOR Jim Coon
CLIENT Matt Rohde
TOOLS Adobe Photoshop

matt rohde

keyboardist/pianist

5540 roswell road
unit e201
sandy springs,
ga 30342

404.303.7735

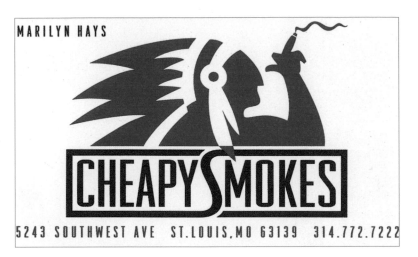

MARILYN HAYS

CHEAPY SMOKES

5243 SOUTHWEST AVE ST.LOUIS,MO 63139 314.772.7222

Francisco José
manager

F. da S. Barbosa, Lda.
Rua de S. Rosendo, 427/431
4300 Porto
Tel: (02) 571986/572789
Fax: (02) 572001

F·S·B
MANUTENÇÃO
CONSERVAÇÃO,
REPARAÇÃO
AO SERVIÇO
DA INDÚSTRIA

© Mário Aurélio & Associados

Kristin V. M. Beattie

MOSTUE & ASSOCIATES

ARCHITECTS, INC.

240A Elm Street
Somerville, MA 02144
Tel: 617-628-5700
Fax: 617-628-1717
E-mail: mostue@aol.com

Pam Widener

DESIGN FIRM The Eikon Marketing Team
ALL DESIGN Dannah Gresh
CLIENT K-DAY 97.5
TOOLS Macromedia FreeHand
PAPER/PRINTING Beckett Laid white

THE TRUE BLUE COMPANY

TRUE BLUE

BRIAN LIPNER

PRESIDENT

939 WEST HURON, No. 108

CHICAGO, ILLINOIS 60622

PHONE 312.563.9944

FAX 312.563.0125

E-MAIL BLIPNER@AOL

DESIGN FIRM Michael Stanard Design, Inc.
ART DIRECTOR Michael Stanard
DESIGNER Kristy Vandekerckhove
CLIENT Brian Lipner/The True Blue Co.
PAPER/PRINTING Strathmore Renewal/Offset

DESIGN FIRM Carl D. J. Ison
ART DIRECTOR/DESIGNER Carl D. J. Ison
CLIENT Carl D. J. Ison
TOOLS QuarkXPress, Adobe Illustrator, Adobe Photoshop
PAPER/PRINTING One color on two sides, various metal and alloy 3D tip ons: eyelet, nut/bolt, and lead discs

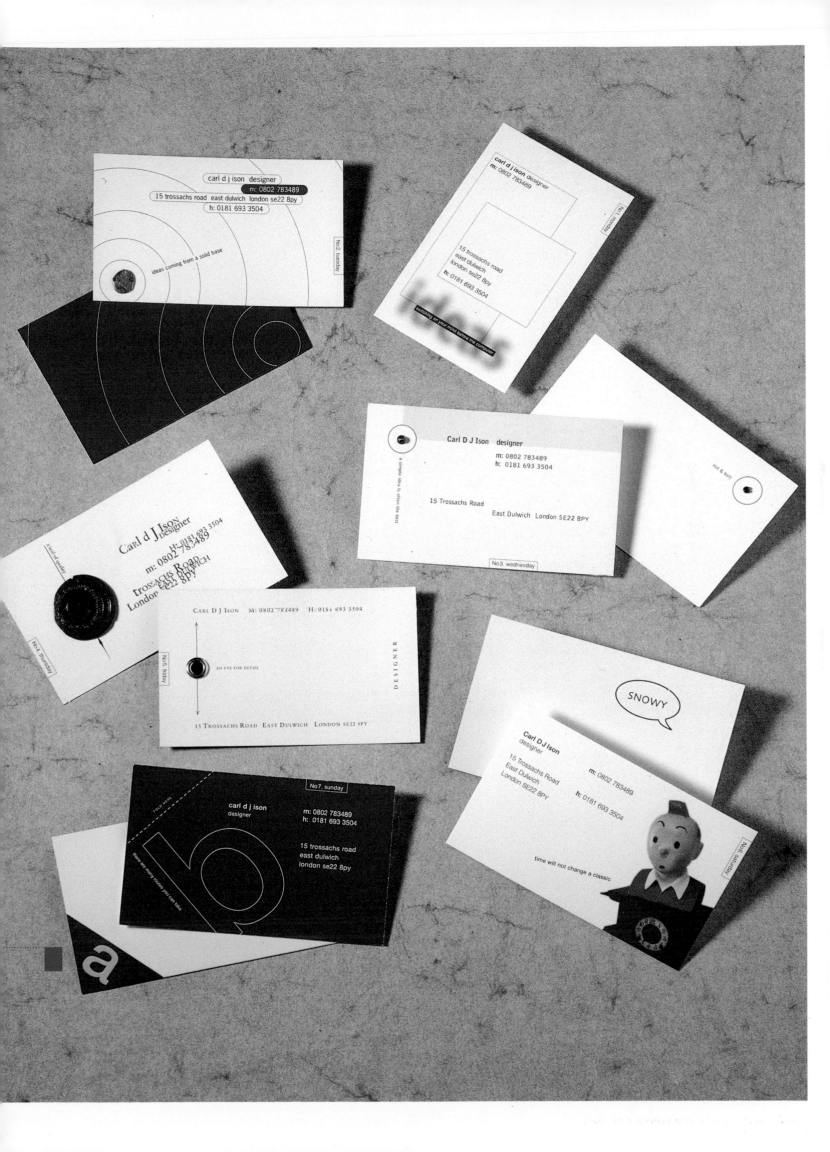

Mary Bold

Interior Designer

5016 South 110 Street
Omaha, NE 68137
402·592·6905

DESIGN FIRM New Idea Design, Inc.
DESIGNER/ILLUSTRATOR Ron Boldt
CLIENT Castle or Cottage Interiors
TOOLS Pen and ink, Macintosh, Macromedia FreeHand
PAPER/PRINTING Strathmore, metallic inks/The Print Shop

RICHARD DURAN

P.O. BOX 6903 〜 ORANGE, CALIFORNIA 92613
TEL 714-633-7549 〜 FAX 714-633-7598

DESIGN FIRM Jon Nedry
ALL DESIGN Jon Nedry
CLIENT Classic Cigar Company
TOOLS Adobe Illustrator, QuarkXPress
PAPER/PRINTING Neenah Environment,
Cover Duplex, Desert Storm/Alpaca

DESIGN FIRM Jane Dill Calligraphy & Design
ART DIRECTORS/DESIGNER Jane Dill
CLIENT Jane Dill
TOOLS Brush, type
PAPER/PRINTING Benefit Champion/blind
emboss, foil stamp

3059-K HOPYARD ROAD, PLEASANTON, CA 94588
PHONE 510 • 846 • 0544

DESIGN FIRM Designing Concepts
DESIGNERS Renee Sheppard, Mariah Parker
CLIENT The Pleasanton Spa
TOOLS QuarkXPress, Adobe Photoshop, Adobe Illustrator
PAPER/PRINTING Wigt's

Steven M. Webb
Division Manager

P.O. Box 297
Emigrant, MT 59027
phone: 800.406.0495
fax: 406.333.4769
grw@goldenratio.com

DESIGN FIRM Roger Gefvert Designs
ALL DESIGN Roger Gefvert
CLIENT Golden Ratio Sports
TOOLS Macintosh, Adobe Illustrator,
Adobe Photoshop, QuarkXPress
PAPER/PRINTING Neenah Classic Columns

Michael N. Macris
President

American Polymer Corp.®	Tel 801.255.9505
9176 South 300 West	Fax 801.255.7123
Suite Number Four	Pager 800.509.7813
Sandy, Utah 84070	

DESIGN FIRM Rick Eiber Design (RED)
ART DIRECTOR/DESIGNER Rick Eiber
CLIENT American Polymer Corp.
PAPER/PRINTING Columns/Three color over two color

Rita Allman
Office Manager

EXECUTIVE DIVERSITY
SERVICES, INC.

675 South Lane Street, Suite 305
Seattle, WA 98104-2942
(206) 224-9293 • Fax (206) 224-9303

DESIGN FIRM Walsh and Associates, Inc.
ART DIRECTOR/DESIGNER Miriam Lisco
CLIENT Executive Diversity Services
TOOLS Adobe Illustrator, Adobe PageMaker
PAPER/PRINTING Classic Crest Natural White/A & A Printing

DESIGN FIRM The Paul Martin Design Co.
ART DIRECTOR Paul Martin
DESIGNER Paul Adams
CLIENT The Paul Martin Design Co.
PAPER/PRINTING Huntsman Velvet
300 gsm/St. Richard's Press

DESIGN FIRM Bullet Communications, Inc.
ALL DESIGN Tim Scott
CLIENT Dal Lido Restaurant
TOOLS QuarkXPress, Adobe Illustrator
PAPER/PRINTING Carolina 8 pt. cover/Offset

DESIGN FIRM Hanke Kommunikation
ART DIRECTOR Kersten Hanke
CLIENT Hanke Kommunikation
TOOLS Macintosh, Adobe Photoshop,
Macromedia FreeHand

KAN TAI-KEUNG
CREATIVE DIRECTOR

28/F, 230 WANCHAI RD
WANCHAI, HONG KONG
TELEPHONE (852) 574 8399
FACSIMILE (852) 572 0199

DESIGN FIRM
Kan & Lau Design Consultants
ART DIRECTOR/DESIGNER
Kan Tai-keung
CLIENT
Tokong Link Design Centre Ltd.
PAPER/PRINTING
Gilbert White Cockle 216 gsm/Offset

DESIGN FIRM Stephen Peringer Illustration
DESIGNER/ILLUSTRATOR
Stephen Peringer
CLIENT Cool Hand Luke's Cafe

rd#6 box 6274, Spring Grove, PA 17362
717-225-6234
fax 717 -225-7185

DESIGN FIRM Burgard Design
ALL DESIGN Todd Burgard
CLIENT Burgard Cycle
TOOLS Adobe Illustrator, Dimensions
PAPER/PRINTING Becket Expression Iceberg/
Two colors over one color

CHEX INTERNATIONAL SALES LIMITED

PATRICK CHAN

OFFICE 50 SILVER STAR BLVD., UNIT 207
SCARBOROUGH, ONTARIO M1V 3L3, CANADA
TEL/FAX (416) 292 4857
SHOP UNIT 56, SCARBOROUGH TOWN CENTRE
300 BOROUGH DRIVE, SCARBOROUGH
ONTARIO M1P 4P5, CANADA
TEL (416) 296 9914

DESIGN FIRM Kan & Lau Design Consultants
ART DIRECTORS Kan Tai-keung, Freeman Lau Siu Hong
DESIGNER Freeman Lau Siu Hong
CLIENT Chex International Sales Ltd.
PAPER/PRINTING Conqueror Brilliant White Wove
220 gsm/Three-color offset

Sam A. Angeloff

Sam A. Angeloff

Writing and Editing

for Visionary Businesses.

The writer's job is to tell a story

that is compelling, factual and

easily understood.

Clear and Direct

Original and Persistent

Accurate and Inventive

Adept and Cost-Effective

DESIGN FIRM Paper Power
ART DIRECTOR/DESIGNER Lyn Hourahine
CLIENT Paper Power
TOOLS Macintosh
PAPER/PRINTING Zeta matt Post Hammer
260 gsm/One color, diecut, offset litho

DESIGN FIRM Pen Ultimate
ALL DESIGN Sara Hanan
CLIENT Joe Hinnegan
TOOLS Initial and fonts after *Book of Kells*,
Macromedia Fontographer, CorelDraw

DESIGN FIRM Paper Power
ART DIRECTOR/DESIGNER Lyn Hourahine
DESIGNER Sherwin Schwartzrock
CLIENT Paper Power
TOOLS Macintosh
PAPER/PRINTING Zeta matt Post Hammer
260 gsm/One color, diecut, offset litho

PAPER POWER

53 WARWICK ROAD. EALING. LONDON W5 5PZ

TEL 0181 579 6631 FAX 0181 840 1990

Lyn Hourahine FCSD

CHARTERED PAPER PRODUCT DESIGNERS

CREATIVE PAPER ENGINEERING DESIGN

PAPER POWER

53 WARWICK ROAD. EALING. LONDON W5 5PZ

TEL 0181 579 6631 FAX 0181 840 1990

Lyn Hourahine FCSD

CHARTERED PAPER PRODUCT DESIGNERS

CREATIVE PAPER ENGINEERING DESIGN

1

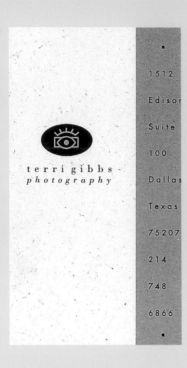

terri gibbs
photography

1512

Edison

Suite

100

Dallas

Texas

75207

214

748

6866

2

CENTRE
CHIROPRATIQUE

BLAINVILLE

Pour vôtre mieux-être

Dr. Michel Delorme, D.C.
Chiropraticien

10 boul. de la Seigneurie
Bureau 202
Blainville Québec
J7C 3V5
Tél.: 971.0824

3

Little&AssociatesArchitects

THOMAS L. BALKE, AIA
Senior Associate

5815 WESTPARK DRIVE
CHARLOTTE, NC 28217

DIRECT LINE: 704.561.3414
FACSIMILE: 704.522.7889
RECEPTIONIST: 704.525.6350

4

The
Jones Collection
MANUFACTURERS' REP

Jacqueline L. Jones

TEL (510) 339-1478
FAX (510) 339-7241

5744 GRISBORNE AVE
OAKLAND, CA 94611

5

METROWEST

LANDSCAPE

COMPANY

P.O. Box 874,

Natick,

Massachusetts

01760

"Complete

Landscape

Services"

METROWEST

Eric Meltzer

508.788.0552

617.444.1305

6

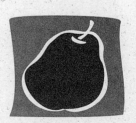

SHELLI McCONNELL

Food Writer · Consultant

811 North B Street
Indianola, Iowa 50125

515-961-9213

1 Design Firm
Sibley/Peteet Design, Inc.
Designer
Derek Welch
Client
Terri Gibbs
Photography

2 Design Firm
D2 Design
Designer
Dominique Duval
Client
Centre Chiropratique Blainville
Chiropractors

3 Design Firm
Mervil Paylor Design
Designer
Mervil M. Paylor
Client
Little & Associates Architects
Commercial architecture

4 Design Firm
Visible Ink
Designer
Sharon Howard Constant
Client
The Jones Collection
Manufacturers' representative

5 Design Firm
Sullivan Perkins
Designer
Art Garcia
Client
Metrowest Landscape Company
Landscaping

6 Design Firm
Visual Advantage
Designer
Ann Hiemstra
Client
Shelli McConnell
Food writer and consultant

1

SANDI Wasserstein

SOFTWARE + HARDWARE Consulting and Training

. SANDIS DESIGNS
20 Locksly Lane
San Rafael, California 94901
Voice [415] 454.0731

2

g∂

GATES
GROUP

276 JERSEY STREET
SAN FRANCISCO ·
CALIFORNIA 94114

PH 415 206 1237
FX 415 206 0711

MARKETING PUBLIC RELATIONS

L A U R A G A T E S

3

31 HODGES ALLEY

SAN FRANCISCO

CALIFORNIA 94133

 MONROY & COVER DESIGN

GRAPHIC DESIGNER

GAIL COVER

TEL / FAX 415 - 986 - 3171

4

g

GINA GALLIGAN & ASSOCIATES

MELISSA GATCHEL-NORTH 2523 MCKINNEY SUITE A

CREATIVE DIRECTOR DALLAS, TEXAS 75201

TELEPHONE (214) 871-7971

FACSIMILE (214) 871-7974

1 Design Firm
Sunny Shender Design
Designer
Sunny Shender
Client
Sandis Designs
Fine jewelry and beadwork retailBC

2 Design Firm
Design Group Cook
Designer
Ken Cook
Client
The Gates Group
Public relations

3 Design Firm
Monroy & Cover Design
Designer
Gail Cover
Client
Amanda Pirot
Marketing and project management

4 Design Firm
David Carter Design
Art Director
Lori B. Wilson
Designer
Ricky Brown
Illustrator
Ricky Brown
Client
Gina Galligan & Associates
Marketing and public relations

5 Design Firm
Chee Wang Ng
Designer
Chee Wang Ng
Client
Treeline Management Corporation
Property management

6 Design Firm
Design Group Cook
Designer
Ken Cook
Client
Niman Schell Ranch
Cattle-raising ranch

5

▶ Jack Lagrassa

TREELINE MANAGEMENT CORP.

371 Merrick Road Tel : 516. 678 2525
Rockville Centre Fax: 516. 678 9859
NY 11570

6

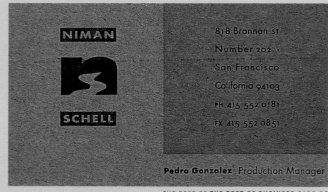

NIMAN

SCHELL

818 Brannan st
Number 202 ·
San Francisco
California 94103
PH 415 552 0181
FX 415 552 0851

Pedro Gonzalez Production Manager

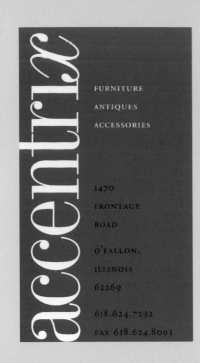

1

accentrix

FURNITURE

ANTIQUES

ACCESSORIES

1470

FRONTAGE

ROAD

O'FALLON,

ILLINOIS

62269

618.624.7292

FAX 618.624.8093

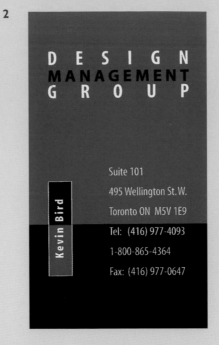

2

DESIGN
MANAGEMENT
GROUP

Kevin Bird

Suite 101
495 Wellington St. W.
Toronto ON M5V 1E9

Tel: (416) 977-4093

1-800-865-4364

Fax: (416) 977-0647

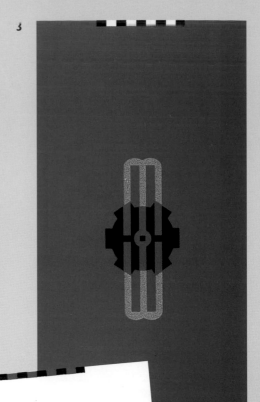

3

1 Design Firm
Phoenix Creative
Designer
Eric Thoelke
Client
Accentrix
High-end furniture and
antique retail

2 Design Firm
Design Management Group
Art Director
Kevin Bird
Designer
Kevin Bird
Client
Self-promotion
Communications counseling, design,
and writing

3 Design Firm
Greteman Group
Designers
Sonia Greteman, James Strange
Client
Motorworks by Autocraf
Auto repair

4 Design Firm
THARP DID IT
Art Director
Rick Tharp
Designers
Laurie Okamura, Colleen Sullivan, Rick Tharp
Illustrator
Georgia Deaver
Client
Integrated Media Group
Multi-media educational materials

ELAINE ARONIS

MARKETING DIRECTOR

M O T O R
W O R K S
BY AUTOCRAFT

1116 EAST DOUGLAS

WICHITA, KS 67214

TEL 316 267-8888

FAX 316 265-0766

SPECIALIZING IN

HONDA MAZDA NISSAN TOYOTA

4

SHELLY S. MOORE
President and CEO

8 Davis Drive
Belmont
California 94002
Tel. 415.637.7600
Fax 415.593.0499

INTEGRATED
MEDIA
GROUP

Romeo to get into **VROOM!** Nobody gets it about technology. People knowing more. People finding out. People getting the message. People fixing the details. People acting in unison. People freeing creativity. People having the time **WHIRRR** Metatypographicon **TAPTAPPETYTAP** Your wrist is exhausted from all that pointing and clicking. Time for some stretching exercises: Converse. Reach. Grab. Lift. Tilt. Drink. Repeat **GLUB** Female hand reaches into view and with weary authority presses **PLAY FWEEP?** "Be it declared for ever that I Bronwyn, wife of Idris of Hampstead, in return for the Miracle of my husband's life..." **CLANGG...** A player does a little victory jig to the congratulations of his friends. Apparently he has just saved their fantasy lives **KA-CHING!** The bad news is: money is ugly. Anchored in the past, hidebound by tradition, the money we scratch to get turns out to be insipid, colorless, prosaic **WHOOSH!** Having obtained a mysterious Object in the Southern Outpost, the players travel to Kalaman to have the Object deciphered by the Dream Merchant in Kalaman's famous open-air bazaar **WHIFF** Pansies, those infallible border brighteners, have a remarkable past. Apothecarists clandestinely plucked them for love potions; Victorians extolled their virtues in art. Turkish perfumers harvested them by the ton **PLUCK** The joys of attempting and accomplishing are powerful currency **THUNK!** Head. Heart. Hands. / The tao of gardens / informs our work. / Nurture. Shape. Cultivate.
cabinet door
oriented **AHA!**
neighbors, a pa
Remember, if y

Ken Eklund Communications

526 Fuller Avenue San Jose CA 95125·1544

VOX *et* FAX 408·280·1441

SHAZAM!

1 Design Firm
Melissa Passehl Design
Designer
Melissa Passehl
Client
Ken Eklund Communications
Copywriting

2 Design Firm
The Bradford Lawton Design Group
Art Directors
Brad Lawton, Jennifer Griffith-Garcia
Designer
Brad Lawton
Illustrators
Brad Lawton, Jody Laney
Client
Redfeather Design
Snowshoe design and manufacturing

3 Design Firm
Cato, Berro García & Di Luzio S.A.
Designer
Gonzalo Berro García
Client
Jose Luis Rodriguez
Photography

4 Design Firm
Choplogic
Designer
Walter McCord
Client
Prospects for Fitness
Health club

5 Design Firm
España Design
Designer
Cecilia España
Client
Self-promotion
Graphic design

3

JOSE LUIS RODRIGUEZ
· FOTOS ·

AV. MITRE 4030
DPTOS. 2.4.5
1605 · VICENTE LOPEZ
TEL./FAX.: 756-4763

2

We at Redfeather Design
are dedicated to building
long-term relationships.

We are committed to
providing quality products,
information and support.

Our goal is that your
Redfeather outdoor
experience exceeds
your expectations.

REDFEATHER
SNOWSHOES

Frank Feder

1280 Ute Ave., #20
Aspen, CO 81611
Tel 303 925·5333
1·800 525·0081
Fax 303 925·231

4

PROSPECTS

Ann T. Harpole

Prospects for Fitness
9207 C U.S. Highway 42
Prospect, Kentucky 40059
(502) 228·8760

5

Cecilia España Diseñadora Gráfica

Av. Figueroa Alcorta 3086-8º

1425 Capital Federal

Teléfono y fax 807-6545

ABcDeF HIJKL

1

JOHN OAT

ART DIRECTION

COMPUTER GRAPHICS

DESIGN & ILLUSTRATION

8900 Tarrytown Drive
Richmond, Virginia 23229
Phone/Fax (804) 741-8649

2

Phillip Esparza

photographer

3711 Parry Avenue

Suite 103

Dallas Texas 75226

214.823.9782

214.823.9784 fax

p.e.

3

WESTMINSTER
CHRISTIAN
FELLOWSHIP

REV. HARRY METZGER

16670 Easton Avenue

Prairie View, Illinois 60069

708.367.1034

4

TRACS

Technical
Research
and
Consulting
Service

Ron Kukas

1128 W. Evergreen

Visalia, CA 93277

Phone or Fax:

209-627-6971

Mobile:

209-730-2244

5

ANTIQUES
RUSSELL P. ROUSHON
296 TAUGWONK ROAD
STONINGTON, CT 06378
SHOP 203.535.4483
RESIDENCE 203.535.9170

6

FREELANCE CAMERAMAN
STEVE BREASHEARS
2822 KINNEY DRIVE
WALNUT CREEK, CA 94595
510/937-2174

1 Design Firm
John Oat Communication Arts
Designer
John Oat
Client
Self-promotion
Graphic design

2 Design Firm
Gibbs Baronet
Art Directors
Steve Gibbs, Willie Baronet
Designers
Kellye Kimball, Steve Gibbs
Illustrator
Kellye Kimball
Client
Phillip Esparza
Photography

3 Design Firm
Associates Design
Designer
Beth Finn
Client
Westminster Christian Fellowship

4 Design Firm
Covi Corporation
Agency Gillham & Associates
Designer
Mona Howell
Illustrator
Mona Howell
Client
Tracs
Soil and pesticide consulting

5 Design Firm
PhD
Designer
Terri Haas
Client
Antiques

6 Design Firm
B3 Design
Designer
Barbara B. Breashears
Client
Steve Breashears
Freelance cameraman

1 CRISPIN CONSULTING GROUP

1450 MADRUGA AVENUE
SUITE 200
CORAL GABLES, FLORIDA
3 3 1 4 6

CHARLES CRISPIN
3 0 5 . 6 6 9 . 9 7 2 1 FAX
3 0 5 6 6 9 . 9 1 4 6

C

1 Design Firm
Pinkhaus Design Corp.
Designer
Susie Lawson
Client
Charles Crispin
Advertising

2 Design Firm
Zauhar Design
Designer
David Zauhar
Client
Scott Gatzke
Photography

3 Design Firm
Design Group Cook
Designer
Ken Cook
Client
Hunter Freeman Photography

4 Design Firm
David Warren Design
Designer
David Warren
Client
Conservation Partners
Land preservation consulting

2

SCOTT GATZKE PHOTOGRAPHY

153 26TH AVE S.E.
SUITE 101
MPLS, MN 55414
TEL: 612·378·0517
FAX: 612·378·9456

3

HUNTER FREEMAN STUDIO

123 South Park

San Francisco

California 94107

Represented by

Bobbi Wendt

HUNTER FREEMAN

Ph. 415 495 1900

Fax 415 495 2594

4

CONSERVATION

1138 Humboldt Street

Denver, Colorado

80218

(303) 831-9378

FAX (303) 831-9379

P
A
R
T
N
E
R
S

MARTY ZELLER
President

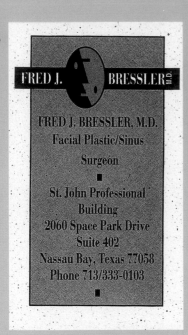

FRED J. BRESSLER, M.D.

Facial Plastic/Sinus

Surgeon

■

St. John Professional
Building
2060 Space Park Drive
Suite 402
Nassau Bay, Texas 77058
Phone 713/333-0103

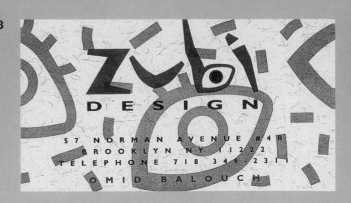

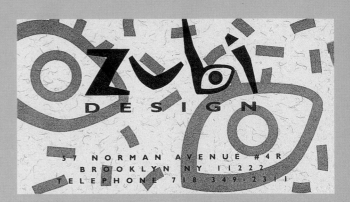

FRANK WIEDEMANN

GRAPHIC DESIGN

2077 Fulton Street
San Francisco, CA 94117
415 221 0192

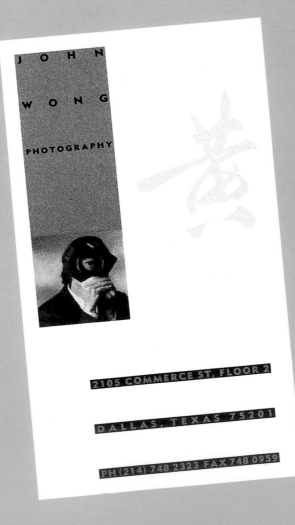

JOHN WONG PHOTOGRAPHY

2105 COMMERCE ST, FLOOR 2

DALLAS, TEXAS 75201

PH (214) 748 2323 FAX 748 0959

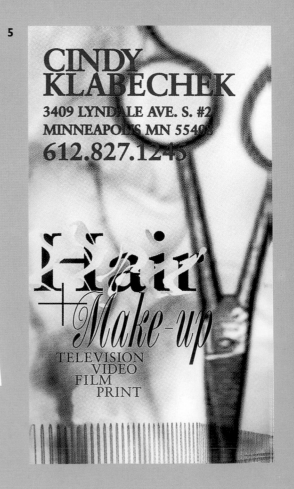

1 Design Firm
MAH Design Inc.
Designer
Mary Anne Heckman
Illustrator
Mary Anne Heckman, Jack Slattery
Client
Fred J. Bressler, M.D.
Facial and plastic surgery

2 Design Firm
Wiedemann Design
Designer
Frank Wiedemann
Photographer
Frank Wiedemann
Client
Self-promotion
Graphic design

3 Design Firm
Zubi Design
Designer
Kristen Balouch
Client
Self-promotion
Design

4 Design Firm
Peterson & Company
Art Director
Bryan L. Peterson
Designer
Bryan L. Peterson
Illustrator
Jan Wilson
Client
John Wong Photography

5 Design Firm
Stress Lab
Designer
Lizz Luce
Client
Cindy Klabechek
Hair and makeup stylist

1

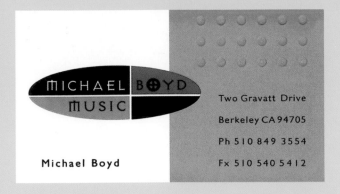

MICHAEL B⊕YD
MUSIC

Two Gravatt Drive
Berkeley CA 94705
Ph 510 849 3554
Fx 510 540 5412

Michael Boyd

2

Charlotte Schiff-Jones
President

830 Lincoln Road, Miami Beach
Florida 33139

Miami
Tel: 305.531.0858
Fax: 305.531.2585
New York
Tel: 212.288.5115

GAMUT MEDIA

3

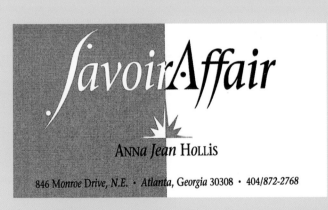

PHOTOGRAPHIC
SCOTT HUNT
ILLUSTRATION

SCOTT HUNT

10837 RUTH ANN DR.
DALLAS, TEXAS 75228
214.613.0930

4

ʃavoirAffair

ANNa Jean HoLLis

846 Monroe Drive, N.E. · Atlanta, Georgia 30308 · 404/872-2768

5

pro
mo
tio
nal.
des
ign

limerock.

drew force

0333 sw flower st.
portland, oregon 97201

503 245 4647

1 Design Firm
Design Group Cook
Designer
Ken Cook
Client
Michael Boyd Music
*Television music and advertising
production company*

2 Design Firm
Pinkhaus Design Corp.
Designer
Todd Houser
Client
Gamut Media
Multi-media productions

3 Design Firm
Sibley/Peteet Design, Inc.
Designer
Derek Welch
Client
Scott Hunt
Photography

4 Design Firm
Two In Design
Designer
Ed Phelps
Client
Savoir Affair
Event planning

5 Design Firm
Drew Force Design
Art Director
Drew Force
Designers
Drew Force, Phil Bradfield
Photographer
Dave Hawkins
Client
Self-promotion,
Graphic design co-operative

1

Anne Semmes

F O O D C O N S U L T A N T

55 Cambridge Drive ❦ Short Hills, NJ 07078 ❦ 201.376.5595

2

fischel.

Fischel Consulting
12136 Madeleine Circle
Dallas, Texas 75230

Bert Fischel

(214) 490-5202 / Fax (214) 490-5220

3

Singulis Vitae
H O M E O P A T I A

DAUTO MIZUTANI

AV AÇOCÊ, 249
MOEMA SP
CEP 04075-021
FONE 884 0242
FAX 884 6782

4

WILSON

FAMILY FUNERAL CHAPEL
"No one will care for your family like our family"

Kim A. Wilson
President

1240 Winton Way at Drakeley Avenue
Atwater, California 95301 • (209) 358-7700 Fax 358-2465

5

LAKE PLACID LODGE

A Classic Adirondack Retreat

1 Design Firm
Toni Schowalter Design
Designer
Toni Schowalter
Client
Anne Semmes
Food consulting

2 Design Firm
Peterson & Company
Designer
Dave Eliason
Client
Fischel
Communications consulting

3 Design Firm
Rocha & Yamasaki Arq.E Design
Designer
Mauricio Rocha
Client
Singulis Vitae
Pharmacy

4 Design Firm
ifx Visual Marketing
Designer
James F. Stone, Jr.
Client
Wilson
Family funeral chapel

5 Design Firm
Kaiser Dicken
Art Director
Craig Dicken
Designers
Craig Dicken, Debra Kaiser
Client
Lake Placid Lodge
Adirondack resort

1

Philip Riis-Carstensen Arkitekt MAA
Ved Højen 10 2900 Hellerup 39 61 23 95

1 Design Firm
Vibeke Nodskov
Designer
Vibeke Nodskov
Client
Philip Riis-Carstensen
Architecture

2 Design Firm
Whitney Edwards Design
Art Director
Charlene Whitney Edwards
Designer
Charlene Whitney Edwards
Illustrator
Nancy Kurtz
Client
Paul Baker Touart
Architectural historian

3 Design Firm
Two In Design
Designer
Ed Phelps
Illustrator
Harriet Burger
Client
Westside Stories
Motion picture production

4 Design Firm
Hornall Anderson Design Works
Art Director
Jack Anderson
Designers
Jack Anderson, Heidi Favour, Bruce
Branson-Meyer
Client
Dave Syferd
Marketing and public relations

5 Design Firm
Phoenix Creative
Designer
Ed Mantels-Seeker
Client
Clayco Accurate Construction
Industrial contracting

6 Design Firm
Melissa Passehl Design
Designer
Melissa Passehl
Client
Alumni Real Estate Group

2

PAUL BAKER TOUART
ARCHITECTURAL HISTORIAN

POST OFFICE BOX 5
WESTOVER, MARYLAND
21871

410 651-1094

3

Westside Stories™

1270 WEST PEACHTREE STREET, NW
SUITE 8B
ATLANTA, GEORGIA 30309
TELEPHONE [404] 908-7499
FACSIMILE [404] 881-1078

4

ALISON T. SEYMOUR, INC.
Natural Fiber Floor Coverings

Alison T. Seymour, Inc.
Natural Fiber Floor Coverings

Voice
206.935.5471

Facsimile
206.935.6409

5423 West Marginal Way SW
Seattle, WA 98106 USA

5

Clayco Accurate
CONSTRUCTION

Dale Robertson
Millwright General Foreman

4124 North Broadway
St. Louis, Missouri 63147
314 241-5444 Office
618 541-8614 Mobile
314 855-6172 Beeper
314 356-9775 Home

6

ALUMNI REAL ESTATE GROUP

POST OFFICE BOX 6952
SAN JOSE, CA 95150
408 226-7653

KARL A. DUMAS

JIM COX
ACOUSTIC AND ELECTRIC BASS
PRIVATE PARTIES • MUSIC CONSULTATION
PHONE 708.329.1213

Andrew Greenberg • 5454 Broadway • Oakland, CA 94618 • Fax 510 420 1574

Greenberg Qualitative Research • 510 420 1514

The Herrington

CINDY PEPPLE
ASSISTANT HOTEL MANAGER

15 SOUTH RIVER LANE
GENEVA, ILLINOIS 60134
7 0 8 · 2 0 8 · 7 4 3 3

D E S I G N • I L L U S T R A T I O N

Michael Lenn

Mi'sha

1638 Commonwealth Av. • Suite 24 • Boston, MA 02135 • Tel. 617.277.7765 • Fax 617.277.3538

1 Design Firm
JOED Design Inc.
Designer
Joanne Rebek
Client
Jim Cox
Musician

2 Design Firm
Stowe Designer
Designer
Jodie Stowe
Client
Greenberg Qualitative
Research

3 Design Firm
Associates Design
Designer
Jill Arena
Client
The Herrington
Bed and breakfast

4 Design Firm
Misha Design
Designer
Michael Lenn
Client
Self-promotion
Design and illustration

Sandy Williamson

(206) 784-7996
1737 NW 56th St.
Suite 101
Seattle, WA 98107
Fax 784-1264

Williamson Landscape
Architecture, LLC

WILLIAL055BF

I

1 Design Firm
Michael Courtney Design
Designer
Michael Courtney
Illustrators
Michael Courtney, Nita Williamson,
Donna Baxter
Client
Williamson Associates
Landscape architecture

2 Design Firm
Marc English Design
Designer
Marc English
Client
Swept Away
Cleaning services

WILLIAMSON LANDSCAPE ARCHITECTURE

Design & Construction

2

WILLIAMSON
LANDSCAPE
ARCHITECTURE

Design & Construction

Sandy Williamson

(206) 784-7996
1737 NW 56th St.
Suite 101
Seattle, WA 98107
Fax 784-1264

Williamson Landscape
Architecture, LLC

WILLIAL055BF

SWEPT AWAY

CHRISTINE BLOMQUIST

49 PLEASANT STREET
EPPING, NEW HAMPSHIRE
03042
TELEPHONE (603) 679-2989

CLEANING SERVICES

1

COMPANY:
Acme Rubber Stamp
NAME
Julie Paquette
TITLE
Artistic Director
STREET
3102 Commerce
CITY | STATE | ZIP
Dallas | **TX** | **75226**
PHONE | FAX
(214) 748-4707 | **1-800-580-6275**
LOCAL FAX
(214) 748-2263

▲ ◆ STAMP HERE ◆ ▲

RUBBER
ACME
STAMP

2

STEINS

3

WellerArchitects

Suite D Albuquerque, New Mexico 87108

Tel 505-255-8270

Fax 505-255-8830

401 Alvarado Drive SE

4

REDSTONE

RICH VLIET
President

DESIGN
DEVELOPMENT
———
144 N. MOSLEY

WICHITA, KS 67202

TEL 316 263 2711

FAX 316 263 4711

5

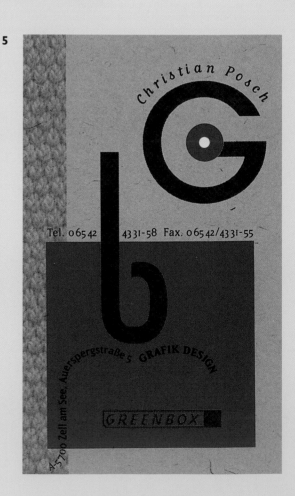

Christian Posch

Tel. 06542 4331-58 Fax. 06542/4331-55

A-5700 Zell am See, Auerspergstraße 5 GRAFIK DESIGN

GREENBOX

1 Design Firm
Peterson & Company
Art Directors
Dave Eliason, Bryan L. Peterson
Designer
Dave Eliason
Client
ACME Rubber Stamp Company

2 Design Firm
Vaughn Wedeen Creative
Designer
Rick Vaughn
Client
Rippelstein's
Men's clothing store

3 Design Firm
Vaughn Wedeen Creative
Designer
Rick Vaughn
Client
Weller Architects

4 Design Firm
Greteman Group
Art Directors
Sonia Greteman, James Strange
Designer
James Strange
Client
Red Stone
Design development

5 Design Firm
Greenbox Grafik
Designer
Christian Posch
Client
Self-promotion
Graphic design

1

DAVE SYFERD

☐ **SUN VALLEY**

207 Aspen Dr.

Ketcham, Idaho

83340

208 726 8837

☐ **BOISE**

350 N. 9th St.

P.O. Box 8283

Boise, Idaho

83707

208 342 0925

☐ **SEATTLE**

8006 Avalon Pl.

Mercer Island,

Washington

98040

206 232 3103

2

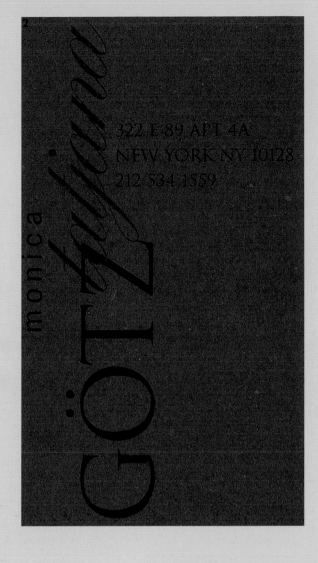

monica

GÖTZ

Hoffman

322 E 89 APT 4A

NEW YORK NY 10128

212 534 1559

3

advies

Proforma

[R DAM]

associatie voor ontwerp

Joop Ridder

algemeen directeur

Slepersvest 5-7

3011 MK Rotterdam

(010) 411 27 22

advies

Proforma

[R'DAM]

associatie voor ontwerp

Els van Klinken

communicatieadviseur

Slepersvest 5-7

3011 MK Rotterdam

4

ARTĒFAB

ALAIN LAUZON

Président

Directeur général

3820 E, rue Isabelle

Brossard, Québec

Canada, J4Y 2R3

Tél.: **(514) 444 2224**

Téléc.: (514) 444 2122

1 Design Firm
Homall Anderson Design Works
Art Director
Jack Anderson
Designers
Jack Anderson, Heidi Favour,
Bruce Branson-Meyer
Client
Dave Syferd
Marketing and public relations

2 Design Firm
Monica Gîtz Design
Designer
Monica Gîtz
Client
Self-promotion
Graphic design

3 Design Firm
Proforma, Association of
Designers & Consultants
Art Director
Aad Van Dommelen
Client
Self-promotion
Design

4 Design Firm
D2 Design
Designer
Dominique Duval
Client
Artefab
*Opera and theatre
set construction*

1 Design Firm
Karen Barranco Design & Illustration
Designer
Karen Barranco
Client
Etienne Bresson
Women's clothing design

2 Design Firm
Becker Design
Designer
Neil Becker
Client
Wave Property Management

3 Design Firm
Choplogic
Art Directors
Walter McCord, Mary Cawein
Designer
Walter McCord
Client
Langsford Center
Speech and reading specialists

4 Design Firm
Choplogic
Art Directors
Walter McCord, Mary Cawein
Designer
Walter McCord
Client
Bruce Carnahan
Landscape architecture

1

Etienne Bresson

• designer • stylist •

213 656 1229

2

Lance Lichter W62 N551 414.375.6868 *p*
President Washington Ave. 414.375.6869 *f*
 Cedarburg, WI
 53012

WAVE
Property Management
~

3

G. Stephen McCrocklin, Director

THE LANGSFORD CENTER
LEARNING TO EXCEL

4

214 Albany Avenue
Louisville, Kentucky 40206
(-)6-1818

Bruce Carnahan Landscape Design

1

DONNA L. ROBINSON

Certified Public Accountant

TEL 404·423·9997
FAX 404·427·5819
1256 COBB PARKWAY N.
MARIETTA, GA 30062

CERTIFIED PUBLIC ACCOUNTANTS

PATRICK
W
LACEY
PC

DEDICATED TO EXCELLENCE

2

JOHN WAGNER

JW

PHOTOGRAPHY

212 THIRD AVENUE NORTH SUITE 380
MINNEAPOLIS MINNESOTA 55401
TELEPHONE 612-330-0946 FAX 612-330-0035

3

GEORGIE MEL B. RACELA
Certified Public Accountant
CERTIFICATE NO. 88266

535 Gen. Luis Street
Novaliches
Quezon City

Telephone : 936-2440

4

ben briggs

unit 19,
21 cohen court,
clovelley park,
SA 5042,
australia

tel: 276 5914

fax: 2765915

director

R A J
THE CLOTHING COMPANY

5

900 Lay Road

St. Louis, MO 63124

Telephone

314-991-0005

Facsimile

314-991-1512

Community School

Chris Green

6

SAM LEE

Jam STREET WEAR

51, CECIL STREET,

HAMILTON,

WAIKATO AREA,

NEW ZEALAND,

TEL: 8490113 FAX: 8492313

1 Design Firm
Wages Design
Designer
Rory Myers
Client
Patrick W. Lacey
Certified public accountant

2 Design Firm
Stress Lab
Designer
Lizz Luce
Client
John Wagner
Photography

3 Design Firm
Design Source, Inc.
Designer
Robert Salazar
Client
Georgie Racela
Certified public accountant

4 Design Firm
Isheo Design House
Designer
Ishmael Sheo
Client
RAJ - The Clothing Company
Boutique

5 Design Firm
Kiku Obata & Company
Art Director
Amy Knopf, Kiku Obata
Designer
Amy Knopf
Illustrator
Sara Love
Client
Community School
Private elementary school

6 Design Firm
Isheo Design House
Designer
Ishmael Sheo
Client
JAM - Street Wear
Clothing maufacturing

GREG COLEMAN
Director of Marketing
Tel. 612.339.5218

RETIREMENT AND ESTATE ADVISORS

1320 Metropolitan Centre Minneapolis, Minnesota Fax 612. 337.5070
333 South 7th Street Zip 55402

INVESTMENT
······ AGE ······
PUBLISHING

KATE LINDE
President

17008 Island View Drive
Huntersville, NC 28078
Telephone 704/896-9631

1 Design Firm
Design Center
Art Director
John Reger
Designer
Sherwin Schwartzrock
Client
Retirement & Estate Advisors
Financial planning

2 Design Firm
Mervil Paylor Design
Designer
Mervil M. Paylor
Client
Investment Age Publishing
Investment texts publishing

3 Design Firm
Robbins Design
Designer
Tom Robbins
Client
Steven C. O'Neal
Horticulture and landscape
architecture

4 Design Firm
Design Center
Art Director
John Reger
Designer
Todd Spichke
Client
Wall Street Advisors
Financial planning

3

STEVEN C.
O·NEAL, M.S.

Consultant

3500 CROSSTREE COURT

HORTICULTURE

COLUMBUS, OH 43221

& LANDSCAPE

(614) 777-1615

4

S.E. TARRAF

President

WALL STREET ADVISORS

950 Interchange Tower

600 South Hwy 169

Minneapolis, Mn 55426

Pho 612-546-5657

800-359-6078

Fax 612-546-5672

1

Beatty·Levine Inc. EVENT PRODUCTION & DESTINATION MANAGEMENT

VICKI EMERICK
DIRECTOR OF
PROGRAM FINANCE

4100 Newport Place
Suite 220
Newport Beach
California 92660
714.251.1111
Fax 714.251.1137
LA 310.598.0085

2

415 574 5894

TRAVIS POWELL

EVENT / MEDIA
PRODUCER

FULL PRODUCTION MANAGEMENT
• EVENTS
• VIDEO
• PRINT

37 TWELFTH AVENUE
SAN MATEO, CA 94402
FAX 415 574 5894

3

Lisa Whitaker
President

Precision Sampling
Incorporated
958 San Leandro Avenue
Suite 900
Mountain View, CA 94043
415 967 8717
FAX 962 0612

4

Craig Williams

Post Office Box 98
Gallatin Gateway, MT 59730
406-763-5044

5

at THE BROADMOOR

1 Design Firm
Vaughn Wedeen Creative
Art Director
Rick Vaughn
Designer
Dan Flynn
Client
Beatty Levine Inc.
Event production and destination management

2 Design Firm
Stowe Designer
Designer
Jodie Stowe
Client
Travis Powell
Event/media production

3 Design Firm
Curtis Design
Designer
David Curtis
Client
Precision Sampling Inc.
Soil sample drilling

4 Design Firm
Palmquist & Palmquist Design
Designers
Kurt Palmquist, Denise Palmquist
Illustrators
Jim Lindquist, Kurt Palmquist
Client
Aspen Grove B & B
Bed and breakfast

5 Design Firm
Marsh, Inc.
Designer
Greg Conyers
Client
Luma
Handmade objects gift shop

1

Joan Deccio Wickham
Food Stylist & Culinary Instructor

P.O. Box 442
Vashon, WA
98070
206-463-3647
Fax 206-463-9223

2

CMO
CUSTOM FLORAL

formerly
Country Maid Originals

Custom
Floral Decorating

Specialty Gifts

C O N N I E H I T E
Proprietor, Floral Designer

6 8 9 - 4 9 9 1
5963 Jefferson St.
Burlington, KY 41005

Located In Tousey House c.1822

3

E l a i n e G a n t z W r i g h t

5552 Belmont Avenue, Dallas, Texas 75206-6724
214.821.3375 fax 214.942.0878

P H I L A N T H R O P I C P A R T N E R S

Building Business Through Community Investments

1 Design Firm
Walsh & Associates, Inc.
Art Director
Miriam Lisco
Designer
Miriam Lisco, Katie Dolejsi
Client
Joan Deccio Wickham
Food stylist and culinary instructor

2 Design Firm
LG Productions
Designer
Laura Gillespie
Client
CMO Custom Floral
Specialty gift and flower shop

3 Design Firm
Sullivan Perkins
Designer
Art Garcia
Client
Philanthropic Partners
Charitable investment company

4 Design Firm
Shields Design
Designer
Charles Shields
Client
Delaney Matrix
Marketing/organizational strategies

4

DELANEY **MATRIX**
organizational
strategies

Michael Delaney, MHSL

1272 West Palo Alto
Fresno, California 93711-1489
209.439.5158
Fax 209.439.9203

1

Lester Childres

The Pretty Penny, Inc.

14534 Memorial Drive

Houston, Texas 77079

Phone 713/493-2430

Fax Line 713/493-5553

2

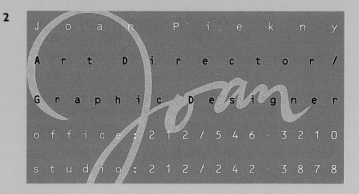

J o a n P i e k n y

A r t D i r e c t o r /

G r a p h i c D e s i g n e r

o f f i c e : 2 1 2 / 5 4 6 - 3 2 1 0

s t u d i o : 2 1 2 / 2 4 2 - 3 8 7 8

3

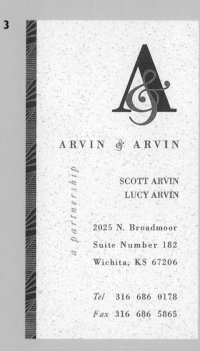

ARVIN & ARVIN

a partnership

SCOTT ARVIN
LUCY ARVIN

2025 N. Broadmoor
Suite Number 182
Wichita, KS 67206

Tel 316 686 0178

Fax 316 686 5865

4

C O M M U N I T Y
R E H A B I L I T A T I O N
C E N T E R S , I N C .

Beth Irtz
Director of
Rehabilitation Services

Cherry Creek Place I
3131 S. Vaughn Way, Suite 405
Aurora, Colorado 80014

303 • 369 • 9685

F A X 303 • 369 • 0609

5

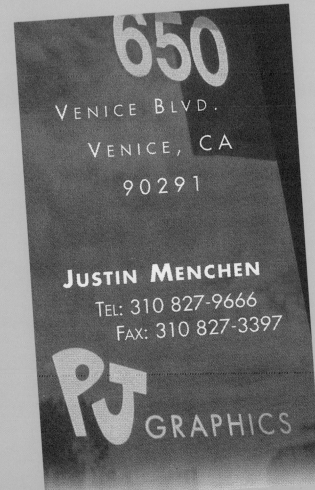

650

VENICE BLVD.

VENICE, CA

90291

JUSTIN MENCHEN

TEL: 310 827-9666

FAX: 310 827-3397

PJ GRAPHICS

1 Design Firm
MAH Design Inc.
Designer
Mary Anne Heckman
Client
The Pretty Penny, Inc.
Gift store

2 Design Firm
Joan Piekny
Designer
Joan Piekny
Illustrator
Paul Shaw
Client
Self-promotion
Graphic design and art direction

3 Design Firm
Greteman Group
Designer
Sonia Greteman
Client
Arvin & Arvin
Motivational speakers

4 Design Firm
Vaughn Wedeen Creative
Art Director
Steve Wedeen
Designer
Dann Flynn
Client
Horizon Health Care
Rehabilation centers

5 Design Firm
PJ Graphics
Art Directors
Justin Menchen, Paula Menchen
Client
Self-promotion
Graphic design

From I-95 Traveling North
• Exit 33. Straight onto Bridgeport Avenue.
• Continue over Devon Bridge.
• Go to second traffic light, Ormond Street.
• Building on left/Parking in rear.

From I-95 Traveling South
• Exit 34. Right onto Bridgeport Avenue.

OPERATED BY CUGINI, INC.

LA CUCINA
PIZZA, PASTA & MORE

RESERVATIONS
203·874·0387

HOME DELIVERY
203·874·5300

128 BRIDGEPORT AVENUE
DEVON, CONNECTICUT 06460

LANDSCAPE SANCTUARIES

Landscape Design, Organics &
Integrated Pest Management Solutions

George Morris
704.663.0378

OCCASIONAL OCCASIONS
by Carlton

CATERING WITH CONTEMPORARY ELEGANCE

Ronald J. Ross · Director of Marketing · (404) 413-9325

COSMED

...ation

Chairman of the Board and
Chief Executive Officer

12360 Manchester Road

Suite Number 204

St.Louis, Missouri 63131

314 | 966.6131

FAX | 966.8148

1 Design Firm
KMC Design
Designer
Kimberly McCoy
Client
La Cucina Restaurant

2 Design Firm
Athanasius-Design
Designer
Jeffrey Wallace
Client
Orland Park Realtors
Real estate

3 Design Firm
Steven Morris Design
Designer
Steven Morris
Client
Landscape Sanctuaries
Natural and organic
landscaping

4 Design Firm
The Design Company
Art Director
Marcia Romanuck
Designer
Fran McKay
Client
Occasional Occasions
Catering

5 Design Firm
Phoenix Creative
Designer
Ed Mantels-Seeker
Client
CosMed Corporation
Cosmetic and specialized
medical service

1

Douglas Manning

Manning Productions, Inc.

300 West Washington Street

Suite 706, Chicago, Illinois 60606

P 312.782.2700 F 312.782.2783

2

BOISÉ
MONT-ROLLAND

ROGER CHARTIER
Conseiller

Boisé Mont-Rolland Inc.
960 rue des Geais Bleus
Mont-Rolland, Québec
J0R 1G0
Téléphone
(514) 623-6345

3

ED LINSTROM
Complete Landscape Maintenance

16011 Winterbrook Road
Los Gatos, CA 95032
(408) 356-8418

4

fawbush's

3420 Galleria, Edina, MN 55435 612.922.5717

5

MAKERS OF FINE TEMPEH

NECTAR
~soy~
products

Michael S. Manser

NECTAR SOY PRODUCTS
57 VINCENT ST DAYLESFORD VIC 3460
TEL/FAX 053) 482 051

1 Design Firm
JOED Design, Inc.
Designer
Edward Rebek
Client
Manning Productions Inc.
Video production

2 Design Firm
D2 Design
Designer
Dominique Duval
Client
Boisé Mont-Rolland
Land developers

3 Design Firm
JWK Design
Art Director
Jennifer Kompolt
Designers
Jennifer Kompolt,
Melissa James
Client
Ed Linstram
Landscaping and maintenance

4 Design Firm
Tilka Design
Art Director
Jane Tilka
Designer
Jane Tilka
Illustrator
Stan Olsen
Client
Fawbush's
Women's clothing retail

5 Design Firm
Mammoliti Chan Design
Art Director
Tony Mammoliti
Designer
Chwee Kuan Chan
Illustrator
Chwee Kuan Chan
Client
Nectar Soy Products
Soy tempeh manufacturers

1

2

GRENE
C O R N E A

CORNEA, CATARACT &
REFRACTIVE EYE SURGERY

MARK WELLEMEYER, M.D.

8020 East Central
Wichita, KS 67206
Tel 316-636-2010
Fax 316-636-5174
1-800-788-3060

3

Keller Groves, Inc.

Herman J. Keller
P R E S I D E N T

P.O. BOX 2468
W A U C H U L A
FLORIDA, 33873
8 1 3 . 7 7 3 . 9 4 1 1

TUMBLE DRUM.sm

JACQUELINE SWARTZ

Mid-Rivers Plaza
5849 Suemandy Drive
St. Peters, Missouri 63376
Tel 314-397-7700

4

Donna Hall

Consultant

104 Randi Drive

Madison, CT 06443

tel 20:

fax 20

DONNA HALL

5

St·PAUL'S
EPISCOPAL
DAY SCHOOL

KAREN MONSEES
DIRECTOR OF ADMISSIONS

4041 MAIN STREET
KANSAS CITY, MO 64111
SCHOOL OFFICE 816-931-8614
SCHOOL FAX 816-931-6860

1 Design Firm
Greteman Group
Designers
Sonia Greteman,
Bill Gardner, James Strange
Client
Tumble Drum
Children's recreational center

2 Design Firm
Greteman Group
Designer
Sonia Greteman
Client
Grene Cornea
*Cornea, cataract,
and refractive surgery*

3 Design Firm
JOED Design, Inc.
Designer
Edward Rebek
Client
Herman Keller
Orange grower

4 Design Firm
Greteman Group
Designers
James Strange, Sonia Greteman
Client
Donna Hall
Health care consultant

5 Design Firm
Eat Design
Art Director
Patrice Eilts-Jobe
Designers
Patrice Eilts-Jobe, Kevin Tracy
Illustrator
Kevin Tracy
Client
St. Paul's Episcopal Day School

1

Mark J Laughlin

617 437 1356
617 437 1406 Fax

LAUGHLIN
Winkler

Marketing + Design

4 Clarendon Street
Boston Massachusetts
02116 6117

2

MaRia S
SAMS

g·r·a·p·h·i·c d·e·s·i·g·n

3310 Thompson Street
Richmond, Va. 23222
(804) 321-4866

3

10284 ROYAL ANN AVENUE

SAN DIEGO

CALIFORNIA · 92126

TEL 619.578.8799

FAX 619.578.8799

STEVEN
MORRIS
DESIGN

5

TONI·VOSS

COPYWRITER
CREATIVE THINKER

455 HUNTERS RIDGE
SALINE•MI 48176
TEL 313•944•0024
FAX 313•944•0190

4

KoLibri
CREATIV HAIRSTYLING

Andrea Neher
A-6774 Tschagguns 487, Tel. 0 55 56 / 39 20

1 Design Firm
Laughlin/Winkler Inc.
Designers
Mark Laughlin, Ellen Winkler
Client
Self-promotion
Graphic design and marketing

2 Design Firm
Maria Sams Graphic Design
Designer
Maria Sams
Client
Self-promotion
Graphic design

3 Design Firm
Steven Morris Design
Designer
Steven Morris
Client
Self-promotion
Graphic design

4 Design Firm
Grafik Design Ganahl Christoph
Designer
Ganahl Christoph
Client
Kolibri
Hair salon

5 Design Firm
el Design
Art Director
Lynn St. Pierre
Designer
Lynn St. Pierre
Illustrator
Kevin Ewing
Client
Toni Voss
Copywriter

a Cat's Garden

Red Rhinoceros

WILLIAM KOLBER
Vice President

1466 BROADWAY SUITE 808

NEW YORK NEW YORK 10036

· TELEPHONE (212) 764 5100

FAX (212) 764 5213 / 5231

JEWEL RUFFIN

131 Jasper Drive
◆
Amherst, NY 14226
◆
716 · 838 · 0553

CHAMELEON
DESIGN LIMITED

TWO BEARS DANCING 1920 ABRAMS PARKWAY

TRADING COMPANY SUITE 367

 DALLAS, TEXAS

SUE SWIGART 75214

PRESIDENT 214 733 9884

1 Design Firm
Hixson Design
Designer
Gary Hixson
Illustrator
Public Domain Engraving
Client
A Cat's Garden
Gift retail

2 Design Firm
Patricia Spencer Advertising & Design
Designer
Patricia Spencer
Client
Red Rhinoceros
Men's sportswear design

3 Design Firm
Chameleon Design Ltd.
Designer
Jewel Ruffin
Client
Self-promotion
Graphic design

4 Design Firm
Joseph Rattan Design
Designer
Joseph Rattan
Illustrator
Greg Morgan
Client
Two Bears Dancing
Trading Company
Native American jewelry
manufacturing

5 Design Firm
Lead Dog Communications
Designer
Suzanne Jacquot
Illustrator
Cliff Jew
Client
Self-promotion
Design and communications

LEAD DOG COMMUNICATIONS

33 BEVERLY ROAD
KENSINGTON
CA 94707

☎ 510 525 3053
fax 510 525 6425

LEAD DOG THE VIEW NEVER CHANGES.

IF YOU'RE NOT THE

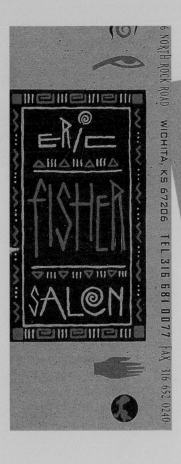

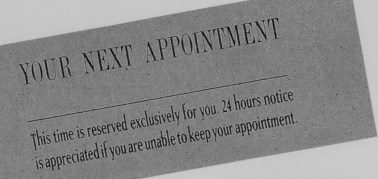

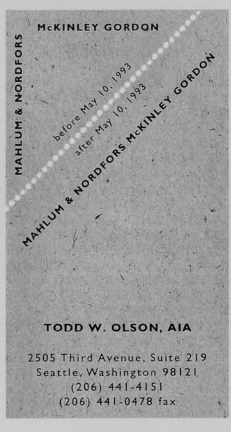

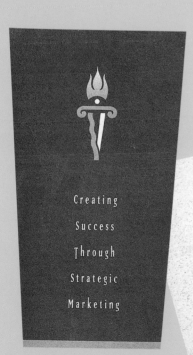

1 Design Firm
Greteman Group
Designers
Sonia Greteman, Bill Gardner
Client
Eric Fisher Salon
Hair sylist

2 Design Firm
Mervil Paylor Design
Art Director
Mervil M. Paylor
Designers
Mervil M. Paylor, Brady Bone
Illustrator
Gary Palmer
Client
Pasta & Provisions
Pasta, wine and sauce retail

3 Design Firm
Hornall Anderson Design Works
Art Director
Jack Anderson
Designers
Jack Anderson, Scott Eggers,
Leo Raymundo
Client
Mahlum & Nordfors
McKinley Gordon
Architecture

4 Design Firm
Greteman Group
Art Director
Sonia Greteman
Designers
Sonia Greteman, Jo Quillin
Client
Winning Visions
Strategic marketing

1

ROBERT WYLIE

MALABAR
C O A S T

2032 Broadway, Santa Monica, California 90404
Telephone: 310.264.7702 Fax: 310.264.7704

2

SPLENDIDO
Biscotti

Celeste de Tessan

P.O. Box 1347 Glen Ellen, CA 95442
707-939-8656

3

3

PENNY IVANOVIC

VIAGGIO

RISTORANTE MEDITERRANEO

14550 BIG BASIN WAY • SARATOGA, CALIFORNIA 95070 • TEL. 408.741.5300

1 Design Firm
Curtis Design
Art Director
David Curtis
Designer
Joan Bittner
Client
Malabar Coast
Furniture importing

2 Design Firm
Holden & Company
Designer
Cathe Holden
Client
Splendido Biscotti
Bakery

3 Design Firm
THARP DID IT
Art Director
Rick Tharp
Designers
Laurie Okamura, Rick Tharp
Client
Viaggio
Mediterranean restaurant

4 Design Firm
Greteman Group
Art Director
Sonia Greteman
Designers
Sonia Greteman, James Strange
Client
Galichia Medical Group
*Heart surgeon and
general practitioners*

4

Care that Starts from the Heart

Betsy Babcock
Chief Executive Officer
• • • • • •

Health Strategies Plaza
551 N. Hillside, Suite 410
Post Office Box 47668
Wichita, KS 67201-7668

Telephone 316-684-3838
Toll Free 1-800-657-7250
Facsimile 316-688-9183

Galichia Medical Group P.A.

1

FITZHUGH L. STOUT
& ASSOCIATES

FITZHUGH L. STOUT, MAI
Real Property Appraiser
and Consultant

505 East Boulevard
Charlotte, North Carolina 28203
704·376·0295
Facsimile 704·342·3704

2

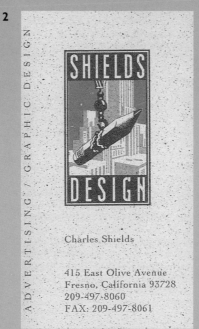

ADVERTISING / GRAPHIC DESIGN

SHIELDS
DESIGN

Charles Shields

415 East Olive Avenue
Fresno, California 93728
209·497·8060
FAX: 209·497·8061

3

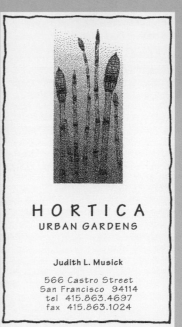

HORTICA
URBAN GARDENS

Judith L. Musick
566 Castro Street
San Francisco 94114
tel 415.863.4697
fax 415.863.1024

4

SUITE
102

A FULL DAY SPA

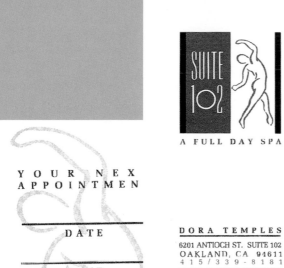

YOUR NEX
APPOINTMEN

DATE

TIME

DORA TEMPLES
6201 ANTIOCH ST. SUITE 102
OAKLAND, CA 94611
415 / 339 - 8181

5

1 Design Firm
Mervil Paylor Design
Designer
Mervil M. Paylor
Client
Fitzhugh L. Stout & Associates
Real estate appraisal

2 Design Firm
Shields Design
Designer
Charles Shields
Client
Self-promotion
Advertising and graphic design

3 Design Firm
Barry Power Graphic Design
Designer
Barry Power
Client
Hortica Urban Gardens
Flower nursery

4 Design Firm
B3 Design
Designer
Barbara B. Breashears
Client
Suite 102
Spa

5 Design Firm
Mitsuta
Art Director
Shiann-juh Lai
Designer
Pey-yng Lin
Illustrator
Shiann-juh Lai
Client
Shui-Li Snake Kiln
Ceramics Cultural Park

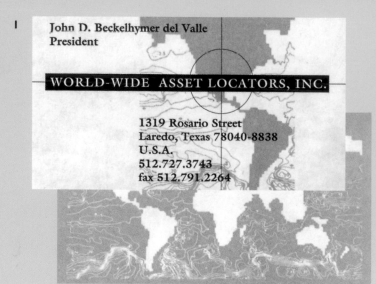

1

John D. Beckelhymer del Valle
President

WORLD-WIDE ASSET LOCATORS, INC.

1319 Rosario Street
Laredo, Texas 78040-8838
U.S.A.
512.727.3743
fax 512.791.2264

2

MACCO Systems

medical & dental
practice management systems

amar patel

457 W. ALLEN AVE. *suite* 117 SAN DIMAS, CA. 91773
fon 909.394.7288 *fax* 909.394.7290

MACCO Systems

3

THE GARRETT
HOTEL GROUP

DAVID W. GARRETT
President

166 BATTERY STREET
BURLINGTON, VERMONT 05401
802-865-0053 802-865-3146 FAX

1 Design Firm
Marc English Design
Designer
Marc English
Client
World-Wide Asset Locators, Inc.
Purchasing brokerage

2 Design Firm
Jeff Labbé Design 0950
Designer
Jeff Labbé
Client
Macco Systems
Medical software development

3 Design Firm
Kaiser Dicken
Art Director
Craig Dicken
Designer
Debra Kaiser
Client
The Garrett Hotel Group
Exclusive hotel developers

4 Design Firm
Vaughn Wedeen Creative
Designer
Steve Wedeen
Client
Juniper Learning
Educational and teacher's aids

5 Design Firm
THARP DID IT
Art Director
Rick Tharp
Designers
Jana Heer, Rick Tharp
Client
Ken Benjamin
Wildlife photography

5

N

KEN BENJAMIN
PHOTOGRAPHER

211 Alexander Avenue • Los Gatos, CA 95030 • 408·354·8626

4

KATHY L. JAHNER

Juniper Learning

POST OFFICE DRAWER O · ESPAÑOLA, NEW MEXICO 87532
TEL 505.753.7410 · TOLL FREE 800.456.1776
FAX 505.747.1107

1

ARTIST
JODI L. YANCEY

615 552 2570

P.O. BOX 2344
CLARKSVILLE, TN 37042

2

Marc English

Design

37 Wellington Avenue
Lexington MA
02173-7110
617 : 860 : 0500 phone | fax

3

PRODUCTIONS di ROSSI

GABRIELLA ROSSI

415 851 4438
1879 ANAMOR STREET
REDWOOD CITY, CA 94061

Judy Merrill
415 965 7452

4

Merrill Communications
100 E. Middlefield Road, Suite 1-D
Mountain View, CA 94043
Fax 415 965 7475
MCI Mail 443 4229
CompuServe 72634,44
Internet merrill@svpal.org

5

CAROL VALMY-MERCHANT

COPYWRITING *for*
CREATIVE MARKETING
COMMUNICATIONS

3565 RIPPLETON ROAD
CAZENOVIA, NEW YORK 13035

315-655-8532

1 Design Firm
Jodi L. Yancy, Artist
Designer
Jodi L. Yancy
Client
Self-promotion
Fine art and illustration

2 Design Firm
Marc English Design
Designer
Marc English
Client
Self-promotion
Design consulting

3 Design Firm
Stowe Designer
Designer
Jodie Stowe
Client
Productions di Rossi
Production art

4 Design Firm
Stowe Designer
Designer
Jodie Stowe
Client
Merrill Communications
Promotion and marketing

5 Design Firm
Jowaisas Design
Designer
Elizabeth Jowaisas
Client
Carol Valmy-Merchant
Copywriter

Design Firm
MC Studio/Times Mirror Magazines
Art Director
Paul Kelly
Designers
Kirsten Heincke, Paul Kelly
Client
Self-promotion
Graphic design

Geek Squad
computer support services
212 Third Avenue North, Suite 579
Minneapolis, Minnesota 55401

Robert C. Stephens
geek-squad@bitstream.mpls.mn.us
tel. 612.751.6205
fax. 612.288.9983

1

Geek **Squad**

2

MIM'S BAKERY

M

let 'em
eat cake
let 'em
eat cake
let 'em
eat cake

890 HUMBOLDT AVE
CHICO, CA 95928
916 345 3331

3

ART
SPACE

REGAN
JACKSON

ART DIRECTION

TEL: 310.841.6061
FAX: 310.841.0350

3111 S. LA CIENEGA BLVD.
LOS ANGELES, CA 90016

4

REAL FAST DELIVERY!

QUALITY DOESN'T COST! *IT PAYS!*

CALL US TODAY!

WURTSBAUGH
SPECIALTY MARKETING SERVICES

731 Carman Meadows Drive
Manchester, Missouri 63021
☎ **(314)227-5615** ☎

MARTHA WEGMANN, PRESIDENT

ALMOST ANY PLACE!

1

LOSE!

das niedrig·energie HAUS GmbH

Gesellschaft für energiesparendes und umweltbewußtes Bauen

Ilona Keller

Im Sacke 8a

31157 Sarstedt

Telefon 0 50 66 - 40 49

Bildhauerin **Rosa Jaisli** Atelier Stresemannstraße 54
Parkallee 23 28209 Bremen
fon 0421-34 19 69

AMPERSAND DESIGN GROUP
7575 NORTHWEST 50TH STREET
MIAMI, FLORIDA 33166

(FAX) 305.471.4583

phone
(305)

471.0119

&

Dan González

CREATIVE DIRECTOR

NEUBAUER
MAINTENANCE

8933 SOUTH 25TH STREET SCOTTS, MICHIGAN 49088

TEL (616) 327-7343

LANDSCAPING
LAWNSERVICE
SNOWPLOWING

JEFF NEUBAUER

JEFF M. LABBE' DESIGN 0950

JEFF M. LABBE'
DESIGN 0950

CONTACT CODE
909-621-6678 PH FX

ROUTE
218 PRINCETON AVE.
CLAREMONT, CA. 91711 USA

FRENCH PAPER: CONSTRUCTION WHITE WASH #100 COVER

R

DUAL USAGE:

1] ROLODEX
2] BUSINESS CARD

00121192 0849110

1 Design Firm
CAW
Designer
Carsten-Andres Werner
Client
das niedrig-energie Haus GmbH
Architecture

2 Designer
Andreas Weiss
Client
Rosa Jaisli
Sculptor

3 Design Firm
Ampersand Design Group
Designer
Dan González
Client
Self-promotion
Graphic design

4 Design Firm
The Woldring Company
Designer
Robert Woldring
Client
Jeff Neubauer
Lawn services

5 Design Firm
Jeff Labbé Design 0950
Designer
Jeff Labbé
Client
Self-promotion
Design

1 Design Firm
Jeff Labbé Design 0950
Designer
Jeff Labbé
Client
Conn Quigley
Shoe repair

2 Design Firm
V. Allen Crawford Design
Designer
V. Allen Crawford
Client
Victoria Sadowski
Independent metalsmith

3 Design Firm
Shelley Danysh Studio
Designer
Shelley Danysh
Client
Self-promotion
Graphic design

4 Design Firm
Giorgio Davanzo Design
Designer
Giorgio Davanzo
Client
Julie Cascioppo
Cabaret and jazz vocalist

5 Design Firm
Jeff Labbé Design 0950
Designer
Jeff Labbé
Client
Ron Perry
Photography

1

OUNG JU LEE

GRAPHIC
DESIGN
212.546.3482
516.767.8440

2

WILLIAM MOREE

LOCATION SCOUT

ALL A SCOUT

FAX 617-423-3769 MIAMI 305-226-

800
MOREE
WT

354 CONGRESS ST. BOSTON MA 02210

BOSTON LOCAL 617-426-7378

3

梅 Billy Moy

2002 Park Road
(Rib Mt. State Park)
Wausau, WI 54401

715.359.5830
1.800.290.6650
414.321.1818 *fax*

MOY'S
Rib Mountain Ginseng™

梅氏勿山花旗蔘

梅英福

1.800.290.6650

RICK WAS BORN IN 1952 IN MANSFIELD, OHIO.
HEN HE WENT TO COLLEGE AT MIAMI UNIVERSIT
NOT IN FLORIDA). AND AFTER THAT HE CAME
ALIFORNIA AND OPENED A SMALL DESIGN STUDI
ALLED THARP DID IT. HE NOW HAS FIVE OR
IX OTHERS DOING IT WITH HIM. SOMETIMES T
WIN AWARDS CERTIFICATES FOR THE STUFF THE
O, (USUALLY NOT ON A COMPUTER), AND HAN
HEM ON A CLOTHESLINE ACROSS THE STUDIO. T
WON A CLIO ONCE, BUT CAN'T FIND IT. RICK
NON-CORPORATE IDENTITY, PACKA
THAT GET INTO THE SMITHSONIAN
Y OF CONGRESS. BIG DEAL YOU SAY?
HER STUFF TOO. LIKE SKI, IRON
PE. HE DISLIKES WHINERS, UPC
MOST SOFTWARE PROGRAMS EXCE
OR A COUPLE OF EASY ONES. H
HAS ANOTHER OFFICE IN PORTL
REGON WITH A CREATIVE DIREC
RIEND. HE DOESN'T HAVE ANY
KIDS THAT HE KNOWS OF. THIS
S PRINTED BY WATERMARK PRES

4

#!@*

rick tharp

1 Design Firm
YoungJu Lee
Designer
YoungJu Lee
Client
Self-promotion
Graphic design

2 Design Firm
Paratore Hartshorn Design
Designer
Paratore Hartshorn Design
Client
William Moree
Location scout

3 Design Firm
Becker Design
Art Director
Neil Becker
Designer
Neil Becker, Terry Lutz
Client
Moy's Rib Mountain Ginseng
Ginseng mail order sales

4 Design Firm
THARP DID IT
Art Director
Rick Tharp
Photographer
Franklin Avery
Client
Self-promotion
Graphic design

1

MICHAEL JEFFCOAT

FAB REP

301 East 7th Street

•

Suite 203

•

Charlotte, NC 28202

•

Facsimile: 704.342.0044

•

Telephone: 704.342.0000

1.800. F₃ A₂ B₂ R₇ E₃ P₇.

FAB REP

2

EAT DESIGN

4 1 1 1 B A L T I M O R E

K A N S A S C I T Y

M I S S O U R I 6 4 1 1 1

T E L E P H O N E

8 1 6 . 9 3 1 . 2 6 8 7

F A C S I M I L E

8 1 6 . 9 3 1 . 0 7 2 3

PATRICE EILTS

3

LEAPING LIZARDS

The Volleyball Team!

LOCATED ON THE COURT, ABOVE THE NET, AND IN YOUR FACE!

4

ELTON WARD

ADVERTISING & DESIGN

STEVE COLEMAN
DIRECTOR

ELTON WARD

FOUR GRAND AVENUE

PARRAMATTA NSW 2124

AUSTRALIA, PO BOX 802

TELEPHONE (02) 635 6500

FACSIMILE (02) 635 3436

1 Design Firm
Mervil Paylor Design
Designer
Mervil M. Paylor
Client
FabRep
Furniture and fabric representative

2 Design Firm
Eat Design
Art Director
Patrice Eilts-Jobe
Designer
Toni O'Bryan
Client
Self-promotion
Graphic design and advertising

3 Design Firm
High Techsplanations
Designer
Mike James
Client
Leaping Lizards
Volleyball team

4 Design Firm
Elton Ward Design
Art Director
Steve Coleman
Designer
Chris De Lisen
Client
Self-promotion
Design

5 Design Firm
Barry Power Graphic Design
Designer
Barry Power
Illustrator
Everett Ching
Client
Everett Ching
Illustration

5

*Everett Y.S. Ching
Pen & Ink Illustration
4910-4 Kilauea Avenue
Honolulu, Hawaii 96816
Telephone: 808.757.6972*

ART KANE STUDIO, INC.
568 BROADWAY • NY, NY 10012 • TEL. 212 925 7334

1

2

Rex Stocklin
Chief Designing Officer

13603 Marina Pt. Dr C421•Marina del Rey, Ca 90292 • p 310-577-4956 • f 310-577-4958

3

41

L I Z O ' B R I E N
41 WOOSTER STREET • NEW YORK, N.Y. 10013
2 1 2 • 3 4 3 • 0 9 3 5

4

CARL R. KOHLER, A.I.A.

3011 Dent Place, N.W.
Washington, D.C. 20007
(202) 338-0986

5

MIRES DESIGN INC

2345 KETTNER BLVD SAN DIEGO CA 92101

PHONE: 619 234 6631 FAX: 619 234 1807

E MAIL: MIRES@MIRESDESIGN.COM

6

A X I O M
I N C
1 2 0
S O U T H
B R O O K
S T R E E T
L O U I S V I L L E
K E N T U C K Y
4 0 2 0 2
5 0 2
5 8 4
7 6 6 6

1 Design Firm
Mike Quon Design Office
Designer
Mike Quon
Client
Art Kane Studio, Inc.
Photography

2 Design Firm
Paradigm Design
Designer
Rex Stocklin
Client
Self-promotion
Graphic design

3 Design Firm
Eric Kohler
Designer
Eric Kohler
Client
"41"
1940s furniture gallery

4 Design Firm
Eric Kohler
Designer
Eric Kohler
Client
Carl R. Kohler
Architecture

5 Design Firm
Mires Design, Inc.
Art Director
John Ball
Designer
John Ball
Client
Self-promotion
Graphic design

6 Design Firm
Choplogic
Designer
Walter McCord
Client
Axiom
Photography

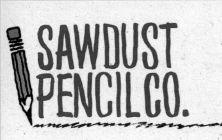

SAWDUST PENCIL CO.

Charles Maguire
Plant Manager

44 National Road
Edison, New Jersey 08817
908•248•9088 **Fax** 908•248•9425

1

Nicola Stranieri
musicista
via Emanuelli 15
28100 Novara, Italia
telefono 0321 450 726

batterista

2

WAYNE GUSTAFSON

JULIAN'S SANTA FE

221 SHELBY • SANTA FE, NEW MEXICO 87501 • 505.988.2355

1 Design Firm
Shelley Danysh Studio
Designer
Shelley Danysh
Client
Sandust Pencil Company
Pencil and marker manufacturing

2 Design Firm
Tangram Strategic Design
Designer
Antonella Trevisan
Client
Nicola Stranieri
Drummer

3 Design Firm
Cisneros Design
Designer
Fred Cisneros
Client
Julian's
Italian restaurant

4 Design Firm
Linnea Gruber Design
Designer
Linnea Gruber
Client
Keri Sims
Writer

5 Design Firm
Gibbs Baronet
Art Directors
Willie Baronet, Steve Gibbs
Designer
Willie Baronet
Illustrator
Willie Baronet
Client
Cheryl Pantuso
Manicurist

6 Design Firm
Advance Design Center
Designer
Bryan Rogers
Client
Promo International
Promotional items production

4

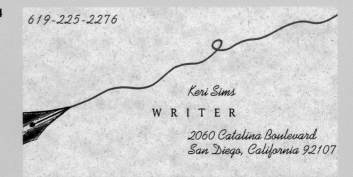

619-225-2276

Keri Sims
W R I T E R
*2060 Catalina Boulevard
San Diego, California 92107*

5

Cheryl Pantuso Nail Technician

Nizi 4906 McKinney Ave Dallas Texas 75204 520-9737/503-1925

6

PROMO
INTERNATIONAL

5622 Dyer Street

Dallas, TX 75206

214.360.8788

214.361.4835 fax

Jaime A. Sendra

1

Rick Mohler

Adams•Mohler
A R C H I T E C T S

3515 Fremont Avenue N
Seattle, WA 98103
206 632-2443
206 632-9023 (fax)

Adams•Mohler
A R C H I T E C T S

2

ARTURO

(617)497-7270
40 LINNAEAN STREET APT. 11
CAMBRIDGE, MA 0 2 1 3 9

3

A DIVISION OF CONSOLIDATED MANAGEMENT CO.

H
U
N
G
R
y

C
A
M
P
E
-

2894 106TH STREET SUITE 104

DES MOINES, IOWA 50322

OFFICE PHONE: (515) 278-9774

HOME PHONE: (303) 936-3827

MIKE ANDERSON

DIRECTOR OF CAMP SERVICES

1 Design Firm
Robert Williamson
Designer
Robert Williamson
Client
Adams-Mohler
Architecture

2 Design Firm
Karyl Klopp Design
Designer
Karyl Klopp
Client
Arturo
Holistic counseling

3 Design Firm
Sayles Graphic Design
Designer
John Sayles
Client
Hungry Camper
Resort food service

4 Design Firm
Cisneros Design
Designer
Fred Cisneros
Client
Custom Properties of Santa Fe
*Commercial and
residential building*

4

CARLA HILEY
office manager

**CUSTOM PROPERTIES
OF SANTA FE**
...a general contracting firm

1494 St. Francis Drive
Santa Fe, New Mexico 87501
505-982-8824
FAX: 505-989-3669

1 Coffee, Tea Espresso & Gifts

Ross Davidson

510-339-8187
5772 Thornhill Drive
Oakland, CA 94611

2 GreenAcres

A Natural Foods Market

TELEPHONE 316 634 1500

8141 EAST 21ST WICHITA, KS 67206-2903

3 MICHAEL ABELL

322 SO. BROADWAY

WICHITA, KANSAS

ZIP 67202 4304

TEL 316 263 6939

FAX 316 265 0081

ABELL PEARSON
PRINTING COMPANY

1 Design Firm
Visible Ink
Designer
Sharon Howard Constant
Client
Albuquerque Connection
Coffee house

2 Design Firm
Greteman Group
Designer
Sonia Greteman
Client
Green Acres
Natural foods market

3 Design Firm
Greteman Group
Designer
Sonia Greteman
Client
Abell Pearson
Printing

4 Design Firm
THARP DID IT
Art Director
Rick Tharp
Designers
Laurie Okamura, Rick Tharp
Illustrators
Jana Heer, Laurie Okamura
Client
Los Gatos Bar and Grill

5 Design Firm
B3 Design
Designer
Barbara B. Breashears
Client
Apple Lane Baker

4 LOS GATOS BAR & GRILL

MARK HACKER
proprietor

15½ NORTH SANTA CRUZ
LOS GATOS, CALIFORNIA 95030
TELEFAX 408.366.2222
TELEPHONE 408.399.LGBG

5 GOURMET FRUIT TARTS

APPLE, CHERRY,
PUMPKIN, LEMON,
STRAWBERRY / RHUBAR
IN SEASON

▼

SUGAR FREE
WHEAT FREE
LOW CHOLESTEROL
LOW FAT
ELEGANT AND DELICIOU

▼

APPLE LANE BAKER

LYNDA BROCKMANN
PRESIDENT

▼

121 PONDEROSA LANE
WALNUT CREEK, CA 94595
RING 510/932-8283
FAX 510/935-8934

1 Design Firm
13th Floor
Designer
Eric Ruffing
Client
Cyan Video Production
Music and video production

2 Design Firm
Blue Sky Design
Designers
Robert Little, Joanne Little,
Maria Dominguez
Client
Self-promotion
Graphic design

3 Design Firm
Peat Jariya Design/Metal Studio
Art Director
Peat Jariya
Designer
Peat Jariya Design Staff
Client
Self-promotion
Graphic design

4 Design Firm
13th Floor
Designer
Eric Ruffing
Client
Susan Frank & David Frisch
Furniture design and fabrication

5 Design Firm
Marise Mizrahi
Designer
Marise Mizrahi
Client
Self-promotion
Consulting

[metal] Studio Inc. 13164 Memorial Drive #222, Houston, Texas 77079

Peat Jariya

[metal]

713.523.5177

JoАNNE C. LITTLE
Vice President & Creative Director

10300 Sunset Drive, Suite 353, Miami, Florida 33173
Telephone 305·271·2063 Facsimile 305·271·2064

furniture
DESIGN
fabrication
SUSAN FRANK ✚ DAVID FRISCH
1928 echo park av, los angeles, ca 90026
FAX 213.644.0496
TEL. 213.644.0495

Design
Art

Marise Mizrahi

274.8663
212.

74 Leonard St. #6A New York, NY 10013

Photography

PURPLE SEAL GRAPHICS

DESIGN

ILLUSTRATION

LIM·HO YEN

P.O. BOX 3041

CARBONDALE

ILLINOIS 62902

林和源
紫篆
廣告
設計

EFFECTIVE
VISUAL
COMMUNICATION

▶ ▶ ▶ 618 ☼ 453·3489 ◑ 549·6537

STEIN

Architects

29 Commonwealth Ave
Boston, MA 02116
Tel 617.437.9458
Fax 617.421.9567

Lynn Parker
Principal

Parker LePla

Brand Development
Public Relations

4464 Fremont Ave. N.
Suite 210
Seattle, WA 98103
(206) 633-1951
Fax (206) 633-2036
Email:74217,2415
@ compuserve.com

LIGHTHOUSE

TELEVISION

GRENADA

MICHAEL MAGNUSON

C.E.O.

P.O. BOX 63,
ONE AROS DRIVE
ST. GEORGE,
GRENADA
WEST INDIES

PHONE 809.440.3586
FAX 809.440.6633

1 Design Firm
Purple Seal Graphics
Designer
Lim-Ho Yen
Client
Self-promotion,
Graphic design

2 Design Firm
Clifford Selbert
Design Collaborative
Art Director
Clifford Selbert, Robin Perkins
Designer
Robin Perkins
Client
Stein Architects

3 Design Firm
Walsh & Associates, Inc.
Designer
Miriam Lisco
Client
Parker LePla
*Brand development
and public relations*

4 Design Firm
Pinkhaus Design Corp.
Designer
Claudia DeCastro
Client
Lighthouse TV Grenada
Caribbean television station

1 Design Firm
Zedwear
Art Director
John Klaja
Designer
John Klaja
Photographer
Stuart Diekmeyer
Client
Self-promotion
T-shirt design and distribution

2 Design Firm
Sommese Design
Designer
Lanny Sommese
Client
Self-promotion
Design and illustration

3 Design Firm
Mike Quon Design Office
Designer
Mike Quon
Client
CD 101.9
Radio station

1 Design Firm
Animus Comunicaçáo
Art Director
Rique Nitzsche
Designer
Rique Nitzsche,
Felício Torres
Client
Less Money
Shoe retail

2 Design Firm
One & One Design
Consultants Inc.
Designer
Dominick Sarica
Client
AMS Woodcrafts
Woodworking

3 Design Firm
Maximum
Art Director
Ed Han
Designer
Deirdre Boland
Illustrator
Deirdre Boland
Client
The Chicago
Bicycle Company
*Hand-crafted
bike manufacturing*

4 Design Firm
Blink
Designer
Scott Idleman
Client
Self-promotion
Graphic design

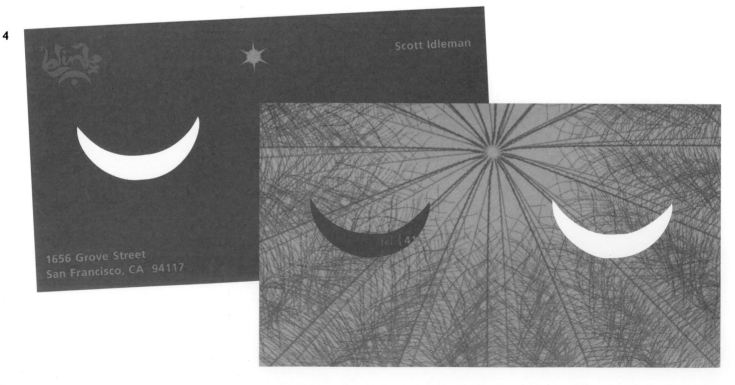

KELLY SHAW

business
[403] 762 • 0243
facsimile
[403] 762 • 4046
residence
[403] 678 • 6004

NUMBER FIVE HAWK AVENUE INDUSTRIAL COMPOUND BOX 2560 BANFF CANADA

TANYA DOELL

business
[403] 762 • 0243
facsimile
[403] 762 • 4046
residence
[403] 762 • 4302

DARREN DELICHTE

business
[403] 762 • 0243
facsimile
[403] 762 • 4046
residence
[403] 762 • 8359

1 Design Firm
Geo Graphics—Banff
Designers
Darren Delichte, Tanya Doell
Client
Self-promotion
Graphic design

2 Design Firm
Mike Quon Design Office
Designer
Mike Quon
Client
The Spot
Hair salon

CHU-LI

521 MADISON AVENUE
NEW YORK, NY 10022
TEL. 212-688-4450

521 MADISON AVENUE
NEW YORK, NY 10022
TEL. 212-688-4450

ANDRÉ TAVERNISE

521 MADISON AVENUE
NEW YORK, NY 10022
TEL. 212-688-4450

1 Design Firm
Squeak
Designer
Robin Dick
Client
Kelly Green
Finishing and millwork

2 Design Firm
Underdog Design
Designer
Loraine J. Princiotto
Client
Mark M. Hails
Boat mate

3 Design Firm
Jim Lange Design
Designer
Jim Lange
Client
Self-promotion
*Graphic design, lettering,
and illustration*

4 Design Firm
Walmsley Design
Designer
Kari Walmsley
Client
Self-promotion
*Tabletop items, housewares,
and giftware*

5 Design Firm
Sullivan Perkins
Designer
Art Garcia
Client
David Hernandez
Auto repair

6 Design Firm
Sayles Graphic Design
Designer
John Sayles
Client
Homeworks
Construction management

1

FLATIRON FINISH & MILLWORK

FINE FINISH CARPENTRY

DOORS • WINDOWS

CUSTOM MILLWORK

KELLY GREEN
619·451·7802

CA LIC. No. 637704

2

Mark M. Hails
Chief Mate Unlimited
Master 1600 Tons

R.R. 2 · Box 250
Richmond, VT 05477
Tel. 802.434.2150

3

CALL 312 606.9313

JIM LANGE DESIGN

FAX 312 220.9277

203
N. WABASH AVE.
SUITE 1312
CHICAGO IL
60601

4

KARI WALMSLEY
PRODUCT DESIGN
& ILLUSTRATION
40 HOBBS BROOK RD.
WESTON, MA 02193
617 • 647 • 5754
FAX • 617 • 894 • 4768

5

David Hernandez Auto Technician

5124 South Francisco

Chicago, Illinois 60632

312.476.6375

6

FOYER
FRENCH

HOMEWORKS

MARY A. MASON
President

CONSTRUCTION MANAGEMENT

MAKING YOUR HOME WORK FOR YOU!

12931 Sunset Terrace

Clive, Iowa 50325

(515) 222-1990

H|W

1

MEN
at
WORK

DALE RICH
PROPRIETOR
375-2316
PAGER NO.
383-7569

2

Margaret Fisher

CREATIVE
OPTIONS
IN
MARKETING
PROMOTIONS

PH 075 75 52 97

3/129
SUNSHINE BLV
MERMAID WATERS
QLD 4218

3

KAMEHACHI
café

**1400 NORTH WELLS ► SECOND FLOOR
CHICAGO IL 60610**

TEL. 312-664-1361
TUESDAY - SUNDAY UNTIL 2:00 AM

FOR LATE NIGHT
SUSHI & SPIRITS

4

JANET
MILLER
*Food Stylist
Home Economist*

310·459·9139

5

GREG STEWART

EVOLUTION

FILM & TAPE, INC.

5358 CARTWRIGHT AVENUE

NORTH HOLLYWOOD, CA 91601

PHONE: 818.505.0333 FAX: 818.505.1333

1 Design Firm
The Woldring Company
Designer
Robert Woldring
Client
Dale Rich
Home maintenance and repair

2 Design Firm
Veronica Graphic Design
Designer
Veronica Tasnadi
Client
Margaret Fisher
Marketing and promotion

3 Design Firm
Peggy Groves Design
Designer
Peggy Groves
Client
Kamehachi Cafe
Late night Japanese restaurant

4 Design Firm
Sage Brush Design
Designer
Danielle Bewer
Client
Janet Miller
Food stylist

5 Design Firm
Lorna Stovall Design
Designer
Lorna Stovall
Client
Evolution Film & Tape

1 Design Firm
Vibeke Nodskov
Designer
Vibeke Nodskov
Client
Groupvision (Nordic)

2 Design Firm
Blue Sky Design
Designer
Maria Dominguez
Client
Nicole Bailey
Design consulting

3 Design Firm
Catalina Communications
Designer
Marji Keim-López
Client
Self-promotion
Environmental graphic design

4 Design Firm
Becker Design
Designer
Neil Becker
Illustrator
Deborah Hernandez
Client
Instinct Art Gallery

1

3

2

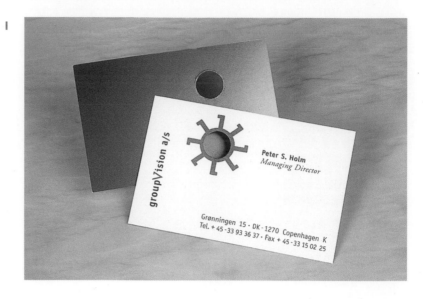

4

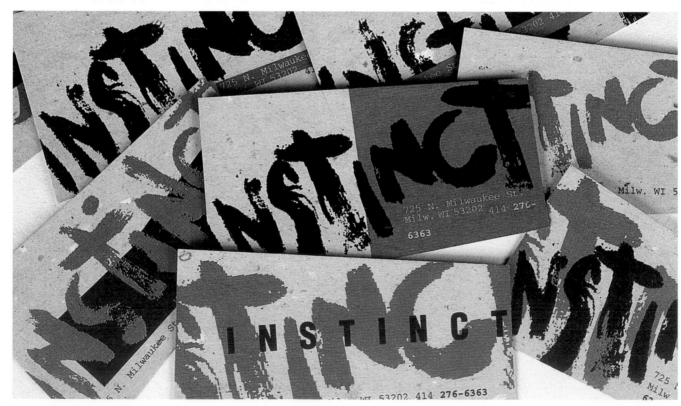

1

CARLO CAPRARO

15466 LOS GATOS BLVD
SUITE 105
LOS GATOS, CA 95030

TEL 408.358.0107
FAX 408.358.8207

2

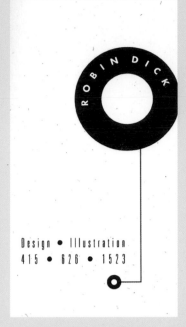

Design • Illustration
415 • 626 • 1523

3

JERRY ROBINSON

CONSTRUCTION

DESIGN

CONSULTING

P O BOX 691246

WEST HOLLYWOOD, CA 90069

TELEPHONE 310 652 7656

4

Emily Brower
Communications Consultant
1728 Union Street, Suite 100
San Francisco, CA 94123
Phone 415 775 8599
Fax 415 775 8597
ebrower@brower.com

5

DAM
SITE
DESIGN

DOUGLAS F. WOLFF., IDSA
PRESIDENT

161 S. 12 MILE RD
CERESCO, MICHIGAN
49033-0106
TEL: 616-979-1221
FAX: 616-979-3720

1 Design Firm
JWK Design
Art Director
Jennifer Kompolt
Designers
Jennifer Kompolt,
Patrick Keller
Illustrator
Patrick Keller
Client
Carlo
Personal fitness trainer

2 Design Firm
Squeak
Designer
Robin Dick
Client
Self-promotion
Design and illustration

3 Design Firm
Jay Vigon Studio
Art Director
Caroline Plasencia
Designer
Caroline Plasencia
Illustrator
Jay Vigon
Client
Jerry Robinson
*Construction,
design, and consulting*

4 Design Firm
Stowe Designer
Designer
Jennifer Lloyd
Client
Emily Brower
Communications consulting

5 Design Firm
Dam Site Design
Art Director
Douglas Wolff
Designer
Stacy L. Wolff
Client
Self-promotion
*Product design and
prototype/model making*

1

FILM & VIDEO COMMUNICATIONS

MIRA
crea
tive
gr
oup

BOB O'DONNELL
creative director

1200 NW FRONT AVE • SUITE 200

PORTLAND, OREGON 97209

TELE:503•464•0630

FAX:503•464•0782

2

IMPORTER AND REPRESENTATIVE OF AFRICAN
TEXTILES • TRADITIONAL CLOTHINGS • ART • ARTIFACTS
WHOLESALE INQUIRIES WELCOME.

FEMI BANJO
Merchant

78 UPPER A

4765

AFRICAN PRIDE
AT UNDERGROUND ATLANTA

3

PAPER
POST

1145 Lindero Canyon Rd., #D3
Thousand Oaks, CA 91362
818·865·0702

4

MARILYN WORSELDINE ◆ MARKET SIGHTS INC
3040 CAMBRIDGE PLACE NORTHWEST WASHINGTON DC 20007
TELEPHONE 202-342-3853 OR FAX 202-337-7851

5

LOS GATOS CYCLERY

FOR THE TOWN
FOR THE TRAIL

THYRA STEVENSON

15954 LOS GATOS BLVD. • LOS GATOS, CA 95032 • FAX 408.356.7092 • TEL 408.356.1644

FOR THE TOWN

1 Design Firm
Oakley Design Studios
Designer
Tim Oakley
Client
Mira Creative Group
Film and video communications

2 Design Firm
Two In Design
Designer
Ed Phelps
Client
African Pride
*Traditional African
merchandise retail*

3 Design Firm
SND, Sue Nan Designs
Designer
Sue Nan Douglass
Client
Paper Post
*Art, rubber stamps
and unusual paper store*

4 Design Firm
Market Sights, Inc
Designer
Marilyn Worseldine
Client
Self-promotion
Graphic design

5 Design Firm
THARP DID IT
Art Director
Rick Tharp
Designers
Laurie Okamura, Rick Tharp
Client
Los Gatos Cyclery
Bicycle retail

1

743 East Lake St.
Wayzata, Minn. 55391
Ph: (612) 473-2940

Black's Ford

Ruth Whitney Bowe

2

ELLINGTON RUCKSACK Co.

ALECIA ELSASSER

0112 SW Hamilton Portland, OR 97201
800-736-1222 503-223-7457 tel 503-223-7453 fax

4

ALFRED DESIGN

1020 Bellevue Avenue
Wilmington, Delaware 19809

302.764.1536

JOHN ALFRED

3

MELISSA PASSEHL DESIGN

1 Design Firm
Tilka Design
Art Director
Jane Tilka
Designer
Anne Koenig
Illustrator
Mike Reed
Client
Black's Ford
Specialty restaurant

2 Design Firm
Robert Bailey Incorporated
Designer
Ellen Bednarek
Client
Ellington Rucksack Co.
*Leather rucksacks, bags,
and wallet manufacturer*

3 Design Firm
Melissa Passehl Design
Designer
Melissa Passehl
Client
Self-promotion
Graphic design

4 Design Firm
Alfred Design
Designer
John Alfred
Client
Self-promotion
Graphic design

5 Design Firm
Melissa Passehl Design
Designer
Melissa Passehl
Client
Glen Rogers Perrotto
Print-making and fine art

5

glen rogers perrotto

18595 ralya court
cupertino, california
95014
408.446.5401

1 Design Firm
John Evans Design
Designer
John Evans
Client
Self-promotion
Graphic design

2 Design Firm
desasterD.
Designer
Daniel Bastian
Client
IMP International
Music tour booking agency

3 Design Firm
Phoenix Creative
Designer
Ed Mantels-Seeker
Client
Self-promotion
Graphic design

4 Design Firm
Mires Design, Inc.
Art Director
José Serrano
Designer
José Serrano
Client
Vanderschuit Studio, Inc.
Photography

1

John Evans Design

2200 North Lamar

Suite Number 220

Dallas, Texas 75202

Tel 214.954.1044

Fax 214.922.9390

2

imp
international
music
promotion
GmbH

Uwe Lohse
Kurtis Young

2800 Bremen 1
Grundstraße 39
Germany
Telefon
49 421 70 66 71/72
Fax
49 421 70 66 73

3

🔥 **Steve Springmeyer**

President

☎ 314 | 421-5646

FAX | 421-5647

Phoenix Creative

611 North Tenth

Seventh Floor

Saint Louis

Missouri 63101

PHOENIX

4

V
Carl VanderSchuit
A
VanderSchuit
N
Studio Inc.
D
751 Turquoise
E
San Diego
R
California
S
92109-1034
C
Telephone
H
619-539-7337
U
Facsimile
I
619-539-2081
T

2

5
WCVB TV
BOSTON

Marc English
Design Shaman

5 TV Place
Needham Heights, MA
02194-2303

617.433.4386
617.449.0260 fax

3

THE WYANT SIMBOLI GROUP, INC.

JULIA WYANT

DESIGN
MULTIMEDIA
VIDEO

•

96 EAST AVENUE
NORWALK, CT 06851

TEL:203.838.0191 FAX:203.853.3125
WSGrp@aol.com

1

Amy Wong-Freeman
architect

M A H L U M
& N O R D F O R S
Mc K I N L E Y
G O R D O N

2505
Third Avenue
Suite 219
Seattle, WA
98121

206 441 4151

4

Antonella Trevisan
Graphic Designer

Via Emanuelli 15, 28100 Novara, Italia
0321 450 726
C.F. TRVNNL62M42B885O
P. IVA 01321610030

5

MICHEAL DOSS: STUDIO TELEPHONE: 206-270-9185

119 W. DENNY WAY

SEATTLE, WA 98119

T: 206 - 270 - 9185

F: 206 - 270 - 9287

ARCHITECTURE

MICHEAL O. DOSS

1 Design Firm
Purple Seal Graphics
Designer
Lim-Ho Yen
Client
Self-promotion
Graphic design

2 Design Firm
WCVB TV Design
Designer
Marc English
Client
Self-promotion
Television station

3 Design Firm
The Wyant Simboli
Group Inc.
Art Director
Julie Wyant
Designer
Kristen Kiger
Illustrator
Kristen Kiger
Client
Self-promotion
Graphic design

4 Design Firm
Tangram Strategic Design
Designer
Antonella Trevisan
Client
Antonella Trevisan
Graphic design

5 Design Firm
Purple Seal Graphics
Designer
Lim-Ho Yen
Client
Debra Jones
Fine art and jewelry design

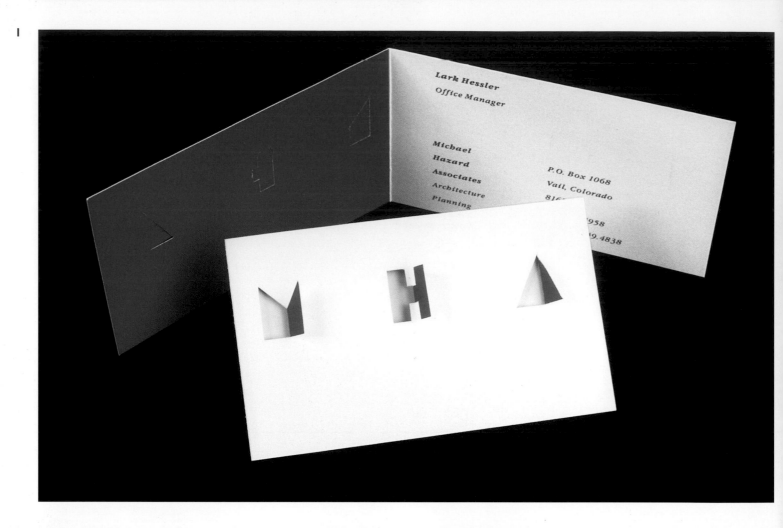

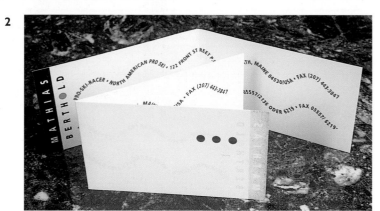

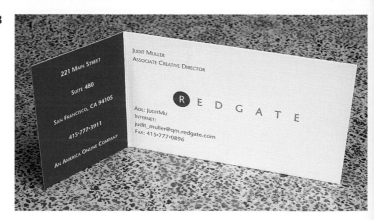

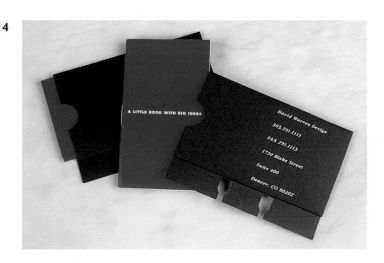

1 Design Firm
David Warren Design
Designer
David Warren
Client
Michael Hazard Associates
Architecture

2 Design Firm
Grafik Design Ganahl Christoph
Designer
Ganahl Christoph
Client
Mathias Berthold
Professional ski racer

3 Design Firm
Regate Communication
Designer
Bob Kasper
Client
New Media
Marketing

4 Design Firm
David Warren Design
Designer
David Warren
Client
Self-promotion
Design

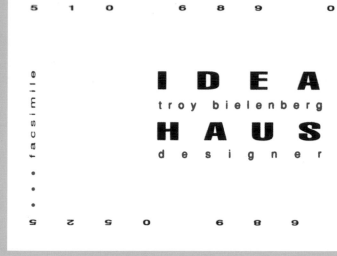

I D E A

troy bielenberg

H A U S

d e s i g n e r

facsimile

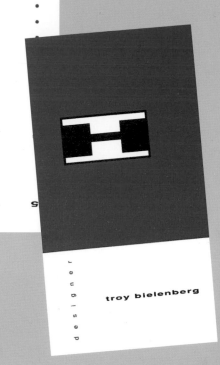

troy bielenberg

designer

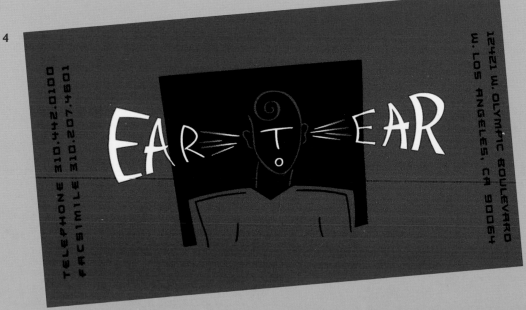

Explosive Aerobatics

MATT CHAPMAN AIRSHOWS

142 Davenport Road
Kennett Square, PA 19348
(fax) 610·444·6212
610·444·6212

TELEPHONE 310.442.0100
FACSIMILE 310.207.4601

12421 W. OLYMPIC BOULEVARD
W. LOS ANGELES, CA 90064

George Gruber

612-430-9824
fax 612-430-0423

**10823 Pawnee Avenue North
Stillwater, Minnesota 55082**

1 Design Firm
Idea Haus
Art Director
Troy Bielenberg
Designer
Erik Weber
Illustrator
Erik Weber
Client
Self-promotion
Graphic design

2 Design Firm
Minkus & Associates
Designer
Nikolas Pfendner
Client
Matt Chapman
Explosive aerobatics

3 Design Firm
Gruber Hill Design
Art Director
Beth Hanson
Designer
Peter Hill
Illustrator
Peter Hill
Client
Self-promotion
Design

4 Design Firm
Mires Design, Inc.
Art Director
Scott Mires
Designer
Scott Mires
Illustrator
Tracy Sabin
Client
Ear to Ear
Music production

1 Design Firm
Peggy Groves Design
Designer
Peggy Groves
Client
Self-promotion
Art and graphic design

2 Design Firm
Jay Vigon Studio
Designer
Jay Vigon
Client
Bedford Falls
Film production

3 Design Firm
Walsh & Associates, Inc.
Art Director
Miriam Lisco
Designer
Miriam Lisco
Calligrapher
Glenn Yoshiyama
Client
Fran's Chocolates
*Hand-wrapped
chocolate manufacturing*

4 Design Firm
Leslie Kane Design
Designer
Leslie Kane
Client
Self-promotion
Graphic design and lettering

5 Design Firm
Monroy & Cover Design
Designer
Gail Cover
Client
Amanda Pirot
*Marketing and
project management*

1

PEGGY GROVES

1906 LINCOLN PARK WEST

CHICAGO, ILLINOIS 60614

TELEPHONE 312.482.9661

2

Jay Vigon

BEDFORD FALLS

1419 Second Street
Santa Monica, Ca. 90401
Tel: 310 · 395 · 3553
Fax: 310 · 394 · 2512

3

Fran Bigelow

Fran's™

CHOCOLATES, LTD.

CORPORATE / LABORATOIRE DU CHOCOLAT
1300 EAST PIKE STREET · SEATTLE WA 98122
206/322-0233 · FAX 206/322-0452
800-422-3726

4

Leslie A. Kane
•graphic design•

4909 69th Street
Urbandale, IA 50322
(515) 278-8449

5

AMANDA PIROT

Marketing and Project Management For Designers
San Francisco, California Tel/Fax 415•474•3702

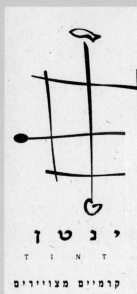

DR. SCHEEL NAYAR

OB/GYN

7355 Barlite

San Antonio

Texas 78224

Tel. 210-921-BABY

Fax 210-921-2360

2

KAMEHACHI

Japanese Restaurant & Sushi Bar

亀
八

1400 North Wells
Chicago, IL 60610
312.664.3663

4

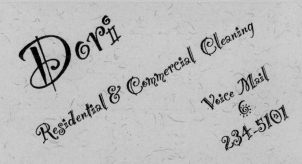

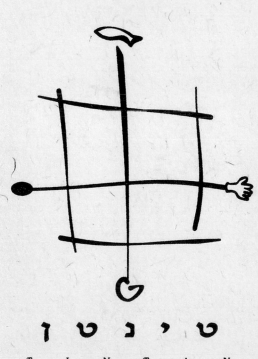

1 Design Firm
The Bradford Lawton
Design Group
Art Directors
Brad Lawton,
Jennifer Griffith-Garcia
Designer
Brad Lawton
Illustrator
Brad Lawton
Client
Dr. Scheel Nayar
Obstetrics and gynecology

2 Design Firm
Peggy Groves Design
Designer
Peggy Groves
Client
Kamehachi Cafe
Late night Japanese restaurant

3 Design Firm
Yaba (Yeh!) Design
Designer
Yael Barnea-Givoni
Client
Self-promotion
Tile design and painting

4 Design Firm
GN Design Studio
Designer
Glenda S. Nothnagle
Client
Dori
*Residential and
commercial cleaning*

1

! 212.246.9697 TEL/FAX !

! IMAGE ! DESIGN ! EVENTS ! ART ! STRATEGIES

340 W 57TH ! SUITE 9A ! NEW YORK, NY 10019 !

I.D.E.A.S. INCORPORATED

MJ HERSON

PRINCIPAL

73623,503@COMPUSERVE.COM

2

STAN **BAROUH**
PHOTOGRAPHY
704 SLIGO CREEK
P A R K W A Y
TAKOMA PARK
M A R Y L A N D
2 0 9 1 2
T 202-265-7035
P 202-837-7946
F 202-265-8128

4

117 W 13TH ST #5 NYC 10011

KAY WAKABAYASHI

212·989·0166

GRAPHIC DESIGN

3

MARIO FINOTTI

FOTOGRAFO

VIA XIII MARTIRI 12
28070 GARBAGNA NOVARESE
ITALIA
0321/845192

PARTITA IVA 0040860037
CCIAA NOVARA 128911

1 **Design Firm**
Mo Viele, Inc.
Designer
Mo Viele
Client
I.D.E.A.S.
Communications and design

2 **Design Firm**
Market Sights, Inc
Designer
Marilyn Worseldine
Illustrator
Norman Ramock
Client
Barouh Photography

3 **Design Firm**
Tangram Strategic Design
Designer
Enrico Sempi
Client
Mario Finotti
Photography

4 **Design Firm**
Kay Wakabayashi
Designer
Kay Wakabayashi
Client
Self-promotion
Graphic design

1

Steven Abrahams
Landscape Works
207 Dolores Street
San Francisco
CA 94103-2211
Tel. 415.626.8021

2

BLACK SHEEP STUDIO

ILLUSTRATION & DESIGN

NINE WHITE BIRCH ROAD

STANHOPE, NJ 07874

SUSAN MARX
(201) 691-7657

3

BROWNE
PRODUCTION GROUP

———

Eric Browne
3429 Airport Way S.
Seattle, WA 98134
(206) 329-4947
Studio - 382-0591

4

HARRY'S DOVE
Ceramic Sculpture

JENNIFER WALKER
(510) 339-3431

5

good food - good price

Ken Takahashi
(good boy)

the Dog House
Waikiki

Sit: King's Village
131 Kaiulani Avenue
Speak: (808) 923-7744
Fetch: (808) 574-2052

1 Design Firm
Barry Power Graphic Design
Designer
Barry Power
Client
Steven Abrahams
Landscape Works
Landscape design

2 Design Firm
Black Sheep Studio
Designer
Susan Marx
Client
Self-promotion
Design and illustration

3 Design Firm
Walsh & Associates, Inc.
Designer
Michael Stearns
Client
Browne Production Group
Photography and film

4 Design Firm
Visible Ink
Designer
Sharon Howard Constant
Client
Harry's Dove
Ceramic sculpture

5 Design Firm
Voice
Designer
Clifford Cheng
Client
The Dog House
Waikiki snack shop

1 Art Director
Vanessa Eckstein
Designer
Vanessa Eckstein
Client
Fernando Arrioja
Mexican filmmaker

2 Design Firm
Tangram Strategic Design
Designer
Antonella Trevisan
Client
Logos Consulenza,
*Employment
placement agency*

3 Design Firm
Kaiser Dicken
Art Directors
Debra Kaiser; Craig Dicken
Designer
Debra Kaiser
Illustrator
Debra Kaiser
Client
Brad Rabinowitz Architect

4 Design Firm
THARP DID IT
Art Director
Rick Tharp
Designers
Amy Bednarek,
Laurie Okamura, Rick Tharp
Client
Self-promotion
*Corporate identity
and brand packaging design*

5 Design Firm
Glazer Graphics
Designer
Nancy Glazer
Client
Self-promotion
Illustration

6 Design Firm
Covi Corporation
Designer
Ursula Loepfe
Client
Self-promotion
Graphic design

1

FILM MAKER 818 792 6243

FERNANDO ARRIOJA

628 E CALIFORNIA BLVD

PASADENA

91106 CA

818 792 6243

2

Antonella Boggio

Logos Consulenza
Logos Consulenza s.n.c.
Viale Roma 43a, 28100 Novara
Telefono 0321 459830 R.A.
Fax 0321 458082
Partita IVA 01289840033

3

200 Main Street
Burlington, Vermont 05401

(802) 658-0430

BRAD RABINOWITZ ARCHITECT

Architecture

Space Planning

Interior Design

4

408.354.6726 ☏

5

Glazer Illustration

Nancy Glazer

505•345•3386

6

COVI Corporation

USA
5850 OBERLIN DRIVE
SUITE 310
SAN DIEGO, CA 92121
PHONE: 619/481-6566
FAX: 619/792-5426

MONA HOWELL

SWITZERLAND
ROSACKERSTR. 18
CH-4573 LOHN
TEL: 065/47 25 19
FAX: 065/47 26 41

COVI

CORPORATE VISUAL IDENTITY

Paperworks design

Graphic Design • Advertising • Photography • Printing

Logos • Brochures • Advertising
Publications • Trade Show Design
Packaging • Environmental Graphics

300 SW Second Street
Corvallis, OR 97333
USA, Planet Earth

503.753.4003
fax 503.754.1006

RON ZAHURANEC
PO BOX 65
TUSTIN CA
92681 0065
909 735 7435

R

LEE ANN RHODES
Graphic Designer

105 DUMBARTON RD.
SUITE D
BALTIMORE, MD
21212

SHARON STOKES

EXECUTIVE VICE PRESIDENT

1051 SERPENTINE LANE
PLEASANTON, CA 94566

RING 510/426•6155 FAX 510/426•9797

SongMart
PRODUCTIONS

CHAS YOUNG
14 CASA DEL ORO LOOP
SANTA FE, NM 87505

505 • 466 • 0818

1 Design Firm
Paperworks Design
Art Director
Joanne McLennan
Designer
Sue Crawford
Client
Self-promotion
Design

2 Design Firm
Z Works
Designer
Ron Zahuranec
Client
Self-promotion
Graphic design

3 Design Firm
Lee Ann Rhodes Design
Designer
Lee Ann Rhodes
Client
Self promotion
Graphic design

4 Design Firm
B3 Design
Designer
Barbara B. Breashears
Client
Class Connection
School fund-raising

5 Design Firm
Glazer Graphics
Designer
Nancy Glazer
Client
SongMart Productions
Music publishing

6 Design Firm
Visible Ink
Designer
Sharon Howard Constant
Client
Self-promotion
*Graphic design
and illustration*

679 13th Street. Suite 202 • Oakland. CA 94612 • TEL (510)836-4845 • FAX (510)836-4848

Visible Ink
Graphic Design
Illustration

Sharon Constant

1 Design Firm
Holden & Company
Designer
Cathe Holden
Client
Ducks in a Row
Interior decorating and creative services

2 Design Firm
Gabriella Hajdu-Advertising/Design
Designer
Gabriella Hajdu
Client
Self-promotion
Advertising and design

3 Design Firm
Tilka Design
Art Director
Jane Tilka
Designer
Wendy Ruyle
Client
Grape Vine Catering

4 Design Firm
Jay Vigon Studio
Art Director
Fred Eric
Designer
Jay Vigon
Producer
Caroline Plasencia
Client
Vida
Restaurant

1

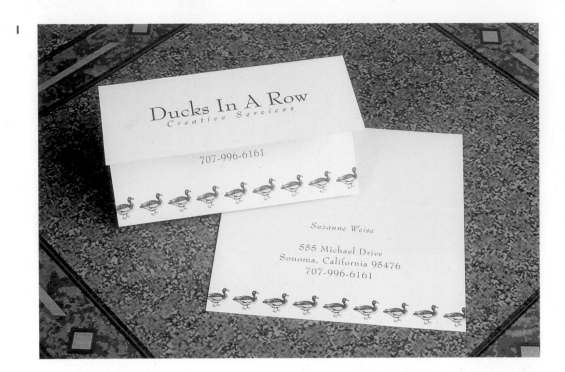

2

3

4

1 Design Firm
Gibbs Baronet
Art Directors
Steve Gibbs, Willie Baronet
Designer
Steve Gibbs, Willie Baronet, Kelly Kimball
Client
Self-promotion
Graphic design

2 Design Firm
Hornall Anderson Design Works
Art Director
Jack Anderson
Designers
Jack Anderson, Julie Keenan
Illustrator
George Tanagi
Client
Rod Ralston Photography

1

2

1 Design Firm
Pinkhaus Design Corp.
Designer
Todd Hauser
Client
Challenge Promotions, Inc.
Public relations

2 Design Firm
Peterson & Company
Art Director
Bryan L. Peterson
Designer
Scott Paramski
Illustrator
Scott Paramski
Client
Rocky Powell
Photography

3 Design Firm
One & One Design
Consultants Inc.
Designer
Dominick Sarica
Client
AMS Woodcrafts
Woodworking

4 Design Firm
Modelhart Grafik Design
Designer
Herbert O. Modelhart
Client
Self-promotion
Graphic design

5 Design Firm
Gibbs Baronet
Art Directors
Willie Baronet, Steve Gibbs
Designer
Jonathan Ingram
Illustrator
Jonathan Ingram
Client
Customwerx
*Custom cabinetry and
woodworking*

1

CHALLENGE PROMOTIONS INC

director
Roberto L. Silva
601 Brickell Key Drive
Suite 1020
Miami, Florida
33131

☎ 305 381 7899
FAX 305 381 9298

2

PRODUCTIONS

R

ROCKY POWELL 2205 COMMERCE DALLAS TEXAS
ZIP 75201 TEL 214.744.4242 FAX 214.748.8762

3

T 206 654 5300
F 206 382 6615
COMPUSERVE: 74603,2713
INTERNET: davidh@xactdata.com
DIRECT: 206 382 6606

XactData C
COLUMBIA S
701 5TH AVE
SEATTLE WA

XACT DATA

K.C. ALY
PRESIDENT

4

Herbert O. Modelhart
Grafik-Design

Pöllnstraße 19 · A-5600 St. Johann / Pg.
Tel. 0 64 12 / 84 66 o. 63 64 · Fax 84 66-4

5

JIM MORSE
CUSTOMWERX • 1594 HART ST
SOUTHLAKE TEXAS 76092
817.481.2677 • FAX 817.488.1738

customwerx

Reiseburo Stranger

Petra Stranger

Inh. Petra Stranger · A-5600 St. Johann im Pongau · Hauptstraße 41 · PF39
Tel.: 0 64 12 / 5757 · Fax: 0 64 12 / 57 57-20

B a r r y P o w e r G r a p h i c D e s i g n

logos / advertising
personalized greetings
business cards / more

3921 19th Street, San Francisco, California 94114 415.863.5085

MUSTARD (SEED)

ENTERPRISES
·ILLUSTRATION·

KAREN L. NAILE
PO Box 932
No. Chatham, NY 12132

(518) 766-2965

JOHN CRAMES

1260 NORTH BROAD STREET

HILLSIDE NEW JERSEY 07205

PHONE 908-353-1644

FAX 908-353-1644

FERNANDO MAGALHÃES PINTO

AV. RIO BRANCO, 12/20° ANDAR
CEP 20090-000 - CENTRO
RIO DE JANEIRO - RJ - BRASIL
TEL.: (021) 263-9179 - 233-6356
FAX.: (021) 233-8152

1 Design Firm
Katy L. Sullivan
Designer
Katy L. Sullivan
Client
Self-promotion
Fine art

2 Design Firm
Cisneros Design
Art Director
Fred Cisneros
Designers
Fred Cisneros, Jim Price
Client
Price Printing
Commercial printing brokerage

3 Design Firm
Isheo Design House
Designer
Ishmael Sheo
Client
Joshua Race Ministry
Music company

4 Design Firm
Shields Design
Art Director
Charles Shields
Designer
Charles Shields
Illustrator
Doug Hansen
Client
The United States Chart Company
Commodities chart service

1

katy sullivan

general fine artist
42 grandview ave. cornwall on hudson, ny. 12520
914.534.8492

2

James Price
P.O. Box 16403
Santa Fe, New Mexico 87506
(505)473-9332

3

JOSHUA RACE MINISTRY

KELVIN LIM

KINGDOM
HERITAGE

Block A, 01-06-15 Brem Park, Jalan Selesa 2, Happy Garden, 58200 Kuala Lumpur.
Tel: 7800842 (h) 7175716 (Off) Fax: 2983670 Pager: 2932000 – 11207

4

The UNITED STATES Chart Company

Chuck Crane
PRESIDENT

333 S.W. 5th Street ◆ Grants Pass, Oregon 97526
503-955-2885 ◆ Fax: 503-955-2889

1

600 CHANEY ST.

LAKE ELSINORE

CALIFORNIA 92530

TEL 714-674-1578

FAX 909-245-2427

1-800-654-1119

2

CHIP LERWICK, *President*

SINCE 1993
HEARTLAND
FUTONS FIBERS
SAINT LOUIS, MISSOURI

800 239-8022
tel. 314 231-8022
fax 231-8104

*Manufacturers of the
highest-quality
futons, made with a 100%
recycled fiber core.*

2107 Lucas Avenue
Saint Louis
Missouri 63103

3

Pitchfork Development, Inc.

Post Office Box 2370
572 Park Avenue
Park City, Utah 84060
Telephone: (801)649-3900
Facsimile: (801)649-3757

James W. Lewis
President

1 Design Firm
Mires Design, Inc.
Art Director
Jose Serrano
Designer
Jose Serrano
Illustrator
Nancy Stahl
Client
Deleo Clay Tile Company
Clay roofing tile retail

2 Design Firm
Phoenix Creative
Art Director
Eric Thoelke
Designer
Eric Thoelke
Client
Heartland Futons
Recycled-fiber futon retail

3 Design Firm
The Weller Institute for
the Cure of Design
Designer
Don Weller
Client
Pitchfork Development Inc.
*Real estate development
and construction*

TIMELESS IMAGES

DENNIS R. HOWE
PHOTOGRAPHER

(708) 433

STUDIO OR LOCATION

320 GREENBAY ROAD, HIGHWOOD, IL

HOWE**H**STUDIOS

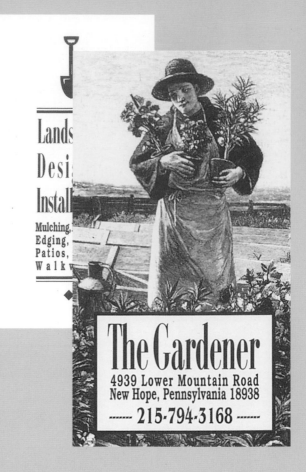

Lands
Desi
Install

Mulching
Edging,
Patios,
Walkw

The Gardener
4939 Lower Mountain Road
New Hope, Pennsylvania 18938
------ 215·794·3168 ------

TASARIM İLLÜSTRASYON 0 · 212 273 18 01

KAGAN ATSÜREN

YAŞARBEY SK. 9/8 80310 MECİDİYEKÖY İSTANBUL

1 Design Firm
Teslick Graphics
Designer
Julie L. Teslick
Client
Howe Studios
Photography

2 Design Firm
Full Moon Creations, Inc.
Art Director
Frederic Leleu
Designer
Lisa Leleu
Illustrator
Lisa Leleu
Client
The Gardener
Landscape design and installation

3 Design Firm
Propaganda
Designer
Kagan Atsüren
Client
Self-promotion
Freelance illustration and design

4 Design Firm
Leslie Chan Design Co., Ltd.
Designer
Leslie Chan Wing Kei
Client
Topline Communication Inc.
Production

林欽賢 藝術指導
STEVEN LIN Art Director

TOP L INE

經典集國際廣告有限公司

經典集國際廣告有限公司
台北市敦化南路一段236巷31號 5 樓
TOPLINE COMMUNICATION INC.
5F. No. 31, Lane 236, Tun Hua S. Road, Taipei, Taiwan.
Tel: (02)731-6666 Fax: (02)751-1522

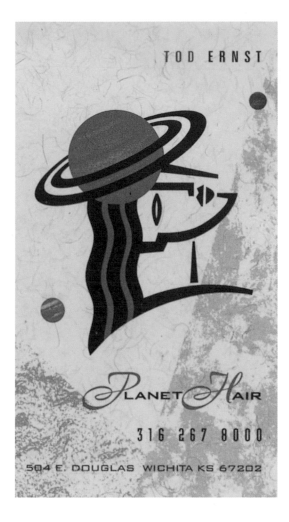

1

TOD ERNST

Planet Hair

316 267 8000

504 E. DOUGLAS WICHITA KS 67202

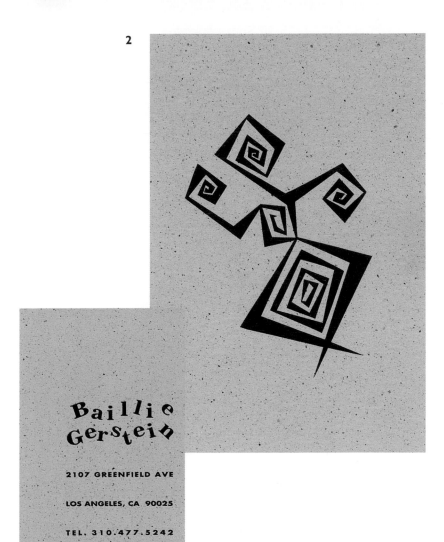

2

Baillie Gerstein

2107 GREENFIELD AVE

LOS ANGELES, CA 90025

TEL. 310.477.5242

FAX. 310.479.7609

3

ELLEN
KNABLE
&ASSOC

INCORPORATED

1 2 3

S O U T H

LA CIENEGA BLVD.

LOS ANGELES

CALIFORNIA

9 0 0 3 5

TELEPHONE

310 855 8855

F A X

310 657 0265

1 Design Firm
Greteman Group
Art Director
Sonia Greteman
Designers
Sonia Greteman, Karen Hogan
Client
Planet Hair
Hair salon

2 Design Firm
Jay Vigon Studio
Art Director
Jay Vigon
Designer
Caroline Plasencia
Producer
Caroline Plasencia
Illustrator
Jay Vigon
Client
Baillie Gerstein
Commercial voice-over specialist

3 Design Firm
Jay Vigon Studio
Designer
Jay Vigon
Client
Ellen Knable & Associates
Artists' representitive

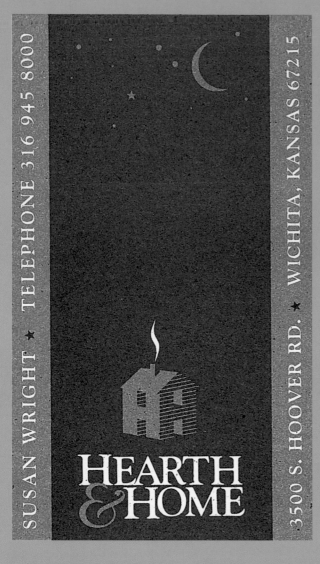

1

SUSAN WRIGHT ★ TELEPHONE 316 945 8000

3500 S. HOOVER RD. ★ WICHITA, KANSAS 67215

Hearth &Home

2

3

MOONLIGHT DESIGNS

Kim Beaty

1025 Ashworth Road, Suite 314, West Des Moines, Iowa 50265
Phone: 515-222-9990 FAX: 515-222-9989

ASTRONOMICAL
SOCIETY OF
KANSAS CITY

P.O. BOX 400
BLUE SPRINGS
MISSOURI 64013
889-STAR X5400

JACKIE
WADE
PRESIDENT

11305 KING
OVERLAND PARK
KANSAS 66210
913.469.0135

ELMCREST
OBSERVATORY

POWELL
OBSERVATORY

1 Design Firm
Greteman Group
Designers
Sonia Greteman, Bill Gardner,
James Strange
Client
Hearth & Home
Fireplace retail

2 Design Firm
Eat Design
Art Director
Patrice Eilts-Jobe
Designers
Patrice Eilts Jobe, Toni O'Bryan
Client
Jackie Wade
Astronomer

3 Design Firm
Moonlight Designs
Designer
Kim Beaty
Client
Self-promotion
Graphic design

SAGE BRUSH DESIGN

DANIELLE BEWER

403 West Channel Road
Santa Monica, California 90402
Tel. 310·459·7487 Fax 310·459·5508

1 Design Firm
Sage Brush Design
Designer
Danielle Bewer
Client
Self-promotion
Art and graphic design

2 Design Firm
Phoenix Creative
Designer
Ed Mantels-Seeker
Client
Art Company London
*Antique painting reproduction
and wholesale*

3 Design Firm
Phoenix Creative
Designer
Ed Mantels-Seeker
Client
The Gifted Gardener
*Gardening gifts, accessories, and
furniture retail*

Art Company London

Michael J. Goodson
PRESIDENT

*Eleven East Wisconsin
Suite 200
Trenton, Illinois 62293*
618 224-9435
FAX:
618 224-9296

THE
GIFTED
GARDENER
™

8935 Manchester
Saint Louis
Missouri 63144

Telephone: 961-1985
Area Code 314

Design Firm
Paper Shrine
Designer
Paul Dean
Client
Vitamin DJ
Disc jockey

Design Firm
Kaiser Dicken
Art Director
Debra Kaiser
Designer
Debra Kaiser
Illustrator
Craig Dicken
Client
Imagine Books
Antique book retail

DIRECTORY

13th Floor
3309 Pine Avenue
Manhattan Beach, CA 90266
305, 314

400 Communications Ltd.
20 The Circle
Queen Elizabeth Street
London SE1 2JE
England
peter_dawson@400.co.uk
31, 45, 55

9Volt Visuals
231 Euclid Avenue
Long Beach, CA 90803
163, 204, 210

Able Design, Inc.
54 West 21st Street, #705
New York, NY 10016
215

Abrams & LaBrecque Design
6 Frost Street
Cambridge, MA 02140
265

Advance Design Center
2501 Oak Lawn, #200
Dallas, TX 75219
311

Aerial
58 Federal
San Francisco, CA 94107
183, 224, 225, 230

Afterhours: pt Grafika Estetika Atria
Jalan Merpati Raya 45
jakarta 12870
Indonesia
brahm@afterhours.co.id
53

Aldeia Design
R.Avaí 15/1401-CEP 90050-100
Porto Alegre RS
Brazil
248

Alfred Design
1020 Bellevue Avenue
Wilmington, DE 19809
325

Alidesign
Alison Goudreault, Inc.
Atlanta, GA 30303
232

Aloha Printing
880 W. 19th Street
Costa Mesa, CA 92627
66

Ameer Design
16 Keyes Road
London NW2 3XA
England
207

Ampersand Design Group
7575 N.W. 50th Street
Miami, FL 33166
306

Amplifier Creative
5545 North Oak Trafficway
Suite 15C
Kansas City, MO 64111
165

Andreas Weiss
Alexanderstrasse
28203 Bremen
Germany
306

Angry Porcupine Design
4662 Hidden Pond Drive
Allison Park, PA 15101
188, 253

Animus Comunicação
Ladeira do Ascurra 115-A
Rio de Janeiro 22241-320, RJ
Brazil
254, 258, 318, 339

Anton Design
9 Rosewood Place
Plainview, NY 11803
248

Apple Graphics & Advertising of Merrick, Inc.
2314 Merrick Road
Merrick, NY 11566
207, 262

Associates Design
278, 284

Atelier Tadeusz Piechura
Zgierska 124/140, M.168
91-320 Lodz
Poland
42, 43, 92, 161

Athanasius-Design
2157 Evergreen Avenue
Chicago, IL 60622
294

Axion Design, Inc.
137 Tunstead Avenue
San Anselmo, CA 94960
260

B3 Design
2822 Kinney Drive
Walnut Creek, CA 94595
278, 301, 335

Barbara Brown Marketing & Design
791 Colina Vista
Ventura, CA 93003
198, 222

Barry Power Graphic Design
3921 19th Street
San Francisco, CA 94114
301, 309, 333, 339

Bartels & Company, Inc.
3284 Ivanhoe Avenue
St. Louis, MO 63139
188, 246, 255, 265

BBS In House Design
PO Box 9, Station o
Toronto, ON M4A 2M9
Canada
260

be
1323 4th Street
San Rafael, CA 94901
will.burke@beplanet.com
62, 63, 120, 142, 160

Becker Design
225 East St. Paul Avenue
Suite 3000
Milwaukee, WI 53202
beckerdsgn@aol.com
104, 288, 308, 322

Belyea
1809 7th Avenue, #1250
Seattle, WA 98101
mandy@belyea.com
81, 88, 89, 169

Bettina Huchtemann Art-Direction & Design
Schröderstiftstrasse 28
20146 Hamburg
Germany
bhuchtemann@real-net.de
80, 125

Big Eye Creative, Inc.
101-1300 Richards Street
Vancouver
British Columbia V6B 3G6
Canada
mecium@bigeyecreative.com
39, 119, 152

Black Letter Design, Inc.
#2 217 10 Avenue, SW
Calgary, ABT2R 0A4
Canada
192

Black Sheep Studio
9 White Birch Road
Stanhope, NJ 07674
333

Blackfish Creative
404 NW 10th Avenue, No. 200
Portland, OR 97209
216

Blink
1656 Grove Street
San Francisco, CA 94117
318

Blue Sky Design
6401 SW 132 Court Circle
Miami, FL 33183
314, 322

Blue Suede Studios
2525 Ontario Street
Vancouver, BC V5T 2X7
Canada
bsuede@istar.ca
206, 229

Bluestone Design
87 Mannamead Road
Plymouth, Devonshire
England
171

Borchew Design Group, Inc.
155 N. Pfingsten
Suite 215
Deerfield, IL 60015
199

Bruce Yelaska Design
1546 Grant Avenue
San Francisco, CA 94133
bruceyelaska@yelaskadesign.com
33, 51, 195

Bullet Communications, Inc.
200 S. Midland Avenue
Joliet, IL 60436
270

Bumbershoot CSC
2221 Peachtree Road NE
Suite D434
Atlanta, GA 30309
240

Burgard Design
342 Walnut Street
Columbia, PA 17512
243, 271

Büro B.
Graf Moltkestrasse 7
28203 Bremen
Germany
249, 254

Cahoots
30 The Fenway
Boston, MA 02215
190, 203

Cairnes
21 Station Road
Barnes London SW 13 0LJ
England
tony.sharman@cairnesdesign.co.uk
64

Carl Chiocca Creative Designs
28 Allen Street
Pittsburgh, PA 15210
256

Carl D.J. Ison
15 Trossachs Road
East Dulwich, London SE22 8PY
England
267

Case
St. Annastraat 1g Breda
The Netherlands
kwcase@knoware.nl
18, 80, 116

Castenfors & Co.
Roslagsgatan 34, SE 11355
Stockholm
Sweden
jonas@castenfors.com
15

Catalina Communications
8911 Complex Drive
Suite F
San Diego, CA 92123
322

Cato, Berro García & Di Luzio S.A.
O. Terrero 2981
(1642) San Isidro Buenos Aires
Argentina
277

CAW
Devrientstrasse 12 a
30179 Hanover
Germany
306

Chameleon Design Ltd.
131 Jasper Drive
Amherst, NY 14226
298

Charney Design
1120 White Water Cove
Santa Cruz, CA 95062
186, 223, 227, 234, 237, 249, 258

Chee Wang Ng
130 Water Street
Suite 3H
New York, NY 10005
275

Choplogic
2014 Cherokee Parkway
Louisville, KY 40204
277, 288, 310

Chris St. Cyr Graphic Design
4 Electric Avenue, #2
Somerville, MA 02144
244

Cincodemayo Design
5823 Northgate, PMB668
5 de Mayo Pte. 1058
Monterrey, N.L.
Mexico 64000
malanis@mail.cmact.com
22, 130

Cisneros Design
1751-A Old Pecos Trail
Santa Fe, NM 87505
cisneros@rt66.com
88, 118, 151, 311, 312, 340

Clark Design
444 Spear Street
Suite 210
San Francisco, CA 94105
163

Clearpoint Communications
50 Oliver Street
Easton, MA 02356
232

Clifford Selbert
2067 Massachusetts Avenue
Cambridge, MA 07140
315

Communication Arts Company
129 East Pascagoula Street
Jackson, MS 39201
212

Cooper-Hewitt, National Design Museum
2 East 91st Street
New York, NY 10128
manuean@ch.si.edu
70, 71

Cordoba Graphics
12028 Madison Avenue
Norwalk, CA 90650
206, 220, 228

Corridor Design
1529 Continental Drive
Eau Claire, WI 54701
206

Covi Corporation
5850 Oberlin Drive
Suite 310
San Diego, CA 92121
278, 334

CR Design
527 Marquette Avenue, #640
Minneapolis, MN 55402
218

Creative Company
3276 Commercial Street SE
Salem, OR 97302
mikeyp@creativeco.com
9, 50

Creech Creative
6467 Park Wood Court
Loveland, OH 45140
242

Curtis Design
3328 Steiner Street
San Francisco, CA 94123
291, 300

D Zone Studio, Inc.
273 W. 7th Street
San Pedro, CA
jyule@dzsinc.com
24, 93

D2 Design
6300 Avenue du Parc, #502
Montreal, QB H2V 4H8
Canada
261, 274, 287, 295

D4 Creative Group
4100 Main Street
Suite 210
Philadelphia, PA 19127
240

Dam Site Design
161 So. 12 Mile Road
Ceresco, MI 49033
323

Daniel Bastian
Alexanderstrasse
28203 Bremen
Germany
317

David Carter Design
4112 Swiss Avenue
Dallas, TX 75204
177, 211, 275

David Warren Design
1730 Blake Street
Suite 400
Denver, CO 80202
279, 317, 328

Dean Johnson Design
646 Massachusetts Avenue
Indianapolis, IN 46204
Dean7jd@aol.com
13, 107

Dennis Irwin Illustration
1251 College Avenue
Palo Alto, CA 94306
dei2465@fhda.edu
86

Design Ahead
Kirchfeldstrasse 16
45219 Essen-Kettwig
Germany
162, 188, 189, 193, 194, 200

Design Center
15119 Minnetonka Boulevard
Minnetonka, MN 55345
dc@design-center.com
17, 19, 123, 129, 162, 205, 237, 290

Design Group Cook
95 Minna Street
San Francisco, CA 4233
275, 279, 281

Design Infinitum
9540 NW Engleman Street
Portland, OR 97229
164

Design Management Group
101-495 Wellington St. W
Toronto, Ont M5V 1E9
Canada
276

Design Ranch
701 E. Davenport Street
Iowa City, IA 52245
219, 259

Design Source
4941 Bridge Street
Soguel, CA 95073
262, 289

Design Works Studio, Ltd.
2201 University
Lubbock, TX 79410
209

Designing Concepts
205 Camino Alto, #230
Mill Valley, CA 94941
269

destasterD.
Grafmolthestrasse 7
28203 Bremen
Germany
326

Dhruvi Art & Design
8200 Wisconsin Avenue
Suite 1607
Bethesda, MD 20814
246

Di Luzio Diseño
Terrero 2981
1642 San Isidro
Argentina
164

DMX Design
338 Broadway, 6th Floor
New York, NY 10003
petrie@dmxdesign.com
116, 117

Dogstar
526 54th Street South
Birmingham, AL 35212
228

DoX Industries
1337 Stillwood Chase
Atlanta, GA 30306
annex@doxindustries.com
55

Drew Force Design
2336 NW Pettygrove, F
Portland, OR 97210
281

Duck Soup Graphics, Inc.
257 Grand Medow Crescent
Edmonton, AB TGL 1W9
Canada
175, 204, 242, 248

Eat Design
4111 Baltimore
Kansas City, MO 64111
296, 309, 344

ed's produce dept.
P.O. Box 7788
Albuquerque, NM 87194
222

el Design
P.O. Box 341
Trenton, MI 48183
297

Elena Design
3024 Old Orchard Lane
Bedford, TX 76021
172, 198, 204, 217

Elizabeth Resnick Design
126 Payson Road
Chestnut Hill, MA 82467
elizres@aol.com
25

Elton Ward Design
4 Grand Avenue
P.O. Box 802
Parramatta NSW 2124
Australia
309

éng Tang Design
12028 Madison Avenue
Norwalk, CA 90650
219

Eric Kohler
280 Riverside Drive, #14J
New York, NY 10025
310

Erwin Zinger Graphic Design
Bunnemaheerd 68, 9739 Re
Groningen
Holland
erwin_zinger@hotmail.com
128

Esfera Design
R Barão Santa Marta, 519/04372-100
Sao Paulo
Brazil
esferadg@uol.com.br
126, 127

Eskind Waddell
471 Richmond Street West
Toronto, ON M5V 1X9
Canada
252

España Design
Av. Figueroa Alcorta 3086
1425 Capital Federal
Argentina
277

Estudio Hache S.A.
Vedia 1682, 3rd Floor
1429 Buenos Aires
Argentina
info@estudiohache.com
138, 148

Evenson Design Group
4445 Overland Avenue
Culver City, CA 90230
233

Fifth Street Design
1250 Addison Street
Studio 4
Berkeley, CA 94702
ifno@fifthstreet.com
126

Fire House, Inc.
314 North St. Joseph Avenue
Evansville, IN 47712
167, 247

Flaherty Art & Design
28 Jackson Street
Quincy, MA 01269
180, 184, 243

Foco Media Digital Media Design & Production GmbH. & Cie
Spitzwegstrasse 6
81373 Munich
Germany
196

Fordesign
533 Twin Bridge
Alexandria, LA 71303
190

Form 5
Alexanderstrasse 98
28203 Bremen
Germany
250

Form Studio
718 W. Howe Street
Seattle, WA 98119
info@formstudio.com
101

Free-Range Chicken Ranch
330 A East Campbell Avenue
Campbell, CA 95008
frcr@earthlink.com
131, 133

Fullmoon Creations, Inc.
81 South Main Street
Doylestown, PA 18901
342

Gabriella Hajdu-Advertising/Design
3069 Judith Drive
Bellmore, NY 11710
336

Gackle Anderson Henningsen, Inc.
2415 18th Street
Bettendorf, IA 52722
194, 220

Gardiner & Nobody, Inc.
3495 Cambie Street
Suite 320
Vancouver, BC V5Z 4R3
Canada
199

Gardner Graphics
2200 6th Avenue
Suite 1103
Seattle, WA 98121
263

Gasoline Graphic Design
5704 College Avenue
Des Moines, IA 50130
180

Geographics
P.O. Box 2560
Number 1-200 Hawk Avenue
Banff, Alberta
Canada
tanya@geodesign.com
151, 319

Gibbs Baronet
2200 N. Lamar, #201
Dallas, TX 75202
278, 311, 337, 338

Gillis & Smiler
737 N. Alfred, #2
Los Angeles, CA 90069
193

Gini Chin Graphics
818 N. Russell
Portland, OR 97227
176

Giorgio Davanzo Design
232 Belmont Avenue East, #506
Seattle, WA 98102
307

Girvin
1601 2nd Avenue, 5th Floor
Seattle, WA 98101
info@girvin.com
143

Glazer Graphics
2629 Oro Vista Drive NW
Albuquerque, NM 87107
334, 335

GN Design Studio
19 Oak Meadow Trail
Pittsford, NY 14534
331

Grafik Design Ganahl Christoph
Kehlerstrasse 79
A-6850 Dornbirn
Austria
297, 328

graphische formgebung
Pulverstrasse 25 D-44869 Bochum
Germany
herbert.rohsiepe@gelson.net
36

Graven Images Ltd.
83a Candleriggs, Glasgow
Scotland
anon@graven.compulink.co.uk
11, 30

Greenbox Grafik
Aversperastrasse 5
A-5700 Zellamsee
Austria
286

Greteman Group
1425 E. Douglas
Wichita, KS 67211
sgreteman@gretemangroup.com
26, 106, 107, 170, 173, 176, 178, 187, 189, 195, 202, 261, 276, 286, 293, 296, 299, 300, 313, 343, 344

Gruber Hill Design
8960 Loeh Lomono Boulevard
Brooklyn Park, MN 55443
329

Guidance Solutions
4134 Del Rey Avenue
Marina del Rey, CA 90292
159

H3/Muse
490 Ridgecrest Avenue
Los Alamos, NM 87544
40, 41

Hanke Kommunikation
Viktoriastrasse 46
52066 Aachen
Germany
270

Hard Drive Design
260 King Street East
Suite 204B
Toronto, ON M5A 4L5
Canada
187

Harris Design
9 Marion Avenue
Andover, MA 01810
maddad@mediaone.net
35

Heads Inc.
176 Thompson, #2D
New York, NY 10012
soso@bway.net
30

Heart Graphic Design
501 George Street
Midland, MI 48640
217

Held Diedrich
703 East 30th Street
Suite 16
Indianapolis, IN 46205
254, 263

Herman Miller Marketing Communications Dept.
855 E. Main MS0162
Zeeland, MI 49464
brian_edlefson@hermanmiller.com
114, 115

Hieroglyphics Art & Design
602 E. Grove Street
Mishawaka, IN 46545
167, 172

High Techsplanations
6001 Montrose Road
Suite 902
Rockville, MD 20852
309

Highwood Communications Ltd.
300-1210 8th Street SW
Calgary, AB T2R IL3
Canada
223

Hixson Design
1414 East Fifth
Charlotte, NC 28204
298

Holden & Company
804 College Avenue
Santa Rosa, CA 95404
300, 336

Hornall Anderson Design Works
1008 Western Avenue
Suite 600
Seattle, WA 98104
c_arbini@hadw.com
37, 98, 99, 136, 139, 147, 153, 176, 183, 228, 287, 299, 337

Horsepower Design
4245-B Ridgeway
Los Alamos, NM 87544
144

Howard Levy Design
40 Cindy Lane
Ocean, NJ 07712
264

Icehouse Design
135 West Elm Street
New Haven, CT 06515
179, 190, 193

Idea Haus
549 Rock Creek Way
Pleasant Hill, CA 94523
329

[i]e design
13039 Ventura Boulevard
Studio City, CA 91604
mail@iedesign.net
27, 72, 78, 158

ifx Visual Marketing
166 E. Broadway
Atwater, CA 95301
282

Imagine That, Inc.
1676 Oak Street
Washington, DC 20010
207

Inkwell Publishing Co., Inc.
10 San Pablo Street
Bo.Kapitolyo
Pasig City
Philippines 1603
inkwell@mnl.sequelnet
85

Inox Design
Via Terraggio 11
20123 Milano
Italy
inox@comm2000.it
33, 52, 54, 74, 91, 123

Insight Design Communication
322 South Mosley
Wichita, KS 67202
176, 178, 184, 232

Isheo Design House
12 SS3/94 Seaport
47300 Petaling Jaya
Selangor Darul Ehsan
Malaysia
289, 340

IVADOME
1111 Park Avenue, #416
Baltimore, MD 21201
info@ivadome.com
122

Izak Podgornik
Jamova c.50
1000 Ljubljana
Slovenija
izak.podgornik@siolnet
91

J. Gail Bean, Graphic Design
613 Hardy Circle
Dallas, GA 30157
gailbean@mindspring.com
12

Jacqúe Consulting & Design
19353 Carlysle
Dearborn, MI 48124
204

James Marsh
21 Elms Road
London SW4 9 ER
England
257

Jane Dill Calligraphy & Design
512 2nd Street
Suite 100
San Francisco, CA 94107
268

Jay Vigon Studio
11833 Brookdale Lane
Studio City, CA 91604
323, 330, 343, 336

Jeff Fisher Logomotives
P.O. Box 6631
Portland, OR 97228
167

Jeff Labbé Design 0950
218 Princeton Avenue
Claremont, CA 91711
302, 306, 307, 317

Jill Morrison Design
4132 Hidden Valley Lane
San Jose, CA 95127
186

Jim Lange Design
203 N. Wabash
Chicago, IL 60601
238, 320

Jim Terrinoni Line of Design
1589 County Route 7
Oswego, NY 13126
231

jk design
41 Yellow Brick Road
Stillwater, OK 74074
222

Joan Piekny
212 West 22nd, #3A
New York, NY 10011
293

Jodi L. Yancy, Artist
303

JOED Design
559 Spring Road
Elmhurst, IL 60126
284, 295, 296

John Evans Design
2200 N. Lamar, #220
Dallas, TX 75202
326

John Oat Communication Art
8900 Tarrytown Drive
Richmond, VA 23229
278

Jon Nedry
505 30th Street, #211
Newport Beach, CA 92663
268

José J. Dias da S. Junior
Rua Nilza Medeiros Martins,
275/103
05628-010 Sao Paulo
Brazil
jjjunior@mandic.com.br
27

Joseph Rattan Design
5924 Pebblestone Lane
Plano, TX 75093
298

Josh Klenert
106 E. 19th Street, 8th Floor
New York, NY 10003
jaykay01@aol.com
86, 87

Jowaisas Design
4 Oxbow Road
Cazenovia, NY 13035
303

Joy Price
8610 Southwestern, #404
Dallas, TX 75206
joy@spddallas.com
48

Judy Kahn
4316 25th Street
San Francisco, CA 94119
211

Judy Wheaton
52 Wheaton Road
Moncton, NB E1E 2K2
Canada
257, 259

JWK Design Group, Inc.
20 N. Santa Cruz Avenue, #C
Los Gatos, CA 94103
262, 295, 323

Kaiser Dicken
149 Cherry Street
Burlington, VT 05401
282, 302, 334, 347

Kan & Lau Design Consultants
28/F Great Smart Tower
830 Wanchai Road
Hong Kong
kan@kanandlau.com
51, 56, 57, 59, 173, 271

Kanokwalee Design
P.O. Box 49125
Austin, TX 78765
220, 247

Karen Barranco Design & Illustration
360 N. Laurel Avenue, #1
Los Angeles, CA 90046
288

Karyl Klopp Design
312

Katie Van Luchene & Associates
11219 West 109 Street
Overland Park, KS 66210
185

Katy L. Sullivan
1721 Linden Avenue
Baltimore, MD 21217
340

Kay Wakabayashi
117 W. 13th Street, #5
New York, NY 10011
332

Keiler Design Group
304 Main Street
Farmington, CT 06032
264

Kelly O. Stanley Design
203 S. Water St.
Crawfordsville, IN 47933
kelly@kosdesign.com
135

Kerrickters
1851 SE 4th Street
Deerfield Beach, FL 33441
258

Kiku Obata & Company
5585 Pershing Avenue
Suite 240
St. Louis, MO 63112
194, 241, 289

Kirby Stephens Design, Inc.
219 E. Mt. Vernon Street
Somerset, KY 42501
214

KMC Design
25 Grand Street
Suite 217
Norwalk, CT 06851
294

Kristy A. Kutch
11555 W. Earl Road
Michigan City, IN 46360
264

Langer Design
Plusstrasse 86
50823 Köln
Germany
6, 15

Laughlin/Winkler Inc.
4 Clarendon Street
Boston, MA 02116
297

Lead Dog Communications
33 Beverly Road
Kensington, LA 74707
298

Lee Ann Rhodes Design
105 Dumbarton Road
Suite D
Baltimore, MD 21212
335

Leslie Chan Design Co., Ltd.
4F, 115 Nanking E Road
Sec. 4 Taipei
Taiwan
342

Leslie Kane Design
4909 69th Street
Urbandale, IA 50322
330

LF Banks + Associates
834 Chestnut Street
Suite 425
Philadelphia, PA 19107
banks@lfbanks.com
20, 21

LG Productions
3484 Bullitsville Road
Burlington, KY 41005
292

Lima Design
215 Hanover Street
Boston, MA 02113
240

Linnea Gruber Design
579 Calla Avenue
Imperial Beach, CA 91932
311

Lorna Stovall Design
1088 Queen Anne Place
Los Angeles, CA 90019
321

Love Packaging Group
410 E. 37th Street North/PL 2
Wichita, KS 67219
159

LSL Industries
910 NW Front Avenue 1-23
Portland, OR 97209
162, 163, 174

Lucy Walker Graphic Design
Level 5, 15-19 Boundary Street
Rushcutters Bay, Sydney, NSW 2011
Australia
236

Lynn Wood Design
34 Hawthorne Road
Windham, NH 03087
210

MA&A-Mário Aurélio & Associados
Rua Eng. Ezequiel de Campos 159 1st
4200 Porto
Portugal
166, 198, 201, 226, 227, 234, 236,
249, 265

MAH Design Inc.
14814 Heritage Wood
Houston, TX 77082
280, 293

Mammoliti Chan Design
P.O. Box 6097
Melbourne, VIC 8008
Australia
202, 295

Manhattan Transfer
545 Fifth Avenue
New York, NY 10017
greg@mte.com
94, 95

Marc English Design
37 Wellington Avenue
Lexington, MA 02173
285, 302, 303

Maria Sams Graphic Design
3310 Thompson Street
Richmond, VA 23222
297

Marise Mizrahi
79 Leonard Street
New York, NY 10013
314

Market Sights, Inc.
3040 Cambridge Place NW
Washington, DC 20007
324, 332

Marketing and Communications
Strategies, Inc.
2218 First Avenue NE
Cedar Rapids, IA 52402
249

Marsh, Inc.
34 W. 6th Street, #11
Cincinnati, OH 45202
291

Mason Charles Design
147 West 38th Street
New York, NY 10018
196

Matite Giovanotte
Via Degli Orgogliosi 47100 Forli
Italy
marimg@tim.it
6

Maximum
430 W. Erie
Chicago, IL 60610
318

MC Studio/Times Mirror Magazines
2 Park Avenue
New York, NY 10016
304

M-DSIGN
Mannerheimintie 118 A 45
00270 Helsinki
Finland
162, 218, 238, 256

Media Bridge
1545 Wilcox Avenue, #B5
Los Angeles, CA 90028
gproven942@aol.com
68

Melinda Thede
102 Murray Street SE
Kentwood, MI 49548
236

Melissa Passehl Design
1275 Lincoln Avenue, #7
San Jose, CA 95125
177, 214, 217, 218, 277, 283, 325

Mervil Palor Design
1917 Lennox Avenue
Charlotte, NC 28203
274, 290, 299, 301, 309

Michael Courtney Design
1218 Third Avenue, #1900
Seattle, WA 98101
285

Michael Kimmerle
Art Direction + Design
Ostendstrasse
106.70788 Stuttgart
Germany
mi@kimmerle.de
15, 46, 73, 76, 77, 82, 83

Michael Stanard Design, Inc.
1000 Main Street
Evanston, IL 60202
189, 266

Michelle Bowers
R.F.D 1 Box 2491
Plymouth, NH 03264
179

Mike Quon Design Office
568 Broadway, #703
New York, NY 10012
310, 316, 319

Mike Salisbury
Communications, Inc.
2200 Amapola Court
Suite 202
Torrance, CA 90501
255

Minkus & Associates
100 Chetwynd Drive
Suite 200
Rosemont, PA 19010
329

Mires Design
345 Kettner Boulevard
San Diego, CA 92101
201, 220, 221, 229, 237, 264, 310,
326, 329, 341

Mirko Illi_ Corp.
07 East 32nd Street
New York, NY 10016
32, 164, 174, 256

Misha Design
638 Commonealth Avenue
Suite 24
Boston, MA 02135
84

Mitsuta
19-2 Lane 138, Sec.1
Taichung-kung Rd. Taichung
03 Taiwan, R.O.C.
301

Mo Viele, Inc.
02 Prospect Street
Suite 102
Ithaca NY 14850
32

Modelhart Grafik Design
np. Ludwig Pechstrasse 7
-5600 St. Johann/Pg
Austria
338, 339

Monica Götz Design
22 East 89th Street, #4A
New York, NY 10128
87

Monroy & Cover Design
1 Hodges Alley
San Francisco, CA 94133
75, 330

Moonlight Designs
025 Ashworth Road
Suite 314
West Des Moines, IA 50265
44

Moos Design
Raphaelstraat 20
077 PV Amsterdam
The Netherlands
205

Mother Graphic Design
Level 5, 15-19 Boundary Street
Rushcutters Bay, Sydney, NSW 2011
Australia
05, 239, 247

Multimedia Asia
P.O. Box 18416
San Jose, CA 95158
65

Mustard Seed Enterprises
P.O Box 932
No. Chatham, NY 12132
39

Nagorny Design
0675 Charles Plaza
Suite 930
Omaha, NE 68114
09

Nancy Stutman Calligraphics
008 Rana Court
Carlsbad, CA 92009
19

Nancy Yeasting Design & Illustration
490 Monmuth Avenue
Vancouver, BC V59 5R9
Canada
02, 246

Natto Maki
o Ramona Avenue, #2
San Francisco, CA 94103
29

Nesnadny + Schwartz
10803 Magnolia Drive
Cleveland, OH 44106
67

New Idea Design, Inc.
3702 S. 16th Street
Omaha, NE 68107
268

Niehinger & Rohsiepe
Pulverstrasse 25
D-44869 Bochum
Germany
herbert.rohsiepe@gelson.net
9

O2 Design
Tanner Place
54-58 Tanner Street
London SE1 3HP
England
102

Oakley Design Studios
519 SW Park Avenue
Suite 521
Portland, OR 97205
213, 324

(ojo)2
Calle 64 No. 4-85 (208)
Bogotá
Columbia
172

Olive Tree
12 Glen Court
Coorparoo, Qld. 4151
Australia
263

On The Edge
505 30th Street
Suite 211
Newport Beach, CA 92663
170, 238, 257

One & One Design Consultants, Inc.
25 West 43rd Street
New York, NY 10036
318, 338

One, Graphic Design & Consulting
812 Gloucester Ferry Road
Greenville, SC 29607
235, 246

Opera Grafisch Ontwerpers
Baronielaan 78
NL-4818 RC Breda
The Netherlands
operath@knoware.nl
18, 28, 44, 61, 108

Palmquist & Palmquist Design
P.O. Box 325
Bozeman, MT 59771
291

Paper Power
53 Warwick Road
Ealing, London W5 5P2
England
272, 273

Paper Shrine
604 France Street
Baton Rouge, LA 70802
346

Paperworks Design
300 SW 2nd Street
Corvallis, OR 97333
335

Paradigm Design
13603 Marina Pointe Drive, #C421
Marina Del Ray, CA 90292
310

Paratore Hartshorn Design
354 Congress Street
Boston, MA 02210
308

Patricia Spencer
Advertising & Design
205 E. 78th Street
New York, NY 10021
298

Peat Jariya Design/Metal Studio
1210 W. Clay
Suite 13
Houston, TX 77019
314

Peggy Groves Design
1906 Lincoln Park West
Chicago, IL 60614
321, 330, 331

Pen Ultimate
83 Windwhisper Lane
Annapolis, MD 21403
272

Peter Comitini Design
611 Broadway
New York, NY 10012
231

Petter Frostell Graphic Design
Roslagsgatan 34
11355 Stockholm
Sweden
petter.frostell@telia.com
96

Peterson & Company
2200 North Lamar
Suite 310
Dallas, TX 75202
280, 282, 286, 338

Pfeiffer plus Company
1910 Pine Street
Suite 515
St. Louis, MO 63103
103

PhD
427 Shawmut Avenue
Boston, MA 02118
278

Phillips Design Group
25 Drydock Avenue
Boston, MA 02210
221

Phoenix Creative
611 N. 10th Street
St. Louis, MO 63101
208, 213, 226, 238, 276, 283, 294,
305, 326, 341, 345

Pinkhaus Design Corp.
2424 South Dixie Highway
Miami, FL 33133
279, 281, 315, 338

Pisarkiewicz & Company
34 West 22nd Street
New York, NY 10010
339

PJ Graphics
650 Venice Boulevard
Venice, CA 90291
293

Prestige Design
602 Johns Drive
Euless, TX 76039
187

Proforma, Association
of Designers & Consultants
Slepersvest 5-7
3011 MK Rotterdam
The Netherlands
287

Propaganda
Inönücaddesi 53/13 Ayazpasa
Taksim 34504 Istanbul
Turkey
342

Purple Seal Graphics
P.O. Box 3041
Carbondale, IL 62902
315, 327

pw design graphics
2040 York Avenue
Suite 215
Vancouver, BC VGJ IE7
Canada
168, 185

R & M Associati Grafici
Traversa Del Pescatore 3
80053 Castellammare Di Stabia
Italia
info@rmassociati.com
10, 16, 58, 91

Ralph Huss
Budapesterstrasse 25
20359 Hamburg
Germany
239

Ramona Hutko Design
4712 South Chelsea Lane
Bethesda, MD 20814
153

Raven Madd Design
P.O. Box 11331 Wellington
Level 3 Harcourts Building
Corner Gray Streer and Lambton
Quay
New Zealand
248

Redgate Communication
221 Main Street
Suite 480
San Francisco, CA 94105
328

Ricardo Mealha Atelier
Design Estrategico
Av. Eno Duarte Dachelo
Torre2
Piso 2 Sazas 9 & 10
Portugal
140, 141

Rick Eiber Design (RED)
31014 SE 58th Street
Preston, WA 98050
186, 210, 216, 241, 252, 260, 269

Ringo W.K. Hui
Rm 404, Wo Hui House
Wo Ming Court
Tseung Kwan o
Hong Kong
77

Robbins Design
1018 Birchmont Road
Columbus, OH 43220
290

Robert Bailey Incorporated
0121 SW Bancroft Street
Portland, OR 97201
325

Robert Williamson
4602 14th Street NW
Seattle, WA 98107
312

Rocha & Yamasaki Arq.E Design
Rua Dos Franceses, 470.C/Ap.164
01329-010 Sao Paulo SP
Brazil
282

Roger Gefvert Designs
4282 Highway 89 South
Livingston, MT 59047
269

S & S Design
Francisco de Toledo 241La
Virreyna
Lima 33
Peru
sanfarmo@comercio.com.pe
45

Sackett Design Associates
2103 Scott Street
San Francisco, CA 94115
132

Sage Brush Design
403 W. Channel Road
Santa Monica, CA 90402
321, 345

Sagmeister, Inc.
222 West 14th Street
New York, NY 10011
ssagmeiste@aol.com
180, 184, 192, 199, 201, 211, 229

Sandy Gin Design
329 High Street
Palo Alto, CA 94301
177, 184

Sayles Graphic Design
3701 Beaver Avenue
Des Moines, IA 50310
156, 157, 166, 175, 185, 192, 200, 241,
263, 312, 320

Sb design
Rua Furriel Luiz A. Vargas
#380/203
90470-130 Porto Alegre RS
Brazil
sbdesign@myway.com.br
90, 131

Second Floor
443 Folsom Street
San Francisco, CA 94105
design@secondfloor.com
32, 137

Shelley Danysh Studio
8940 Krenstown Road, #107
Philadelphia, PA 19115
307, 311

Shields Design
415 East Olive Avenue
Fresno, CA 93728
198, 292, 301, 340

Sibley Peteet Design
3232 McKinney, #1200
Dallas, TX 75204
rhonda@spddallas.com
8, 133, 274, 281

Siebert Design Associates
1600 Sycamore
Cincinnati, OH 45210
178

Sivustudio
Tontunmaentie 22H
0220 Espoo
Finland
234, 261

Skarsgard Design
807 Hutchins Avenue
Ann Arbor, MI 48103
skarsgard@bigfoot.com
154

SND, Sue Nan Designs
1145 Lindero Canyon Road
Thousand Oaks, CA 91362
324

Solo Grafica
11251 Caminito Rodar
San Diego, CA 92126
243

Sommese Design
481 Glenn Road
State College, PA 16803
316

Spectrum Graphics Studio
2860 Carpenter Road
Suite 100B
Ann Arbor, MI 48108
49

Spin Productions
620 King Street West
Toronto, Ontario M5V1M6
Canada
norm@spinpro.com
146

Squeak
14851 Summerbreeze Way
San Diego, CA 92128
320, 323

Stang
Gedempte Zalmhaven 835
3011 BT Rotterdam
Holland
stang@ipr.nl
47, 61

Stefan Dziallas Design
Olbersstrasse 9
28307 Bremen
Germany
262

Stephen Peringer Illustration
17808 184th Avenue NE
Woodinville, WA 98072
173, 271

Steve Trapero Design
3309-G Hampton Point Drive
Silver Spring, MD 20904
255

Steven Morris Design
10284 Royal Ann Avenue
San Diego, CA 92126
294, 297

Stewart Monderer Design, Inc.
10 Thacher Street
Boston, MA 02113
sm@monderer.com
96

Storm Design &
Advertising Consultancy
174 Albert Street, Prahran
Victoria 3181
Australia
194, 242

Stowe Design
125 University Avenue
Suite 220
Palo Alto, CA 94301
185, 228, 284, 291, 303, 323

Stress Lab
212 3rd Avenue N, #385
Minneapolis, MN 55401
280, 289, 305

Studio Boot
Brede Haven
8A's-Hertogenbosch
The Netherlands
69, 79, 87, 109, 112, 113, 121, 124, 149

Suburbia Studios
53 Tovey Crescent
Victoria, BC V9B 1A4
Canada
195

Sullivan Perkins
2811 McKinney
Suite 310 LB111
Dallas, TX 75204
274, 292, 320

Sunny Shender Design
2865 S. Atlantic Street
Seattle, WA 98144
275

Susan Guerra
30 Gray Street
Montclair, NJ 07042
166, 215

Tanagram
855 W. Blackhawk Street
Chicago, IL 60622
174, 196, 254

Tangram Strategic Design
Via Negroni 2
28100 Novara
Italy
311, 327, 332, 334

Teikna
366 Adelaide Street East
Suite 541
Toronto, ON M5A 3X9
Canada
212, 223, 244

Teslick Graphics
41 Elm Avenue
Highwood, IL 60040
342

Tharp Did It
50 University Avenue
Suite 21
Los Gatos, CA 95030
206, 233, 235, 276, 300, 302, 308,
313, 324, 334

"That's Nice" l.l.c.
1 Consulate Drive, #3N
Tuckahoe, NY 10707
84

The Bradford Lawton
Design Group
719 Avenue E
San Antonio, TX 78215
277, 331

The Design Company
3103 East Shadowland Aveunue
Atlanta, GA 30305
203, 212, 251, 294

The Eikon Marketing Team
901 Pine
Rolla, MO 65401
266

The Hive Design Studio
10 Jackson Street, #204
Los Gatos, CA 95032
amyb13@aol.com
23, 38, 78

The Home Studio
3105 Moss Side Avenue
Richmond, VA 32222
229

The Paul Martin Design Co.
32 Dragon Street
Petersfield, Hampshire GU31 4JJ
England
270

The Puckett Group
7521 Buckingham Drive, #2W
St. Louis, MO 63105
candy_freund@simmons-
durham.com
134

The Riordon Design Group
131 George Street
Oakville, ON L6J 3B9
Canada
group@riordondesign.com
6, 7

The Running Iron Studio
726 Long Drive, #26B
Sheridan, WY 82801
227

The Weller Institute for
the Cure of Design, Inc.
P.O. Box 518
Oakley, UT 84055
chachaw@allwest.net
29, 341

The Woldring Company
306 West Michigan Avenue
Kalamazoo, MI 49007
306, 321

The Wyant Simboll Group, Inc
96 East Avenue
Norwalk, CT 06851
327

Tilka Design
1422 West Lake Street, #314
Minneapolis, MN 55408
295, 325, 336

Tim Kenney Design Partners
3 Bethesda Metro Center
Suite 630
Bethseda, MD 20814
135

Toni Schowalter Design
1133 Broadway, 1610
New York, NY 10010
218, 182

Total Creative, Inc.
8360 Melrose Avenue, 3rd Floor
Los Angeles, CA 90069
105

Tower of Babel
24 Arden Road
Asheville, NC 28803
226, 235

Tracy Design
5638 Holmes
Kansas City, MO 64110
197

Transparent Office
Overgadeau O.Vandet 54 A2
DK-1415 Cph.K
Denmark
247

Treehouse Design
10637 Youngworth Road
Culver City, CA 90230
tr_treehouse@pacbell.net
14, 145

Troller Associates
12 Harbor Lane
Rye, NY 10580
55

twenty2product
440 Davis Court
Apt. 509
San Francisco, CA 94111
terry@twenty2.com
34

Two In Design
1270 West Peachtree Street NW
Suite 8B
Atlanta, GA 30309
281, 283, 324

Underdog Design
4147 49th Avenue SW
Seattle, WA 98116
320

Urbangraphic
3165 Kershawn Place
Escondido, Ca 92029
urbangraph@aol.com
68

V. Allen Crawford Design
25 Locust Lane
New Egypt, NJ 08533
307

Val Gene Associates
5208 Classen Boulevard
Oklahoma City, OK 73118
197, 258, 259

Vanessa Eckstein
12 Charles Street, #3C
New York, NY 10014
334

Vaughn Wedeen Creative
407 Rio Grande NW
Albuquerque, NM 87104
286, 291, 293, 302

Veronica Graphic Design
Suite 67 Isle of Capri
Commercial Centre QLO. 4217
Australia
321

Vestígio
Rua Chaby Pinheiro, 191-2°
P-4460-278
Sra. da Hora
Portugal
info@vestigio.com
29, 83, 135

Via Vemeulen
William Boothlaan 4
Rotterdam
The Netherlands
viarick@ipr.nl
36

Vibeke Nødskov
Overgaden Oven Vandet 54A2
DK-1415 Copenhagen
Denmark
239, 283, 322

Visible Ink
678 13th Street
Suite 202
Oakland, CA 94612
274, 313, 333, 335

Visser Bay Anders Toscani
Assumburg 152, Postbus
P.O. Box 71116
1008 BC Amsterdam
Holland
75, 155

Visual Advantage
13080 Woodlands Parkway
Clive, IA 50325
274

Visual Marketing Associates
322 S. Patterson Boulevard
Dayton, OH 45402
info@vmai.com
100, 143

Voice Design
1385 Alewa Drive
Honolulu, HI 96817
voice@lava.net
66, 150, 333

Vrontikis Design Office
2021 Pontius Avenue
Los Angeles, CA 90025
200, 221, 224

Wages Design
887 W. Marietta Street
Studio 5-111
Atlanta, GA 30318
289, 317

Wallace/Church
330 E. 48th Street
New York, NY 10017
wendy@wallacechurch.com
33

Walmsley Design
40 Hobbs Brook
Weston, MA 02193
320

Walsh and Associates, Inc.
1725 Westlake Avenue North
Suite 203
Seattle, WA 98109
269, 292, 315, 330, 333

Watts Graphic Design
79-81 Palmerston Crescent
South Melbourne 3205
Australia
233

WCVB TV Design
5 TV Place
Needham Heights, MA 02194
327

WDG Communications
3011 Johnson Avenue NW
Cedar Rapids, IA 52405
213

Whitney Edwards Design
14 West Dover Street
Easton, MD 21601
283

Widmeyer Design
911 Western Avenue, #305
Seattle, WA 98104
165, 182, 206, 214, 215, 232, 239,
244

Wiedemann Design
227 Shipley Street
San Francisco, CA 94107
280, 305

Witherspoon Advertising
1000 West Weatherford
Fort Worth, TX 76102
231

Yaba (Yeh!) Design
5 Bialik Street
Tel Aviv, Israel 63324
331

YoungJu Lee
2 Kaywood Road
Port Washington, NY 11050
308

Z Works
P.O. Box 65
Tustin, CA 92681
335

Zappata Designers
Lafayette 143, Anzures
C.P. 11590 Mexico City
Mexico
221

Zauhar Design
510 1st Avenue N, #405
Minneapolis, MN 55403
279

Zedwear
1718 M Street NW
Suite 1010
Washington, DC 20036
316

Zeigler Associates
107 E. Cary Street
Richmond, VA 23219
zeiglera@erols.com
27, 97

Zeroart Studio
P.O. Bos 71466, Kowloon
Central Post Office
Hong Kong
zeroart@netvigator.com
127, 216

Zubi Design
57 Norman Avenue, #4R
Brooklyn, NY 11222
280